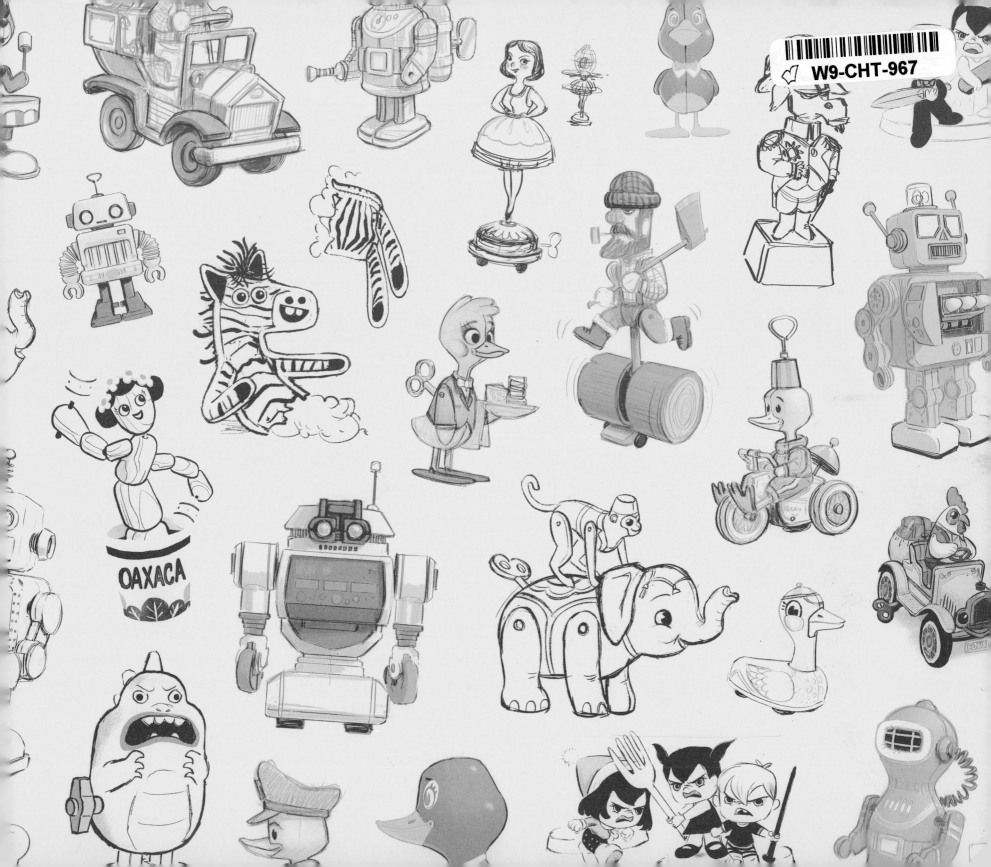

OAXACA

THE ART OF

Disney · PIXAR

Foreword by Annie Potts, Introduction by Josh Cooley

CHRONICLE BOOKS
SAN FRANCISCO

Front cover: John Lee, DIGITAL

Back cover: John Lee, DIGITAL PAINTING

Jacket, front flap: Erik Benson, PEN AND PENCIL

Jacket, back flap: Michael Yates, DIGITAL

Endsheets: Jason Deamer, Albert Lozano, Celine You, Nancy Tsang, DIGITAL

This spread: John Lee, DIGITAL PAINTING

Library of Congress Cataloging-in-Publication Data

Names: Potts, Annie, writer of foreword. | Cooley, Josh, writer of
 introduction.
Title: The art of Toy story 4 / foreword by Annie Potts, introduction by Josh
 Cooley.
Other titles: Art of Toy story four
Description: San Francisco, CA : Chronicle Books LLC, 2019.
Identifiers: LCCN 2018037318 (print) | LCCN 2018040442 (ebook) | ISBN
 9781452164083 | ISBN 9781452163826 (alk. paper)
Subjects: LCSH: Toy story 4 (Motion picture) | Animated films--United States.
Classification: LCC NC1766.U53 (ebook) | LCC NC1766.U53 T69374 2019 (print) |
 DDC 791.43/340973--dc23
LC record available at https://lccn.loc.gov/2018037318

Manufactured in China

MIX
Paper from
responsible sources
FSC
www.fsc.org FSC™ C104723

Designed by Neil Egan
Layout and composition by Liam Flanagan

10 9 8 7 6 5 4 3 2

Chronicle Books LLC
680 Second Street
San Francisco, CA 94107
www.chroniclebooks.com

CONTENTS

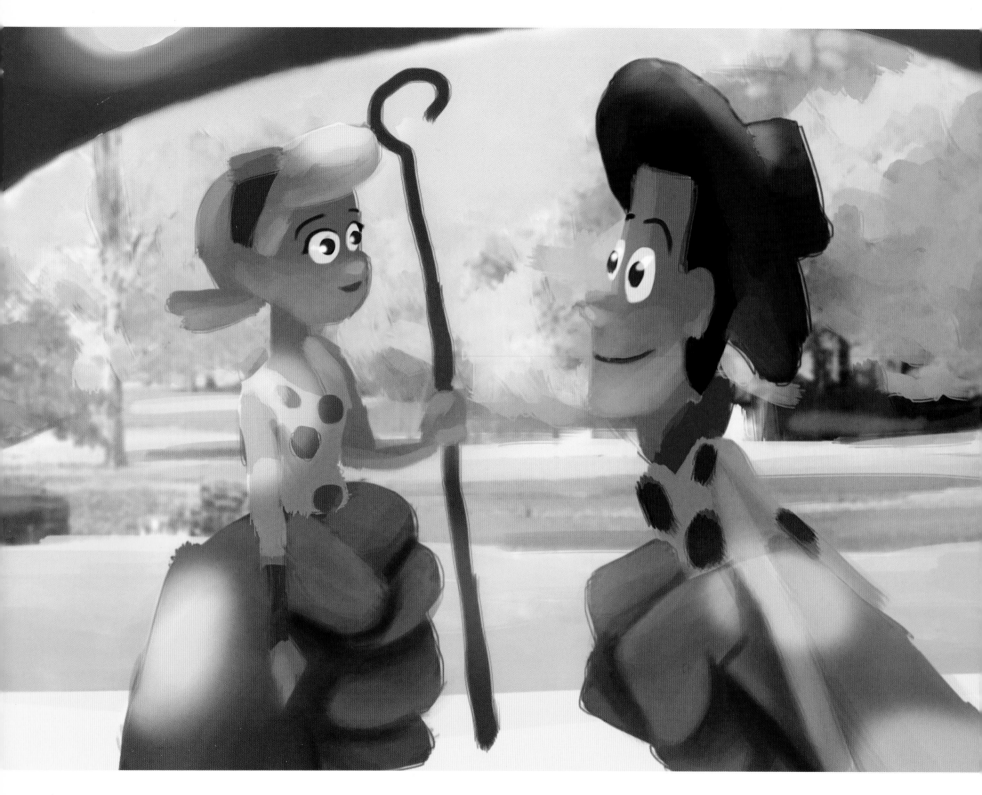

FOREWORD by Annie Potts

It was 1994. I had been working all day. I came in the back door, where I was immediately tackled by my young son, who pulled me into the den where he was watching a video sent to me some weeks before by John Lasseter. A call had come from my agents with the arrival of the package stating that Mr. Lasseter would like me to be a voice in his animated movie . . . "the *first* completely computer-animated full-length feature film." I had tossed it aside with a yawn. I was overwhelmed with work and two young children. And as I told my manager, I don't really do cartoons. "Well," he said, "take a look at his shorts." I promptly forgot about the offer until that moment when my son pushed the "play" button and one marvel after the other unspooled in front of my disbelieving eyes. *Luxo Jr., Red's Dream, Tin Toy, Knick Knack.* The world stopped while we watched them all twice.

So utterly original and beautiful and funny and touching and like NOTHING ANYONE HAD SEEN BEFORE. I practically tripped over myself trying to get to the phone (this was before cell phones!) to make the call to say, "YES, YES, YES! Please I want to be a voice for you!!" That was twenty-four years ago now. And here we are with *Toy Story 4*, Pixar's 21st animated feature. These beautiful stories and characters and films are a foundational language known now to the world. This was so richly illustrated to me last year when I was cruising the Amazon River and discovered, as we rounded a bend, a remote jungle village and a young boy playing on the banks of the river . . . dressed in a *Toy Story* T-shirt with Woody's face. Like stardust and sunshine, Pixar's spirit is everywhere. And it is welcome.

I can tell you there is almost nothing more fun than being in a recording session with these masters of storytelling—not to mention getting to work with the matchless Tom Hanks. A vast team of people brings our beloved characters to the big screen. It will be a revelation to most to see in this book how mind-bogglingly complex the making of these masterpieces is, from the earliest sketches and storyboards to fully realized worlds where toys come to life.

I've given some thought to how it is that what Pixar does is so thoroughly good. So beloved by all. It seems that it is about the values and virtues that each picture extols. Be kind. Be a friend. Reach out a hand. Hold on tight. Understand that there might be monsters under the bed—but they might be your friends! It's good to share. It's good to be nice to old people. Boys and girls are equally smart and brave. Your parents love you no matter what. Your toys love you unconditionally. No one is "bad"—they probably just have a hurt they're hiding. We're all the same INSIDE. We are ONE. We are ALL ONE. There is one single force that unifies us and makes us laugh and cry and dance and be more than we thought we could be, and the force that animates every single thing in the universe is LOVE. That's what Pixar gives us with every frame. Love. And Hope.

Keep shining your light, Pixar. We need it.

[opposite] John Lee, DIGITAL PAINTING

INTRODUCTION by Josh Cooley, director

"The only constant is change."
–Heraclitus, Greek philosopher

There were two reactions I would get from people when I mentioned we were making *Toy Story 4*. Either the largest grin from ear to ear, usually followed by a high-pitched squeal of delight and then dancing . . . or that smile would morph into confusion. "But . . . wasn't the third one the end?"

How *do* you follow the ending of a great trilogy?

That question was what got me excited about the idea of *Toy Story 4*. If every end is a new beginning, then what is next for Woody? What is Woody's life without Andy? How would the most loyal toy in the world deal with being in a new kid's room, with new toys, new relationships . . . and not being a favorite toy anymore? He couldn't be the same toy he's always been. He would have to change.

I wanted to make that film.

Turns out that making a *Toy Story* film that feels like a *Toy Story* film but is different enough so it doesn't feel similar to the past three *Toy Story* films . . . is not easy. We went down a LOT of different story paths over the years. (We could fill a twenty-volume set of *Toy Story 4* "Art of" books with all the material created for the different versions of the film. But one will work just fine.)

When I began as an intern at Pixar sixteen years ago, my mentor, Joe Ranft, would always tell me to "trust the process." He talked of how, in his experience working on films, if you work long and hard enough, the film will eventually reveal itself to you. The characters will begin to tell you what they want to do and say. Sounds hard to believe, but it happened. We were unknowingly populating our story with characters that were all dealing with transition in their lives. Woody was grasping for anything familiar so he didn't have to change, Gabby Gabby was doing anything in her power to create change, Duke Caboom couldn't accept the change from his past, Forky physically changed and wanted no part of it, and Bo had accepted and embraced change and was a catalyst for Woody to embrace it as well. We were touching on a universal truth, which is always a good sign when creating stories. Life is constantly shifting the sands beneath us, and how we adapt to it (or don't) shows our true character.

I've learned that "trust the process" also means "trust the people you work with." I have had the honor of working with some of the greatest story minds, artists, and technical geniuses in the world on this film. (Some of whom worked on the first *Toy Story*.) Their talent would blow my mind daily, so I'm excited to share a small fraction of their brilliance in the pages of this book. As a young artist, I was endlessly inspired while looking through Pixar's "Art of" books. The artwork transcends the page, invoking the images on screen that create emotion and connection with the audience.

I was reminded of this one day when I ordered a sandwich for lunch from outside the studio. When it was delivered, there was a note attached from the sandwich maker. Somehow they knew who it was coming to because the note read:

"Thank you for *Toy Story*. I never thought toys could teach me what it means to be human."

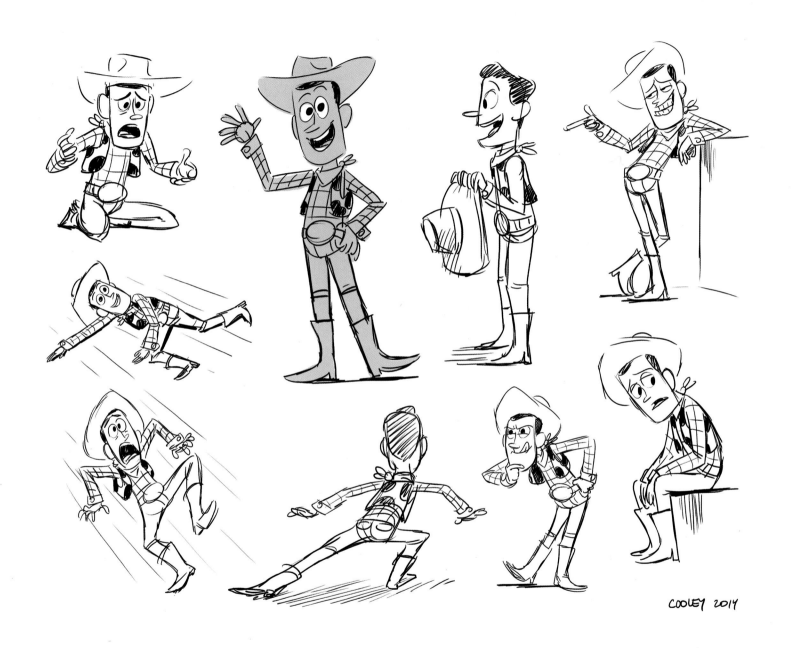

Josh Cooley, STORY DRAWING

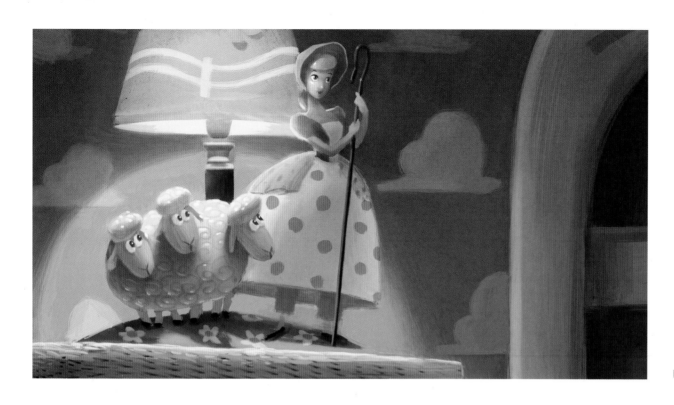

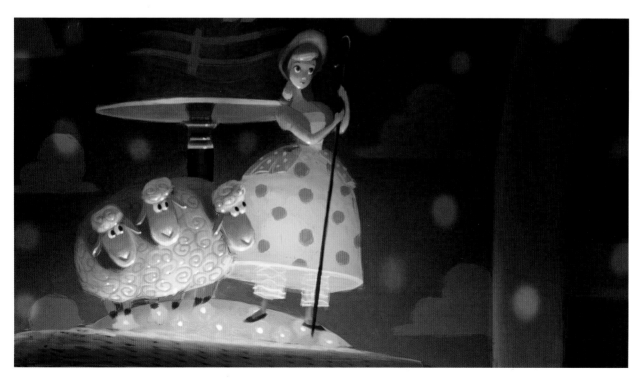

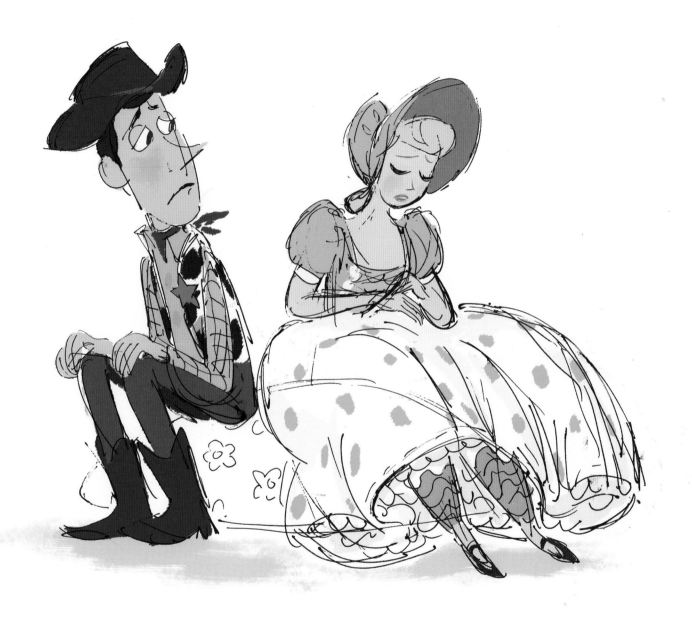

Daniela Strijleva, INK PEN AND DIGITAL COLOR

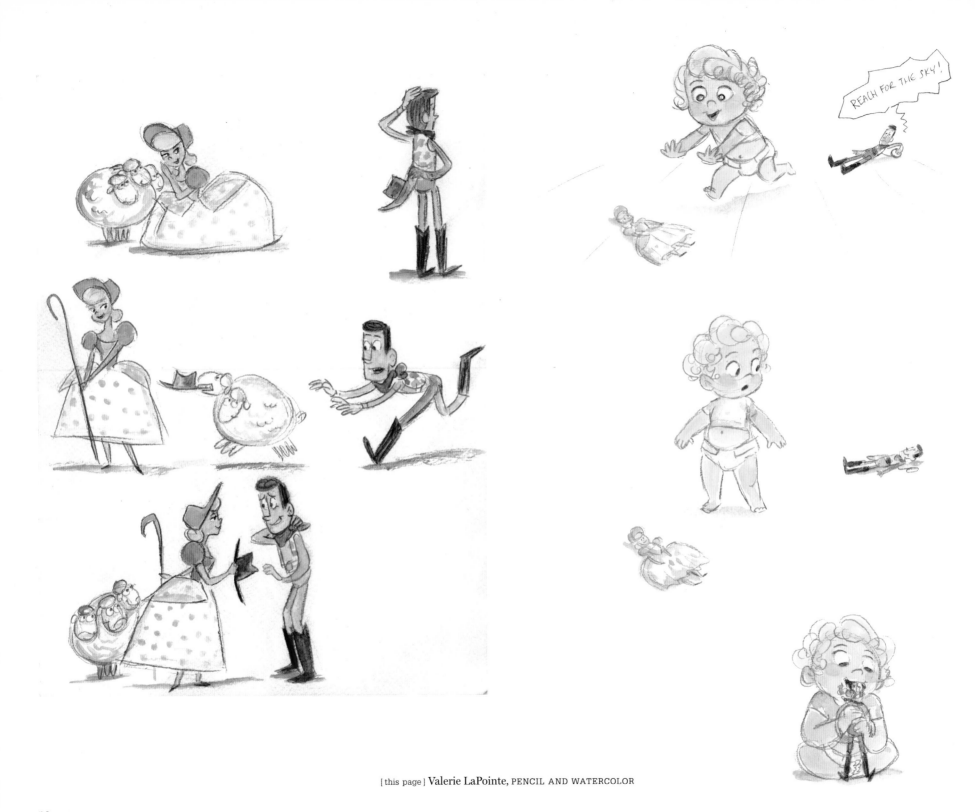

[this page] Valerie LaPointe, PENCIL AND WATERCOLOR

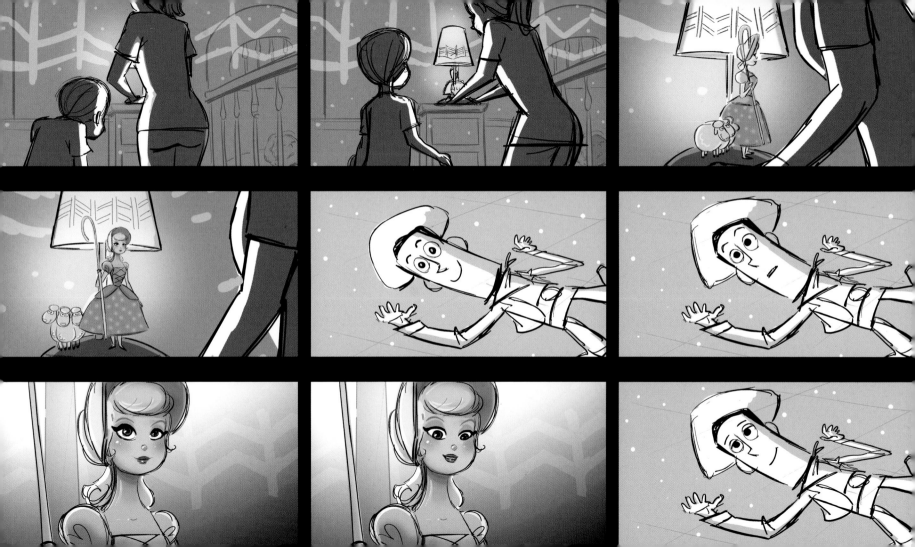

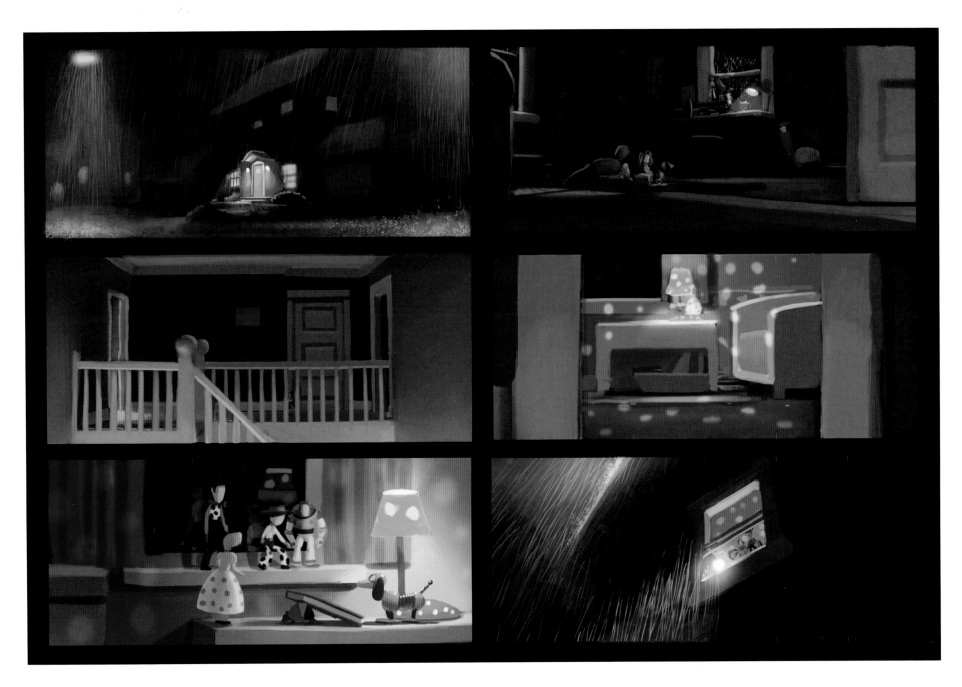

John Lee, DIGITAL PAINTING

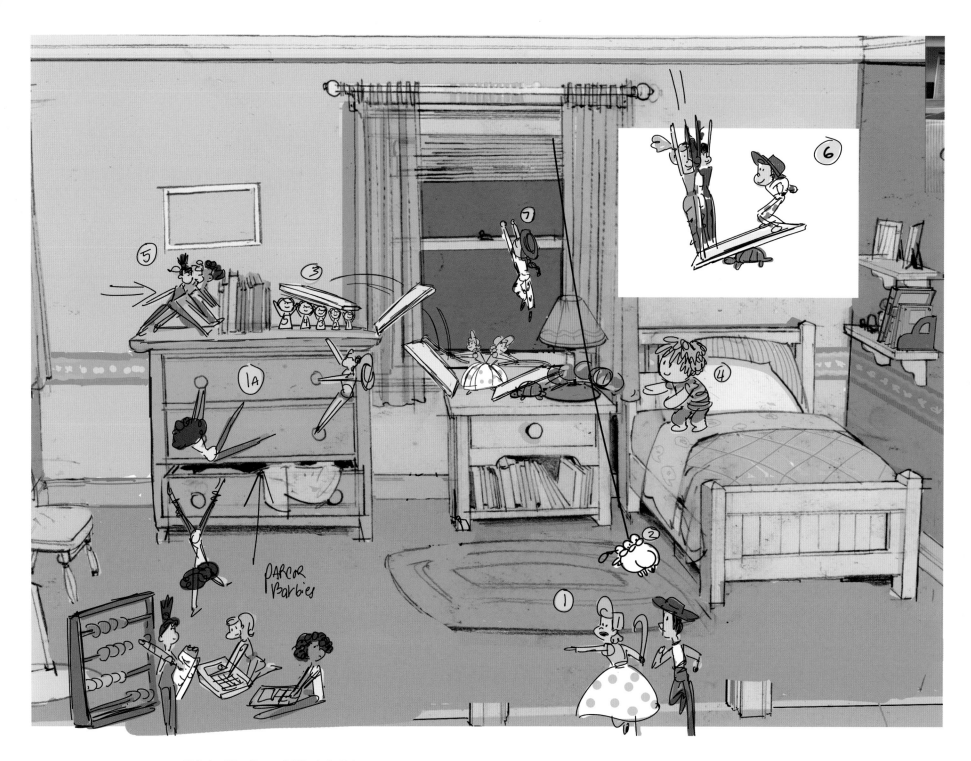

Kristian Norelius and Valerie LaPointe, DIGITAL OVER PENCIL

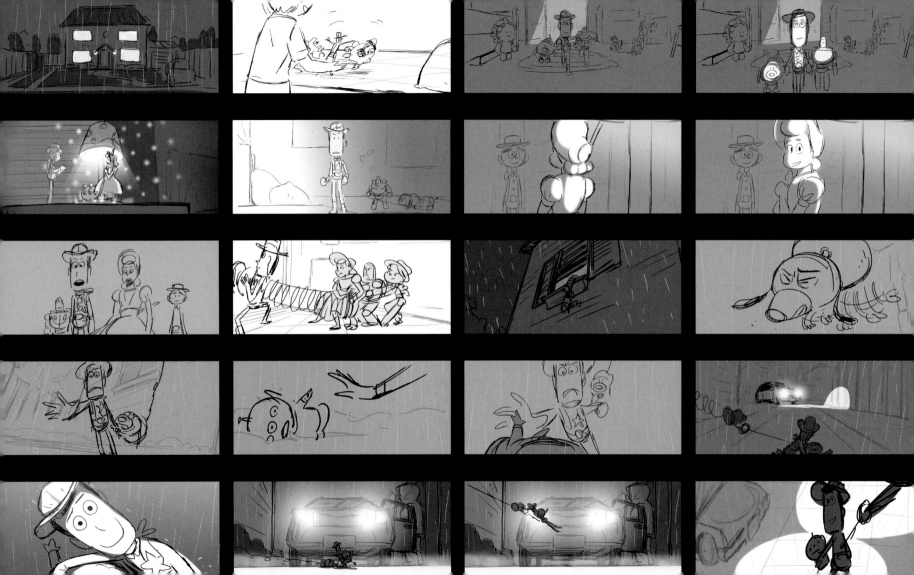

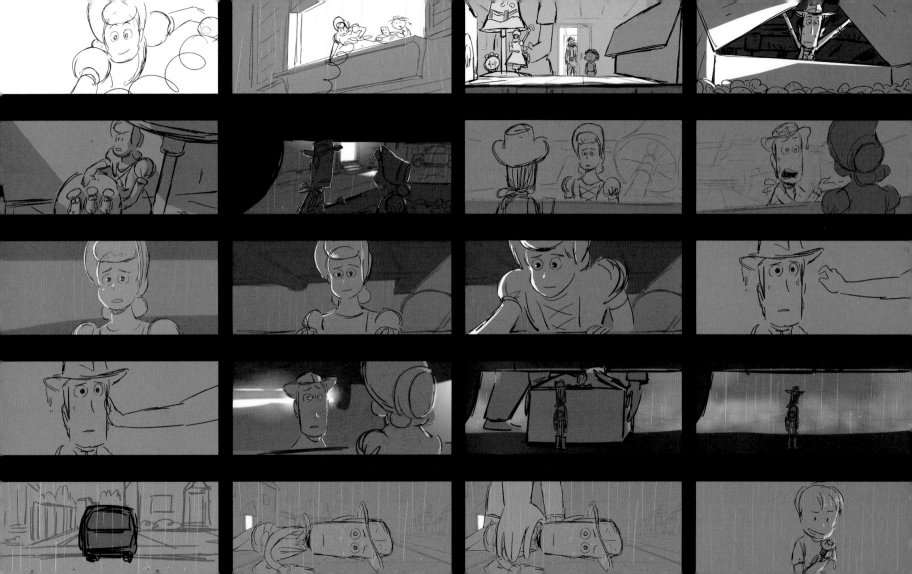

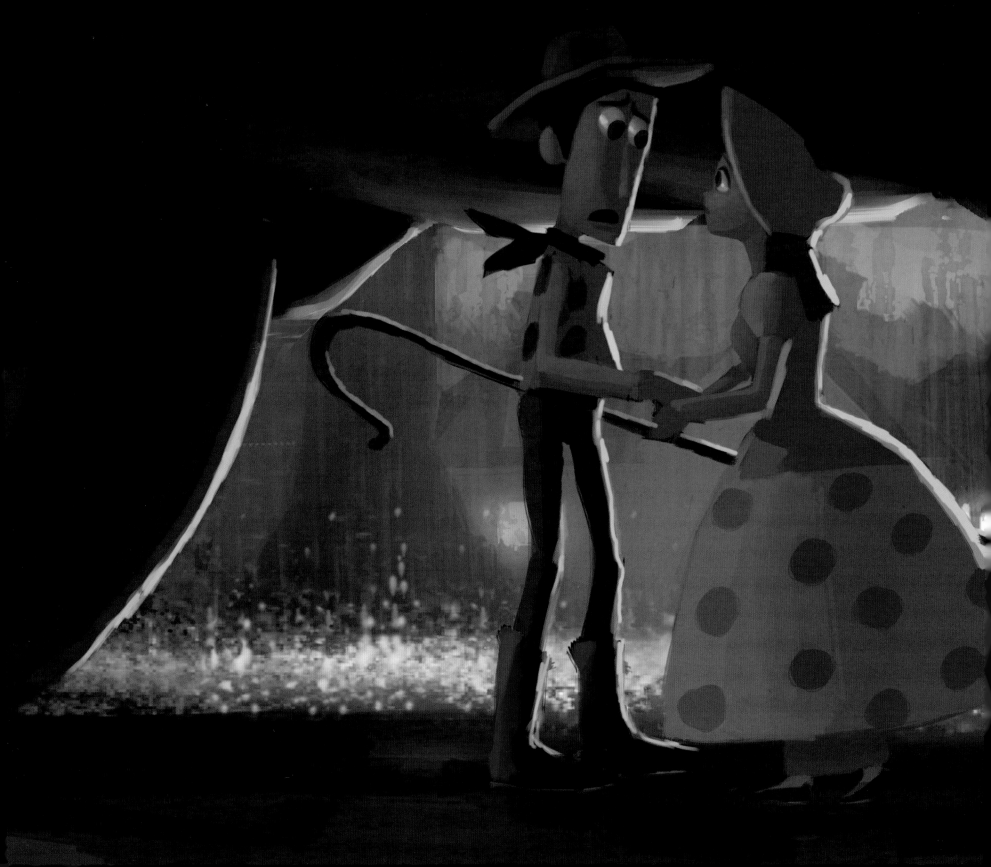

John Lee, DIGITAL PAINTING

BO PEEP

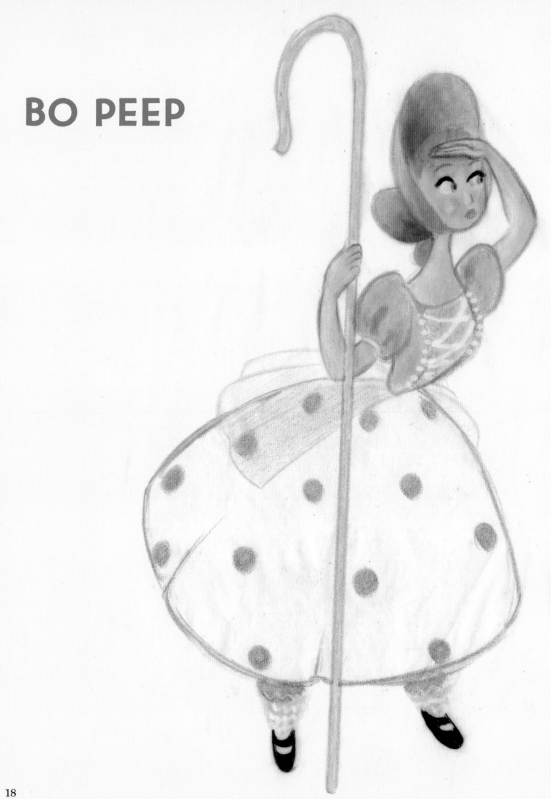

Ralph Eggleston, PASTEL AND INK PEN

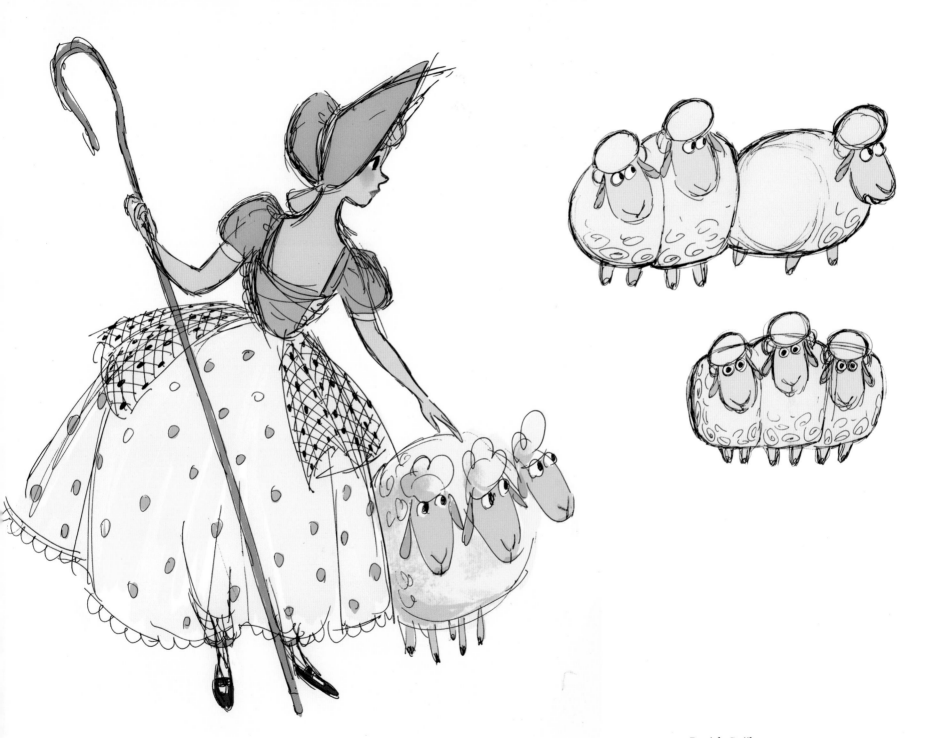

[this page] Daniela Strijleva, INK PEN AND DIGITAL COLOR

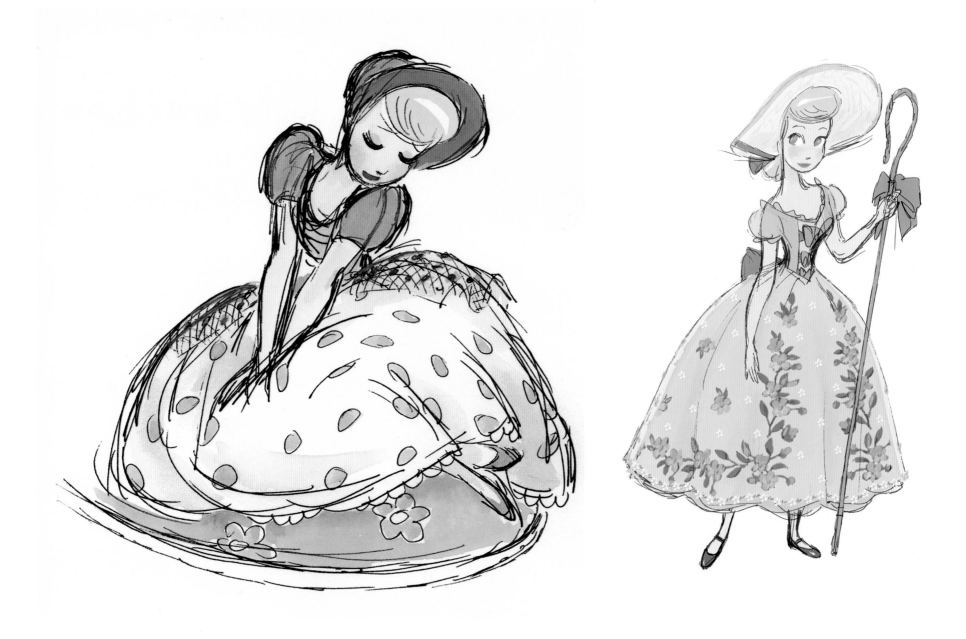

Daniela Strijleva, INK PEN AND GOUACHE

Daniela Strijleva, INK PEN AND DIGITAL COLOR

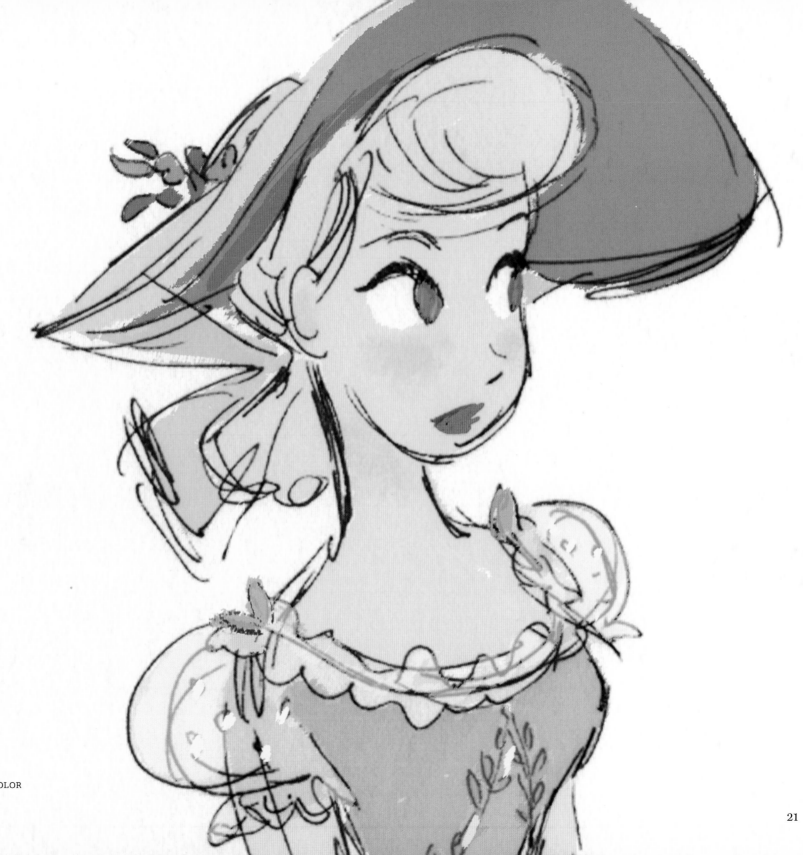

Daniela Strijleva,
INK PEN AND DIGITAL COLOR

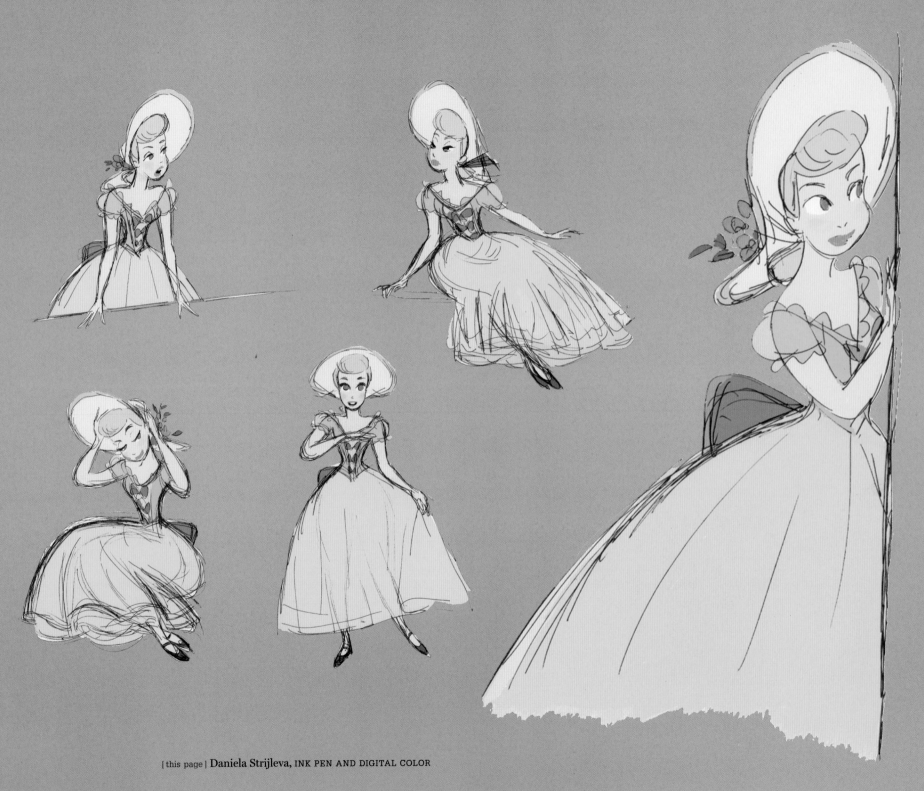

[this page] Daniela Strijleva, INK PEN AND DIGITAL COLOR

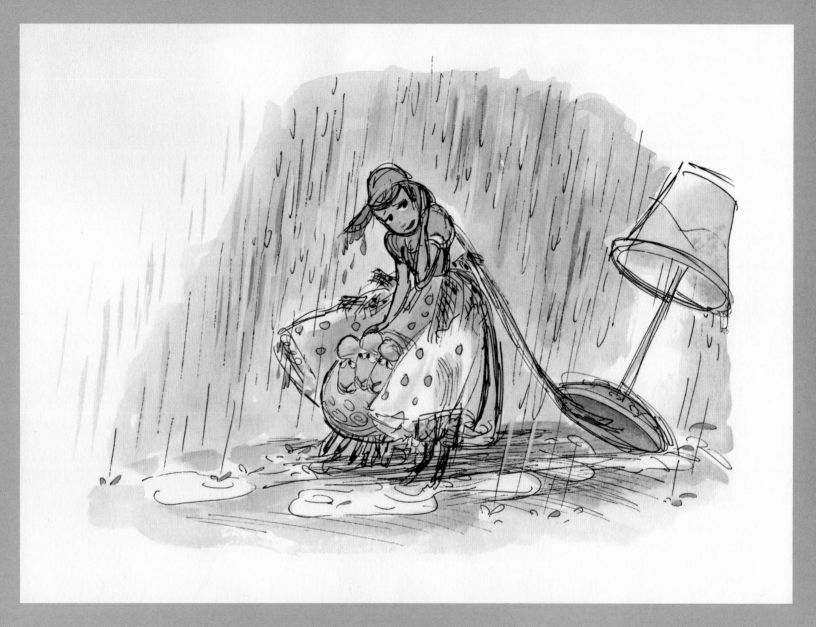

Daniela Strijleva, INK PEN
AND GOUACHE

I loved the idea of seeing the moment when Bo was given away early in the film. When Woody meets up with Bo years later, Bo originally went into great detail about what happened to her after she left Andy's house in a flashback. We saw her given to a new family, placed in storage for years, donated, bought at a thrift store, given as a white elephant gift, and then broken accidentally by a child. Bo then made a huge choice and left that kid. She and her sheep traveled through rain and cover of night to create a new life at the antique store. Although emotional, the flashback was ultimately cut as the story evolved. —JOSH COOLEY, DIRECTOR

24

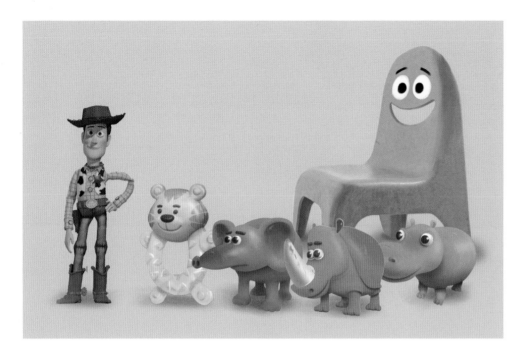

[above] **Celine You and Bill Zahn**, DIGITAL PAINTING

[opposite] **Valerie LaPointe**, PENCIL

Erik Benson, DIGITAL

Celine You, DIGITAL PAINTING

There are a *lot* of toys in Bonnie's room, and it was a challenge deciding which ones she would bring on the trip and that would help us tell the story. Putting both Mr. Potato Head and Mrs. Potato Head's pieces on one potato, an idea that I was surprised we had never done in the past, lowered the body count, and could have been a lot of fun for the animators. But in the end, it didn't serve Woody's story. —JOSH COOLEY, DIRECTOR

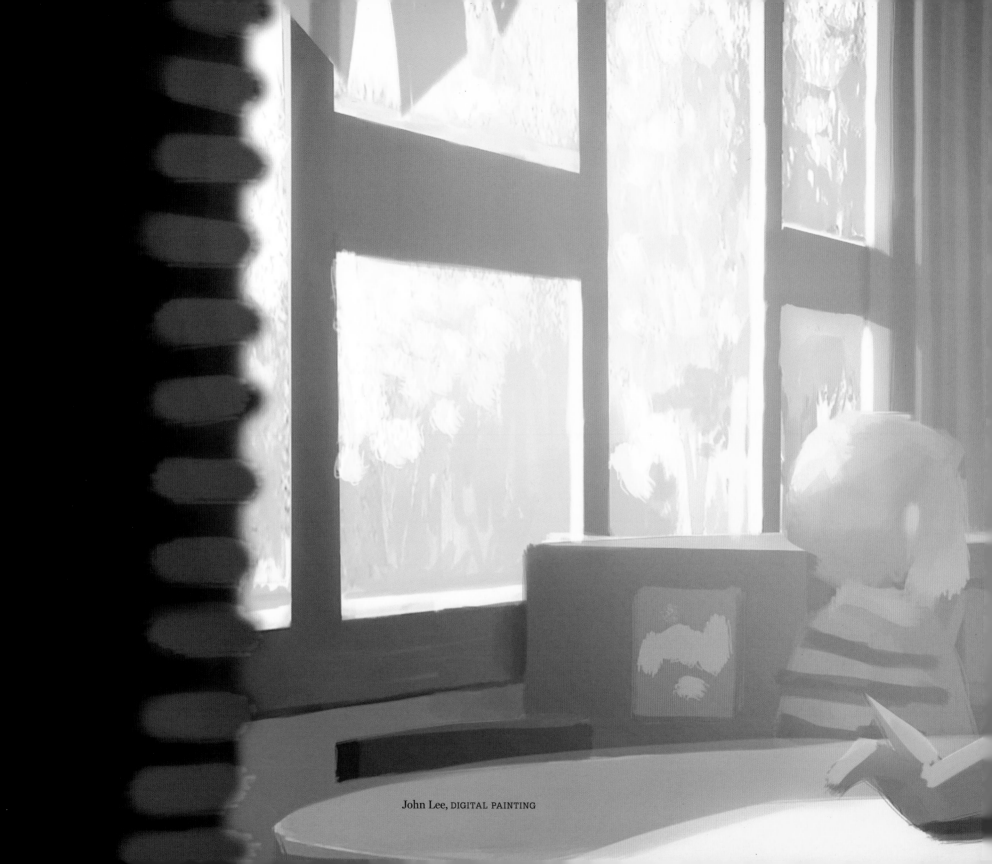

John Lee, DIGITAL PAINTING

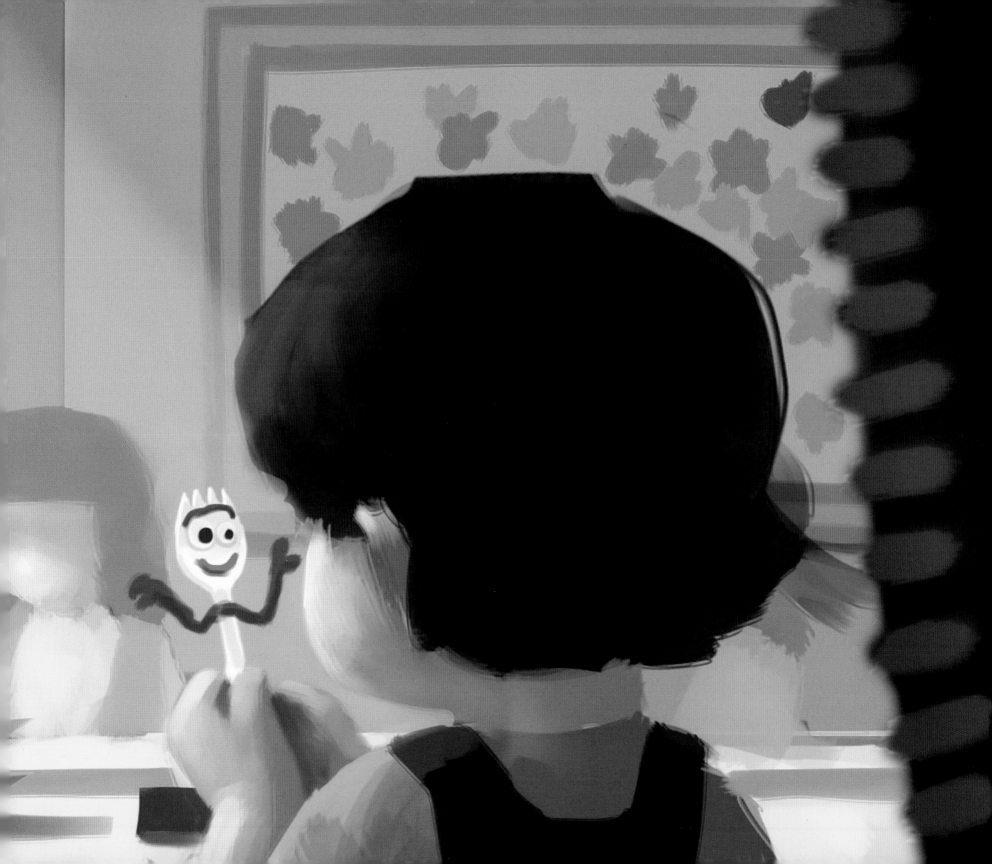

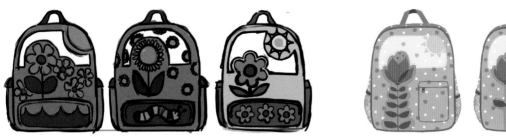

Daniel Holland, DIGITAL DRAWING

Ana Ramírez González, DIGITAL

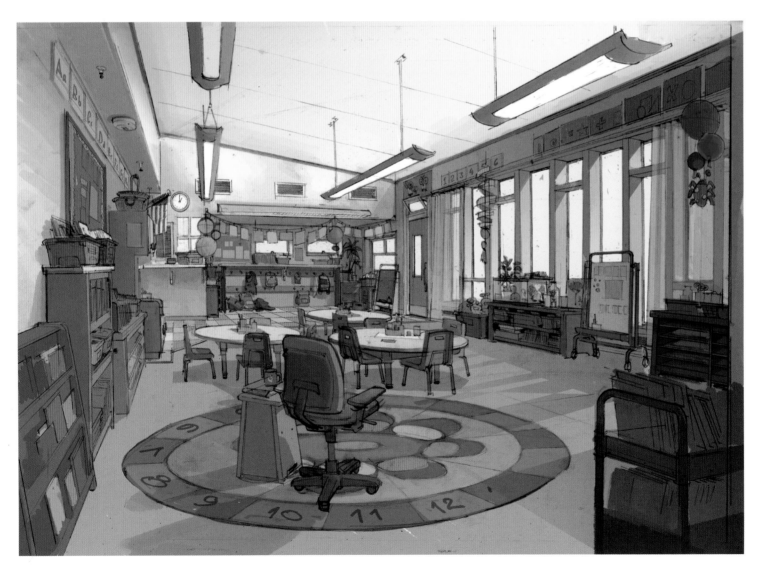

Kristian Norelius,
DIGITAL OVER PENCIL

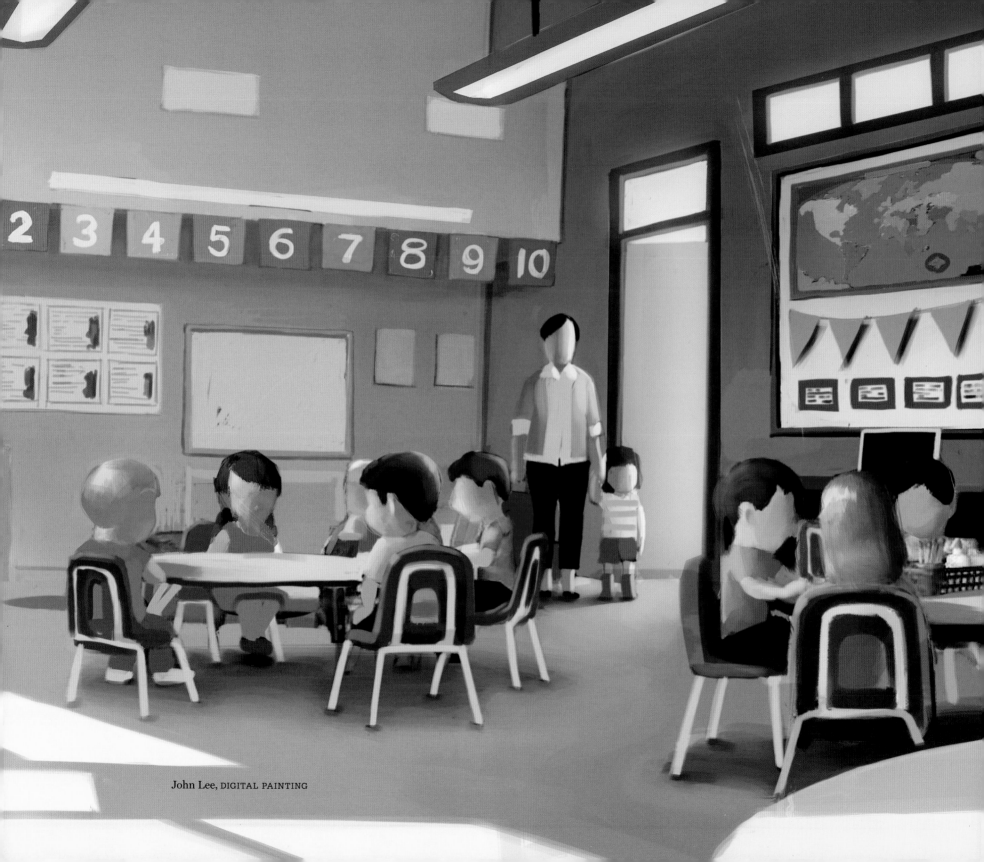

John Lee, DIGITAL PAINTING

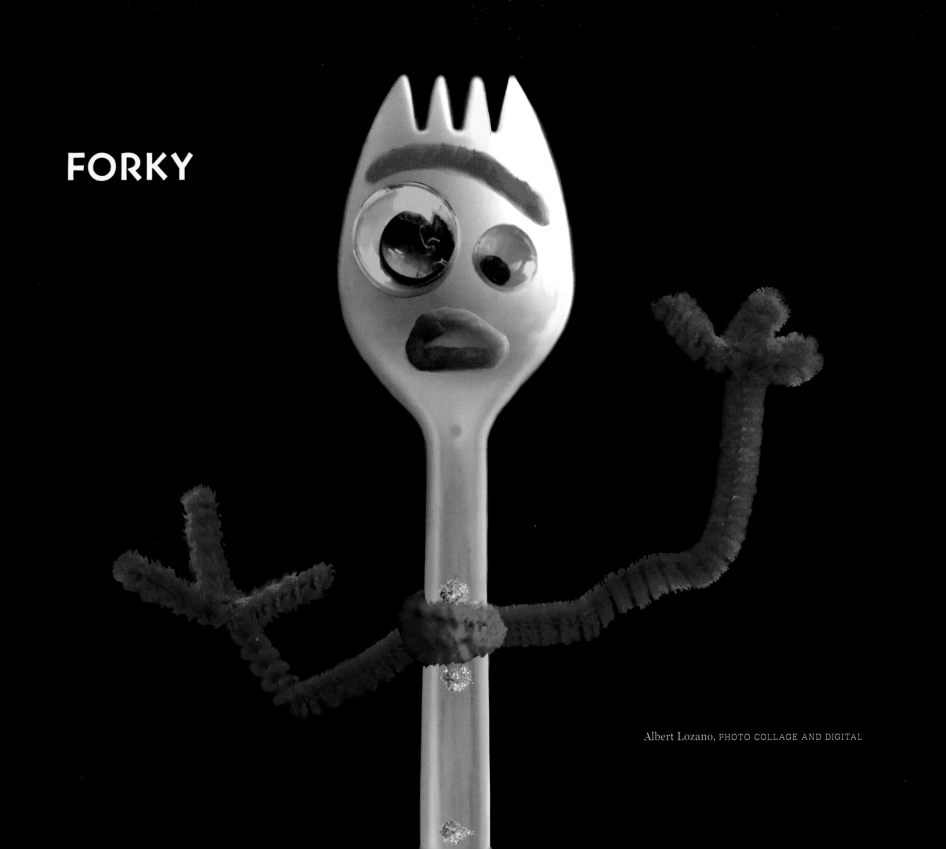

FORKY

Albert Lozano, PHOTO COLLAGE AND DIGITAL

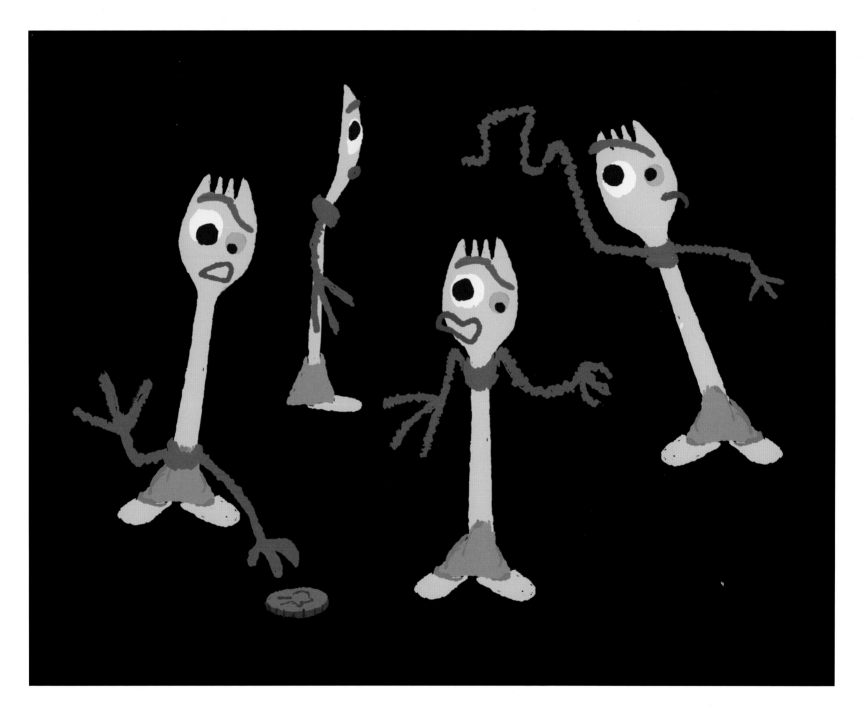

Albert Lozano, DIGITAL

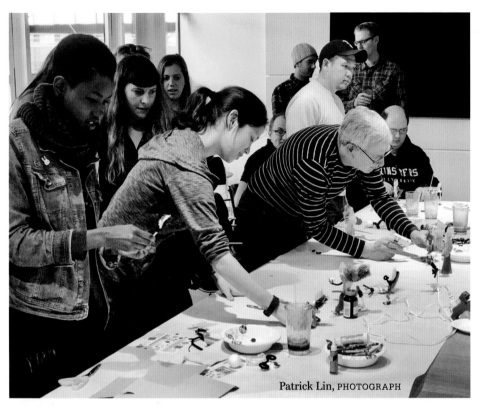

Patrick Lin, PHOTOGRAPH

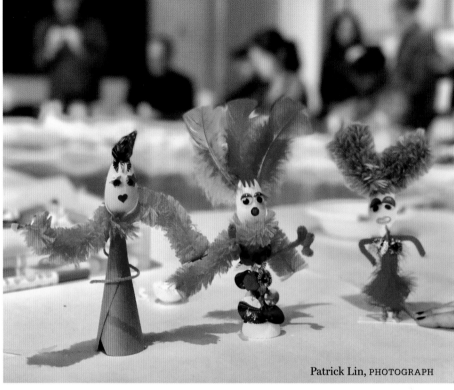

Patrick Lin, PHOTOGRAPH

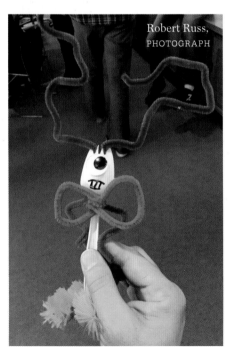

Robert Russ, PHOTOGRAPH

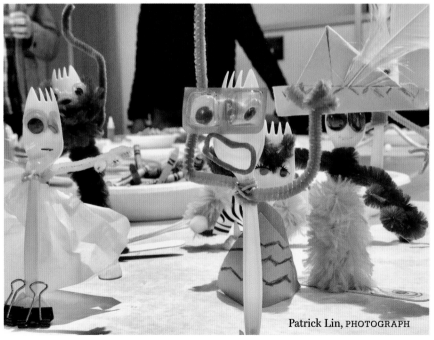

Patrick Lin, PHOTOGRAPH

Forky is essentially a character that is a craft project. Rather than design via drawings and the traditional model packet, we brought everyone on our crew together for what we dubbed the Forkshop. We bonded, and learned from the materials and the process. It was super fun to do. The Forkshop directly led to the character design, with Albert Lozano taking individual photos of each creation and designing within those photos, using Josh Cooley and John Lasseter's original sketches as inspiration.

Forky is a prime example of truth in the materials given that he has pipe cleaner arms with no shoulders to shrug, and that he can't bend or twist. The constraints will be fun for the animators to work within to make Forky emote. —BOB PAULEY, PRODUCTION DESIGNER

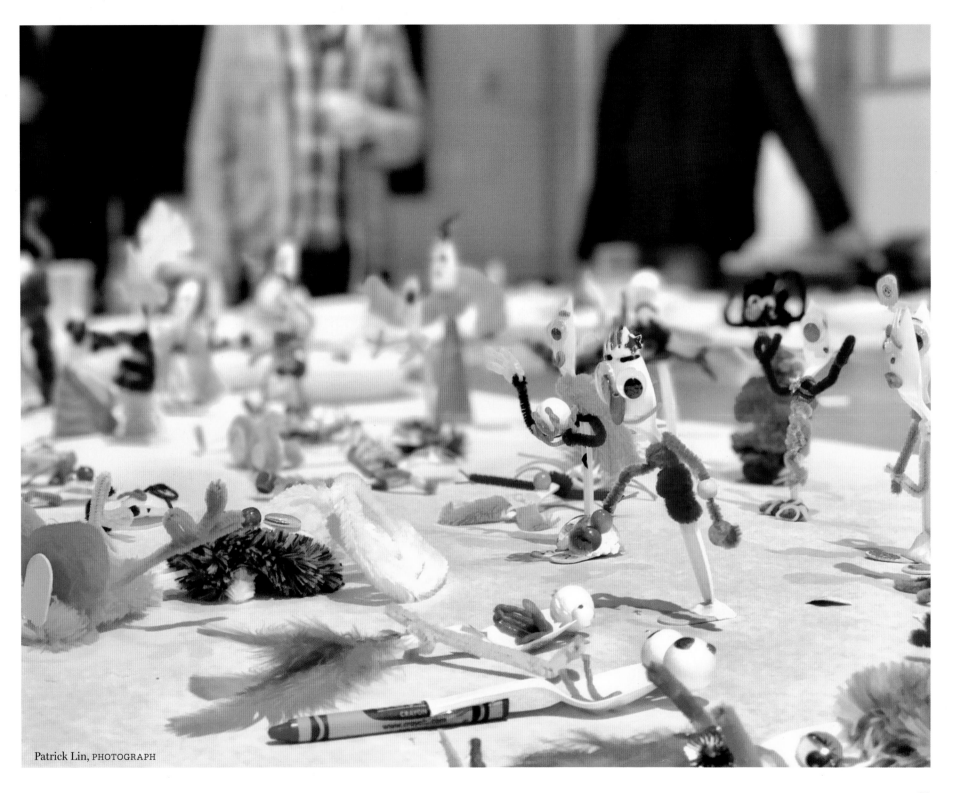

Patrick Lin, PHOTOGRAPH

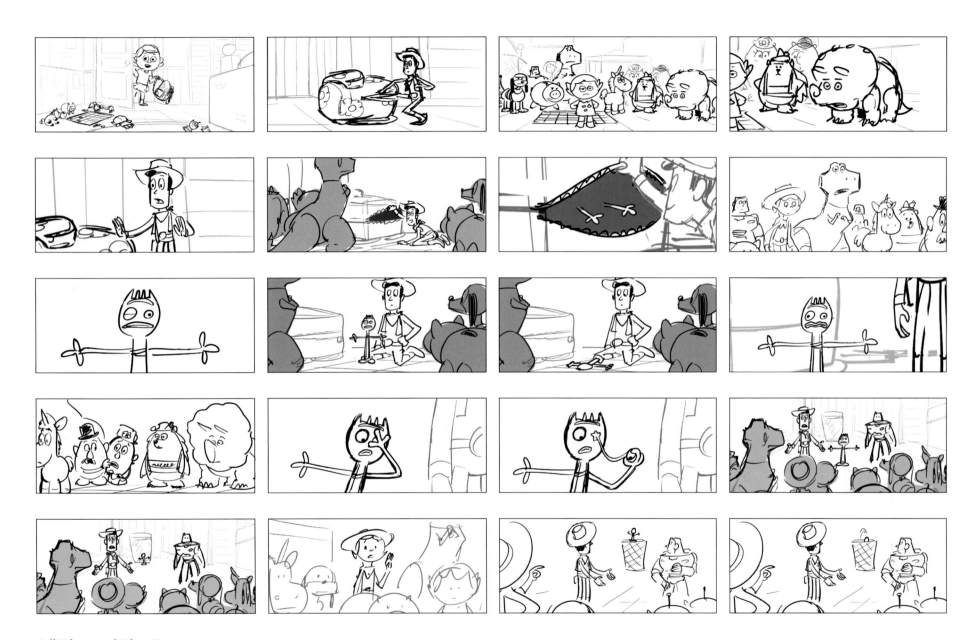

Jeff Pidgeon and Edgar Karapetyan, DIGITAL STORYBOARDS

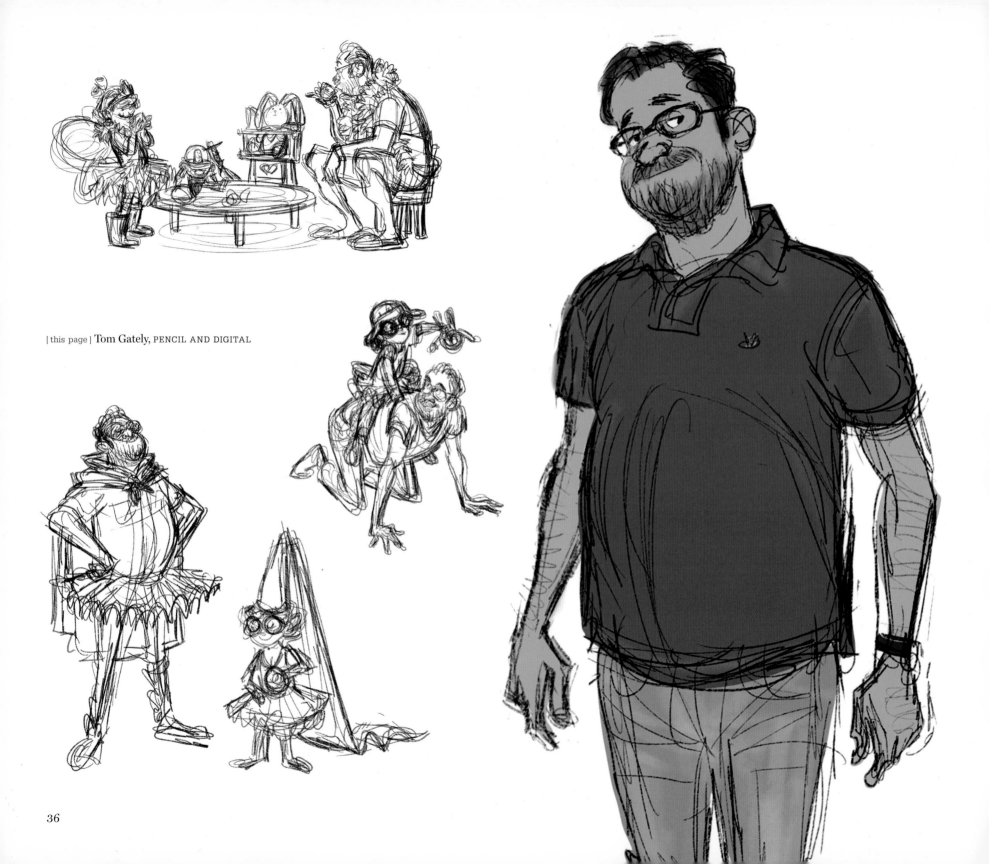

[this page] Tom Gately, PENCIL AND DIGITAL

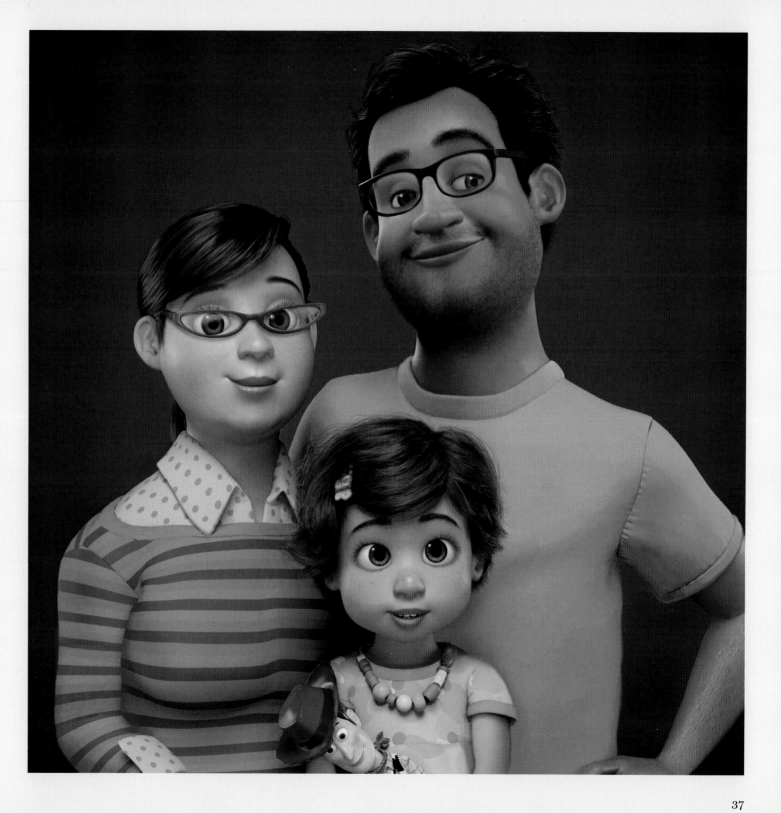

Laura Phillips, DIGITAL PAINTING

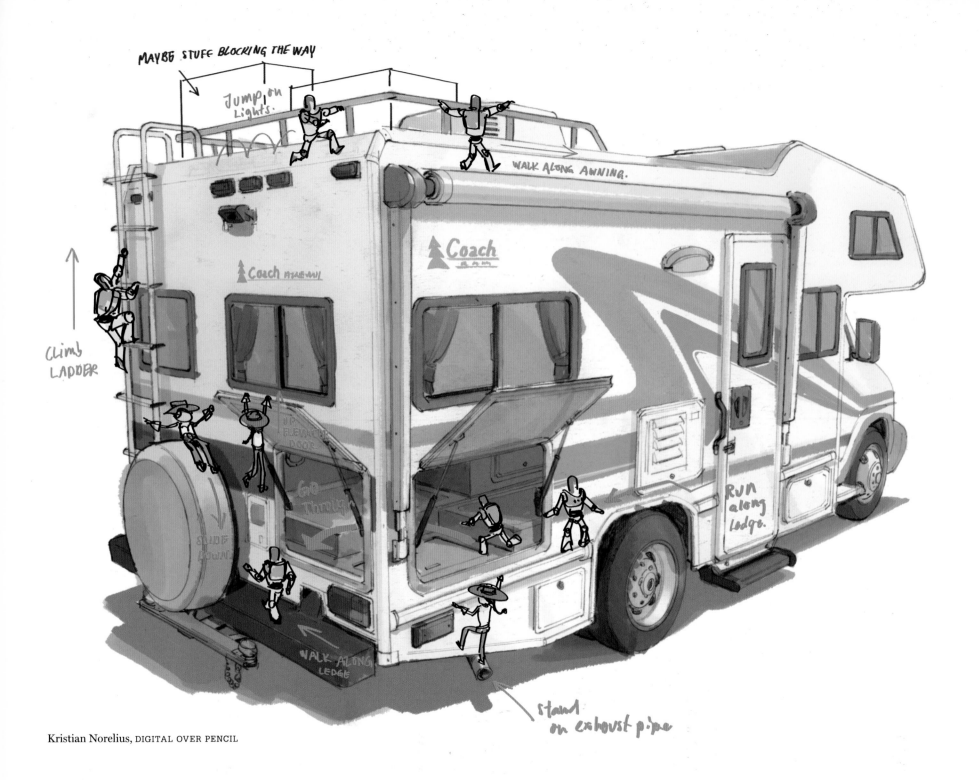

Kristian Norelius, DIGITAL OVER PENCIL

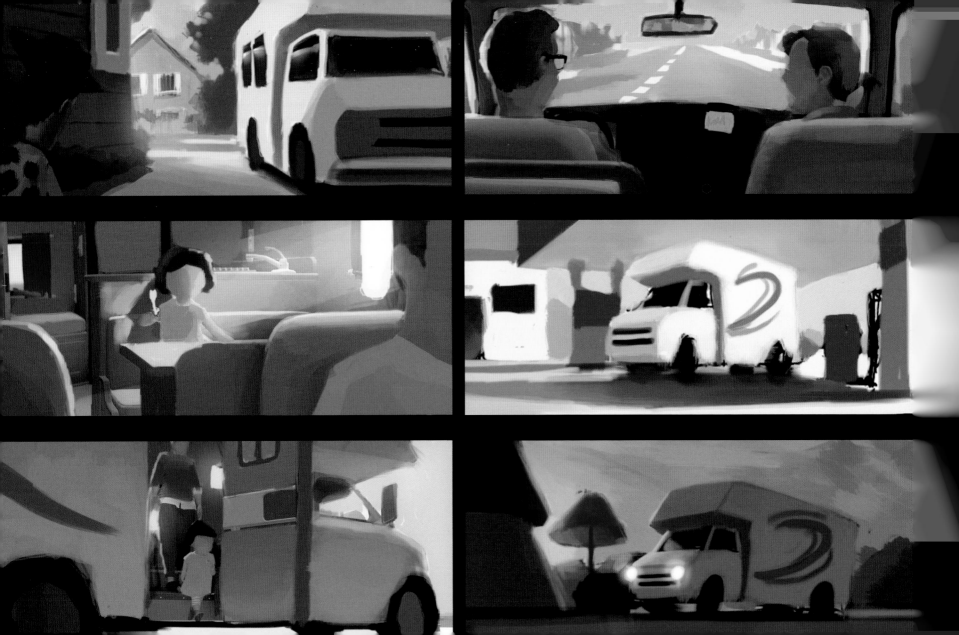

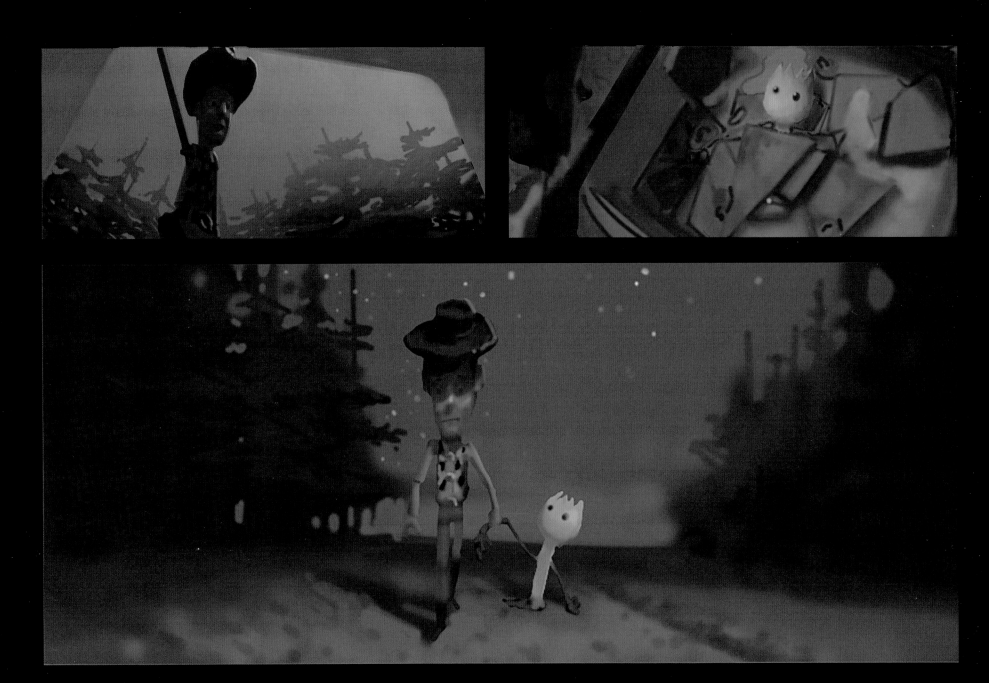

[this page] **Bill Cone,** DIGITAL PAINTING

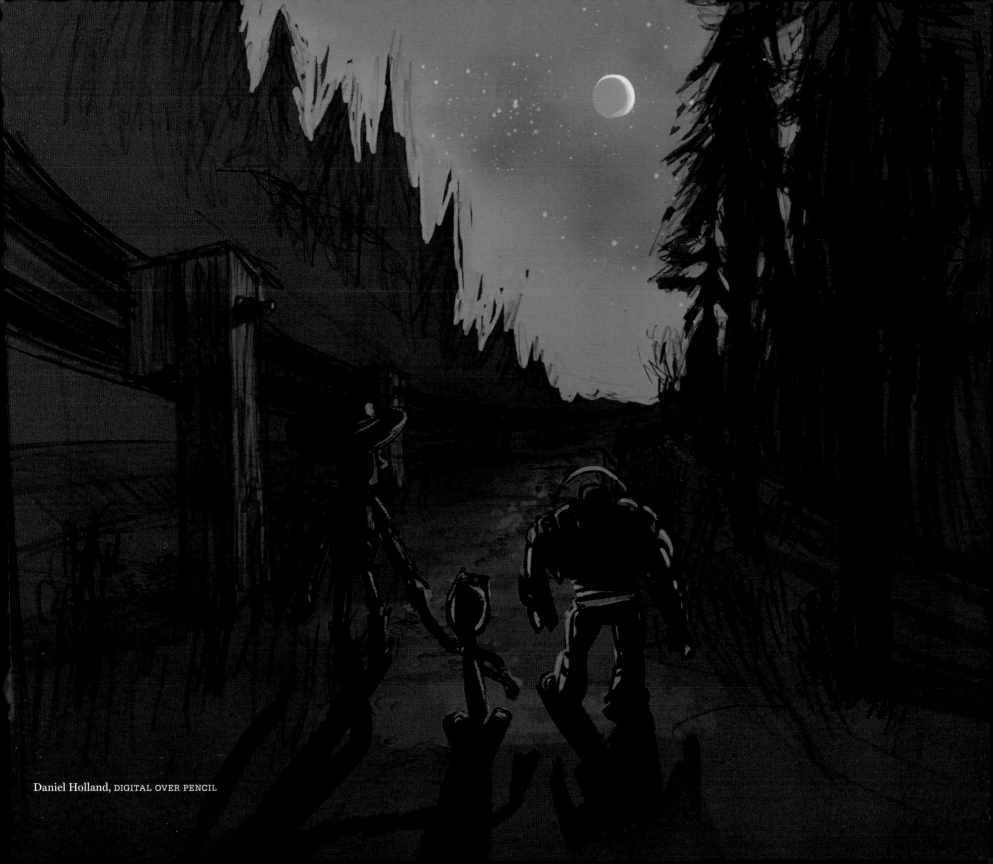

Daniel Holland, DIGITAL OVER PENCIL

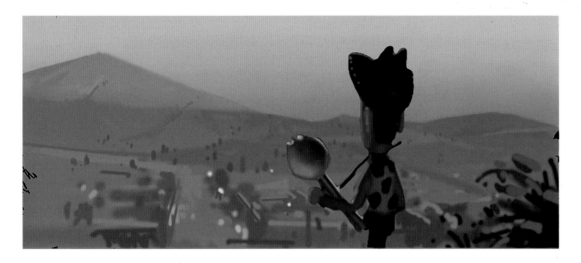

Bill Cone, DIGITAL PAINTING

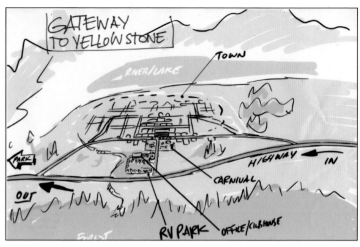

Bob Pauley, DIGITAL

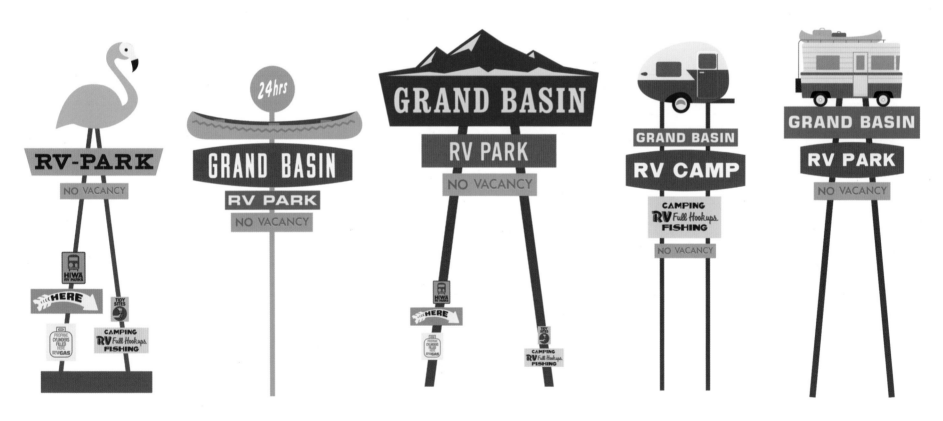

Craig Foster, DIGITAL

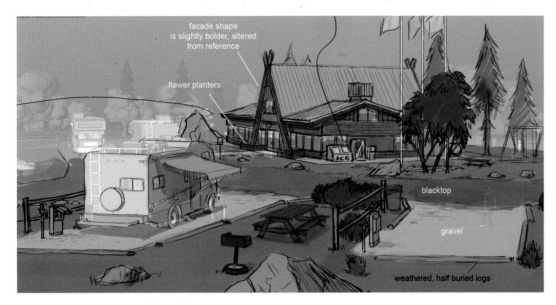

facade shape
is slightly bolder, altered
from reference

flower planters

blacktop

gravel

weathered, half buried logs

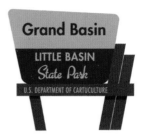

Grand Basin

LITTLE BASIN
State Park

U.S. DEPARTMENT OF CARTUCULTURE

GRAND BASIN 5mi ↑

VIEWING
AREA

INFO CENTER
AREA OPEN UNTIL SUNSET
NO DAY USE

[left and above] **Craig Foster,** DIGITAL

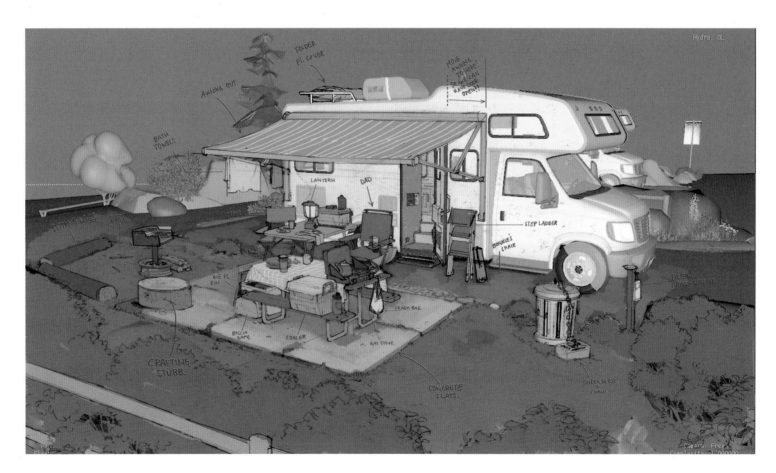

Kristian Norelius,
DIGITAL OVER PENCIL

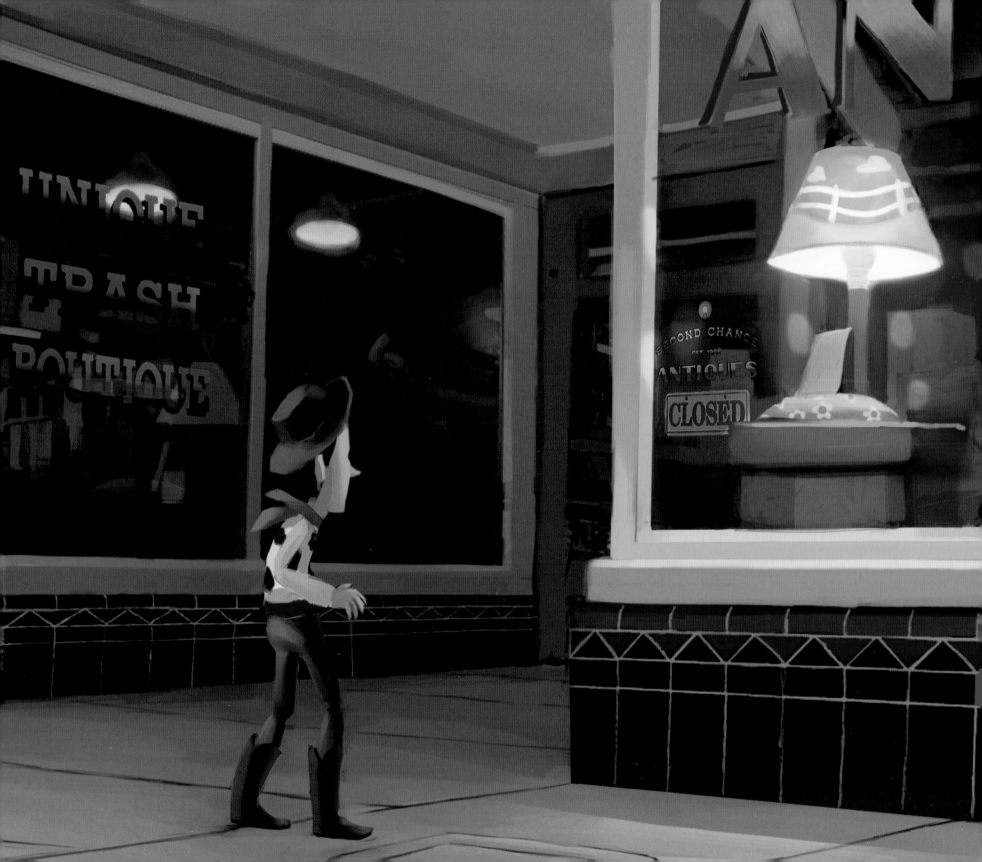

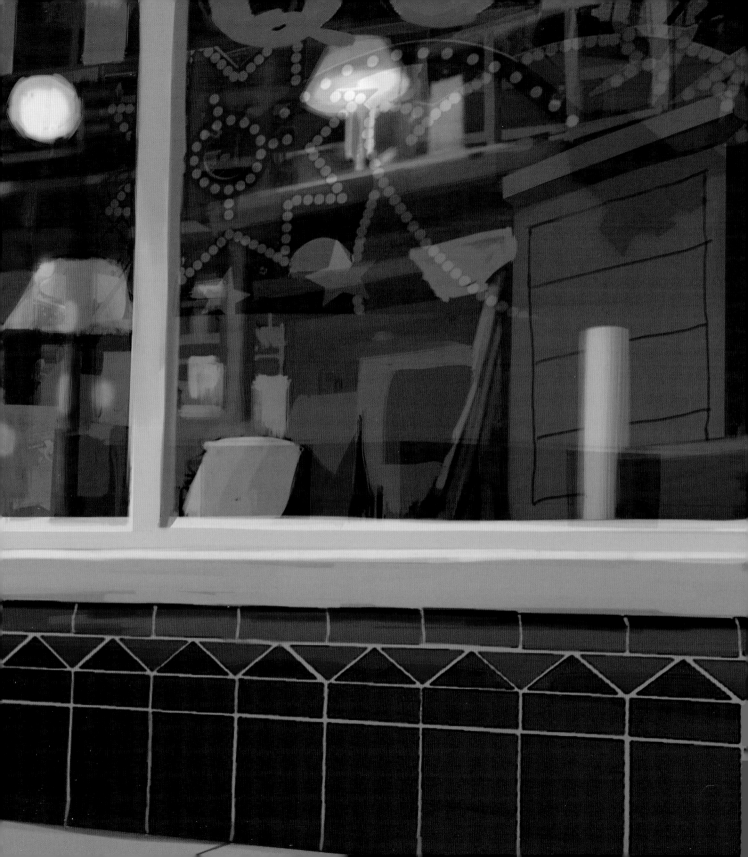

We decided early on that what is now our antique mall was originally an art deco furniture store. Giving it layers of invented history helps create an authentic sense of place.
—DANIEL HOLLAND, ART DIRECTOR, SETS

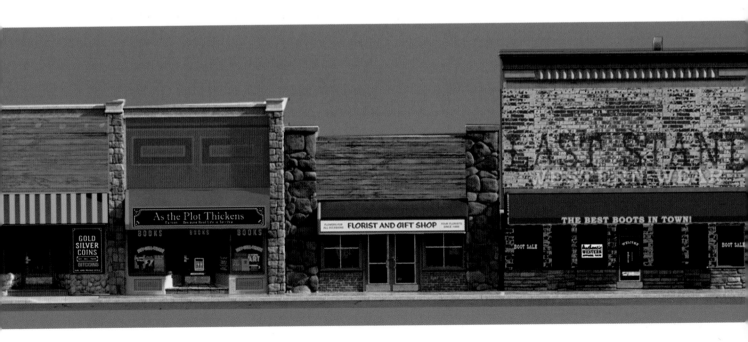

rry, DIGITAL; Graphics on storefronts: Craig Foster and Catherine Kelly, DIGITAL

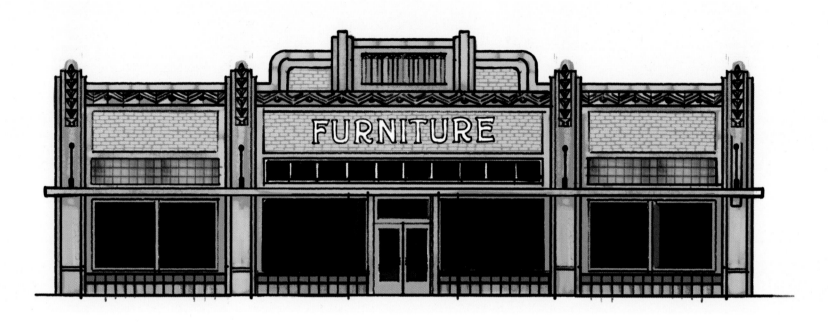

Daniel Holland, DIGITAL

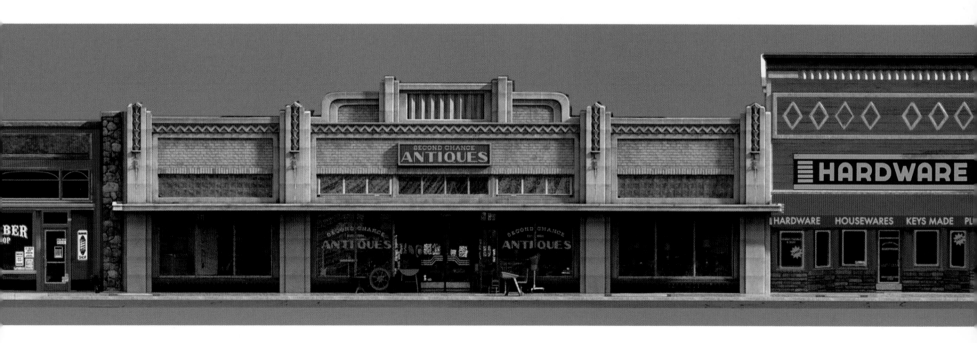

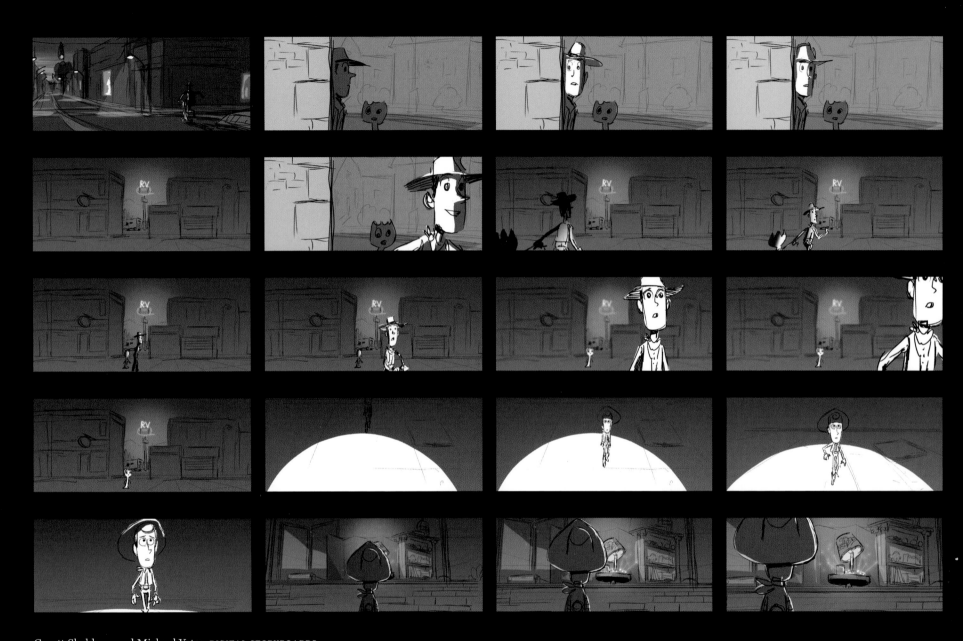

Garett Sheldrew and Michael Yates, DIGITAL STORYBOARDS

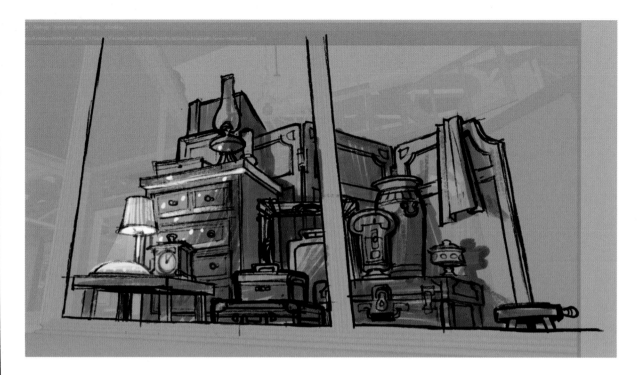

Daniel Holland, DIGITAL

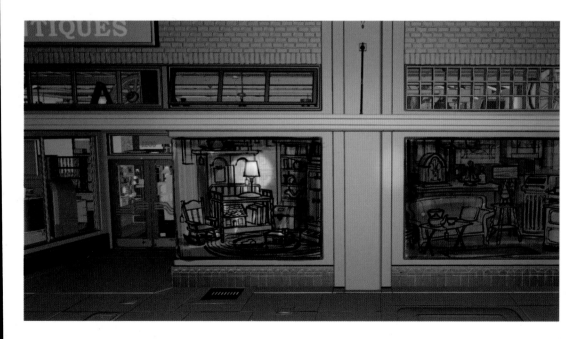

Daniel Holland, DIGITAL

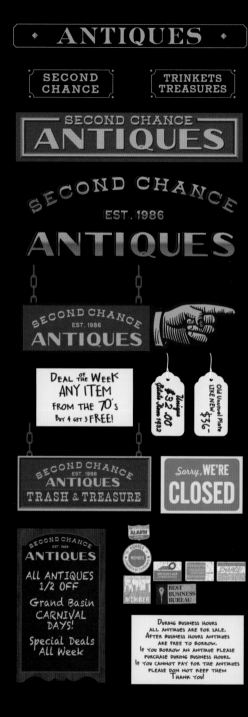

Craig Foster, DIGITAL

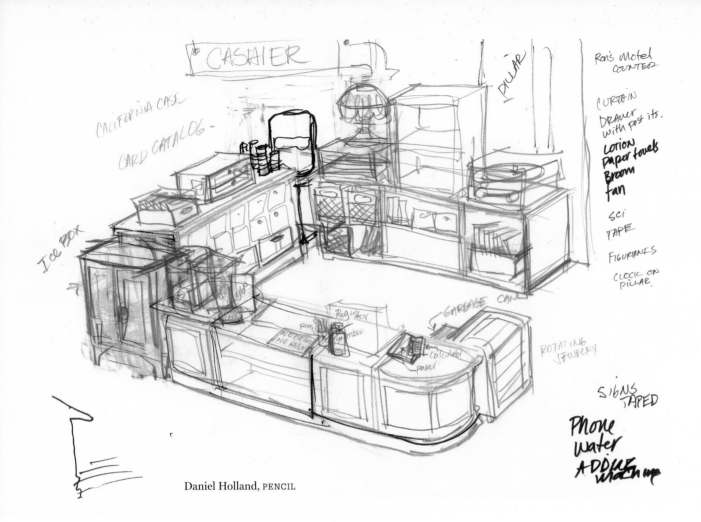

Daniel Holland, PENCIL

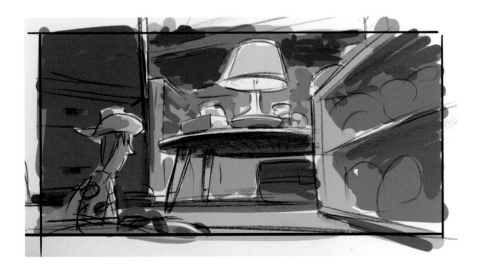

[left] Bob Pauley, DIGITAL

[right] Kristian Norelius,
DIGITAL OVER PENCIL

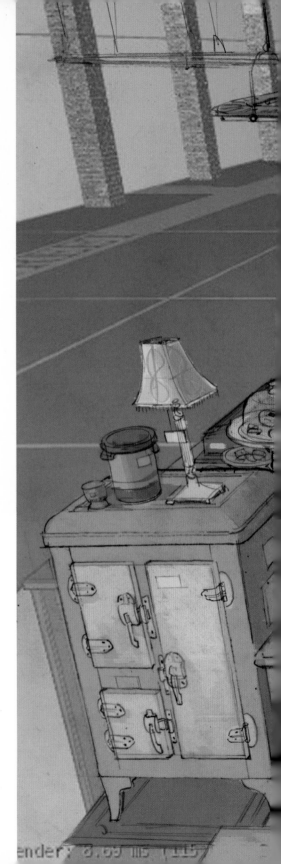

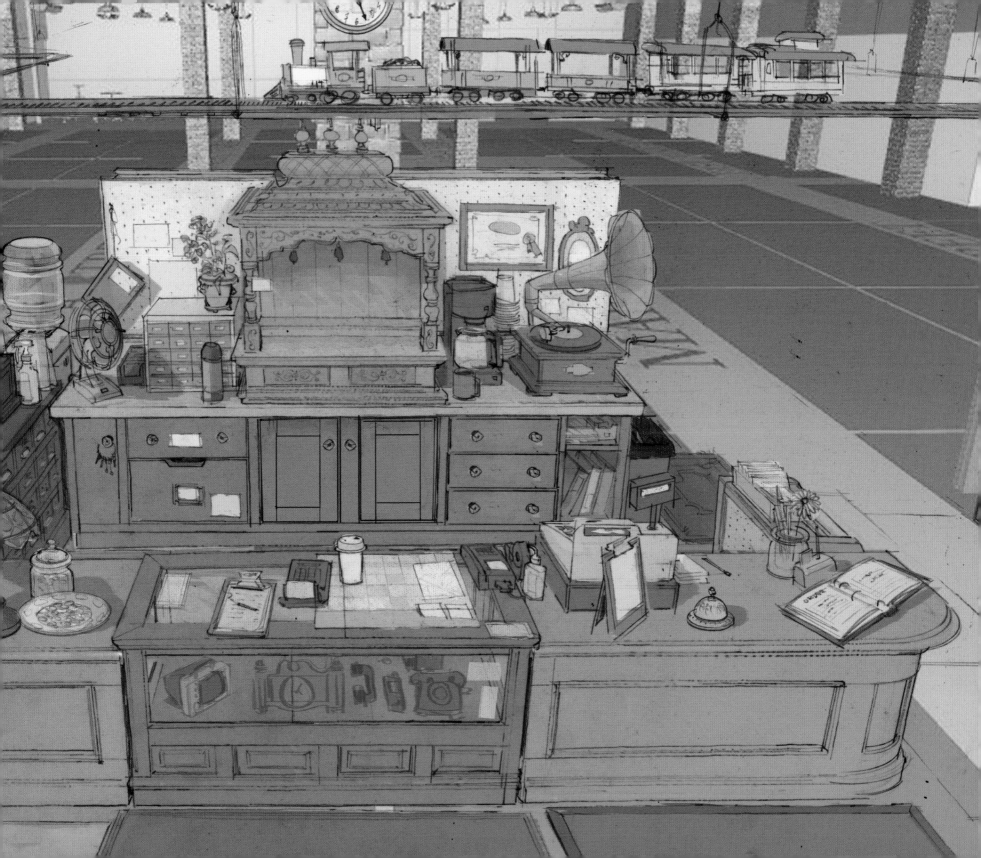

Bob Pauley, DIGITAL

Bob Pauley, DIGITAL

Our antique store started out as an antique mall made up of individually-themed booths operated by various owners. That idea transformed into a single store, taking residence in an old Art Deco retail space that has been a dozen or so businesses in its lifetime. We liked the idea of keeping themed booths that were rich in layers of history.

We spent a lot of time in antique malls researching, and had great fun bringing the quirkiness and charm we found in the real world into our store.
—DANIEL HOLLAND, ART DIRECTOR, SETS

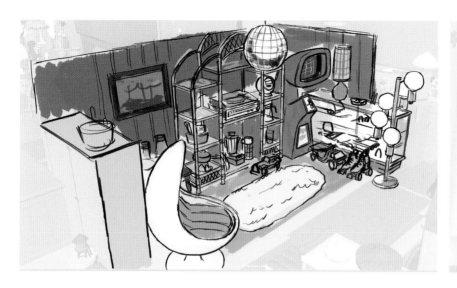
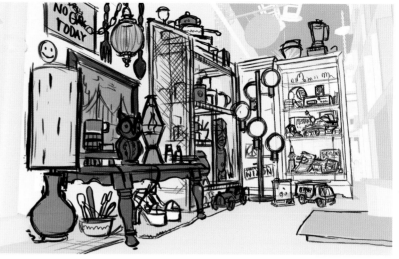

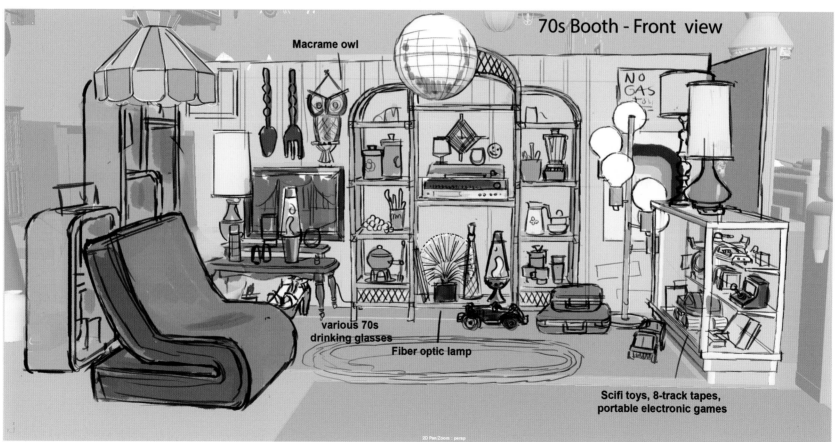

Macrame owl

70s Booth - Front view

various 70s
drinking glasses

Fiber optic lamp

Scifi toys, 8-track tapes,
portable electronic games

NO GAS TODAY

[this page] Nathaniel McLaughlin, DIGITAL

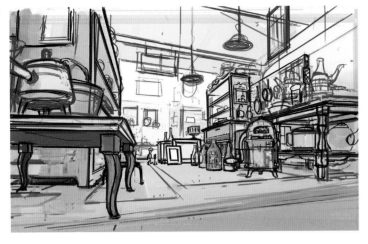

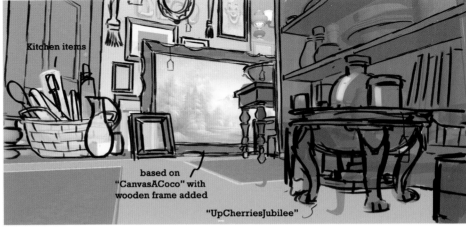

Kitchen items

based on
"CanvasACoco" with
wooden frame added

"UpCherriesJubilee"

Nelson Bohol, DIGITAL

Nathaniel McLaughlin, DIGITAL

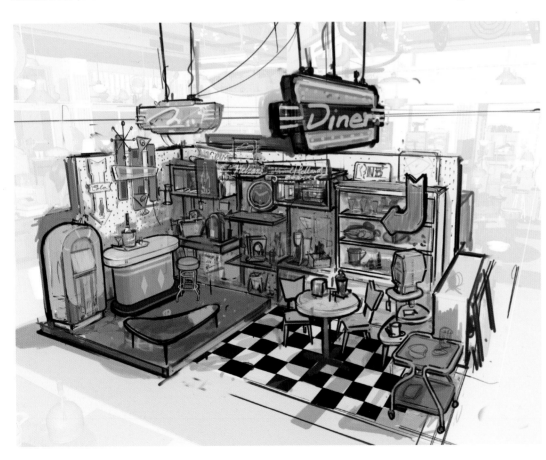

To search, start typing a word or phrase

Nelson Bohol, DIGITAL OVER PENCIL

Bob Pauley, DIGITAL

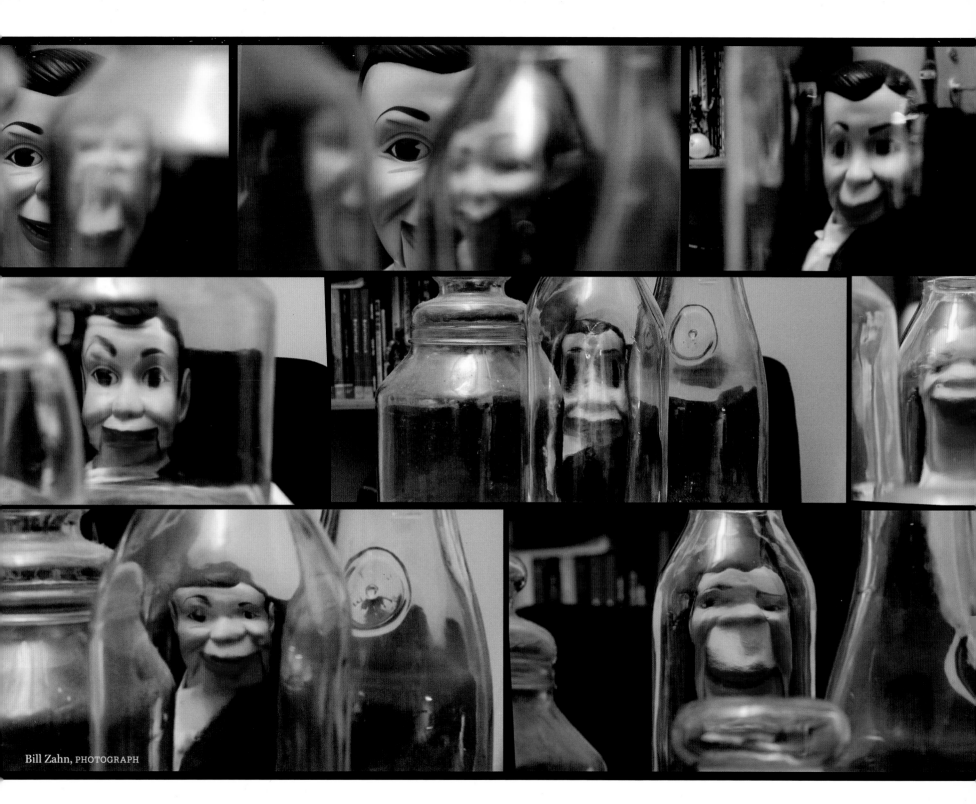

Bill Zahn, PHOTOGRAPH

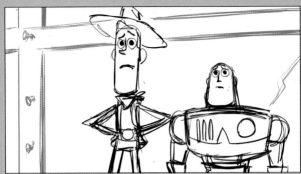
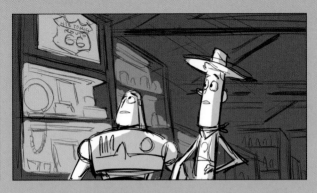
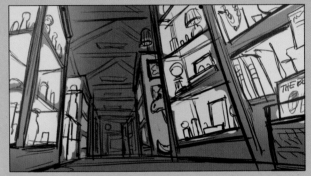
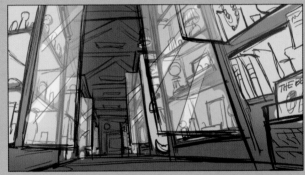
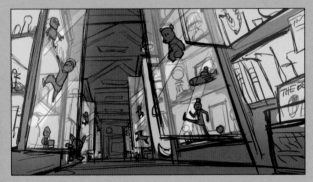

[this spread] Bobby Rubio and Valerie LaPointe, DIGITAL STORYBOARDS

In one version of the story, Buzz and Woody search the antique mall to find Bo Peep. We thought, *What if the store was a toy city that came alive at night?* We imagined a cutthroat economy where toys bartered and sold parts to repair themselves in order to have a second chance at finding a kid. It would have been an overwhelming new world for Buzz and Woody to walk into while interacting with all these new characters and places as they tried to track down Bo.
—VALERIE LAPOINTE, STORY SUPERVISOR

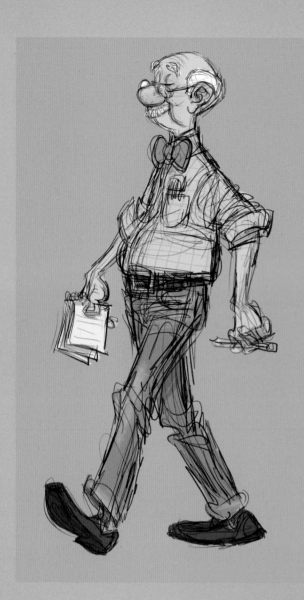

The antique store was originally owned by a couple: Margaret and her husband, Dan. Animation fans may recognize that these designs were based on one of Walt Disney's Nine Old Men, Ollie Johnston. The character of Dan eventually became unnecessary to the story and was cut from the movie. —JOSH COOLEY, DIRECTOR

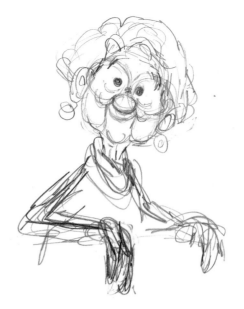

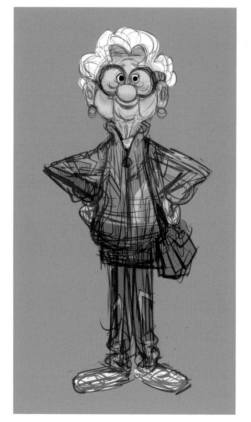

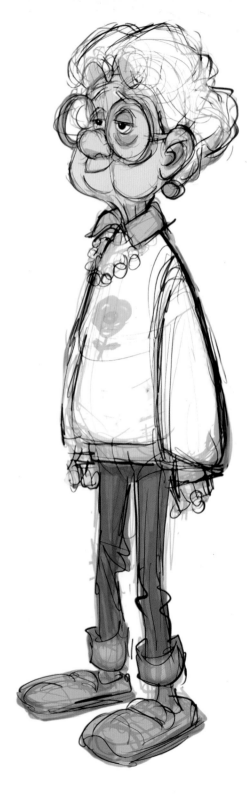

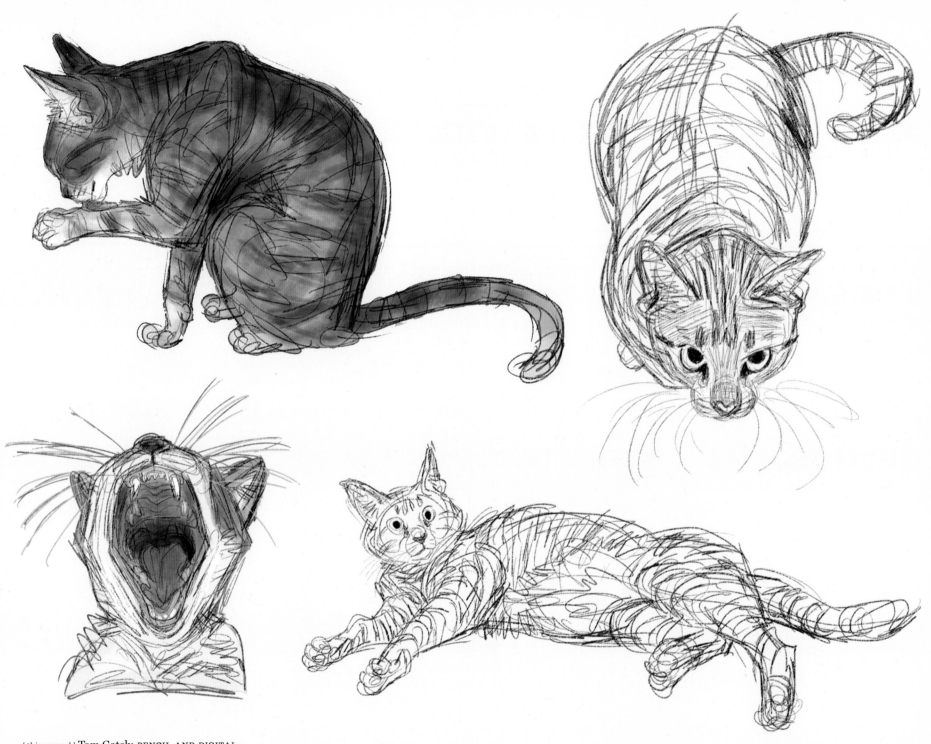

[this spread] Tom Gately, PENCIL AND DIGITAL

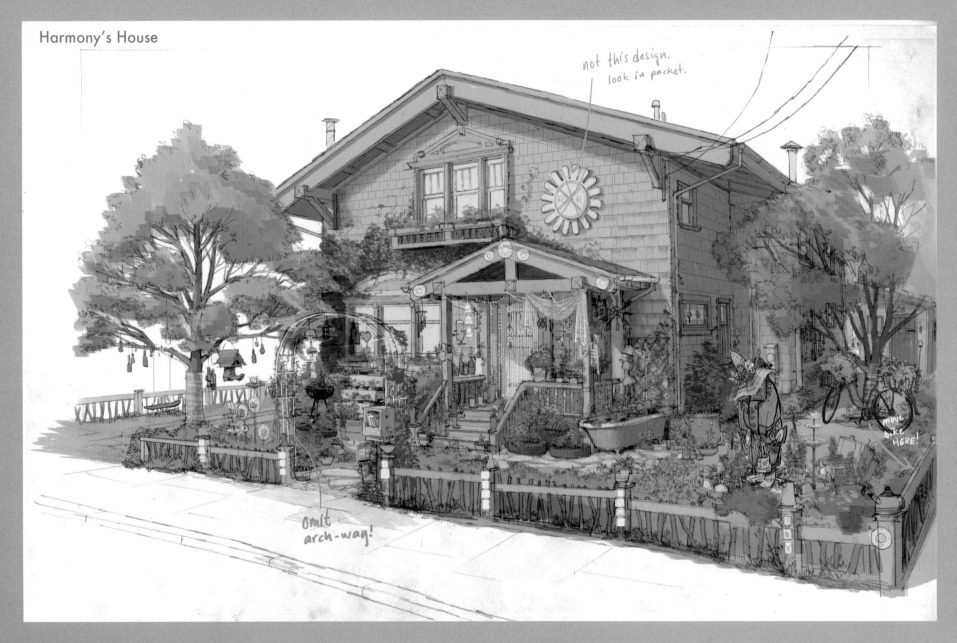

Kristian Norelius, DIGITAL OVER PENCIL

In an early version of the story, Woody and Buzz had stowed away in Bonnie's backpack for a playdate with Harmony. Harmony's Mother was a fan of "upcycling" and therefore had many unusual props in the house and yard, including a makeshift scarecrow. The duo concocted a plan to cross the busy street, hiding inside the boots of the scarecrow, and wheeled themselves across the street to the antique mall. They encountered many obstacles along the way and hilarity ensued! —BOB PAULEY, PRODUCTION DESIGNER

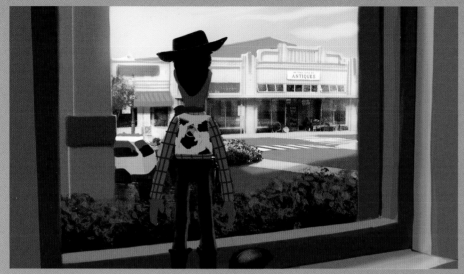

John Lee, DIGITAL PAINTING

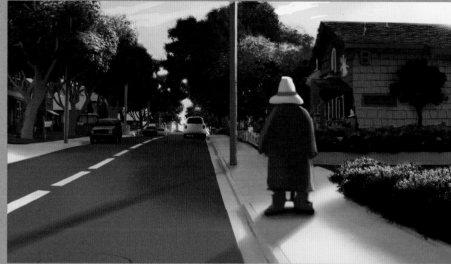

John Lee, DIGITAL PAINTING

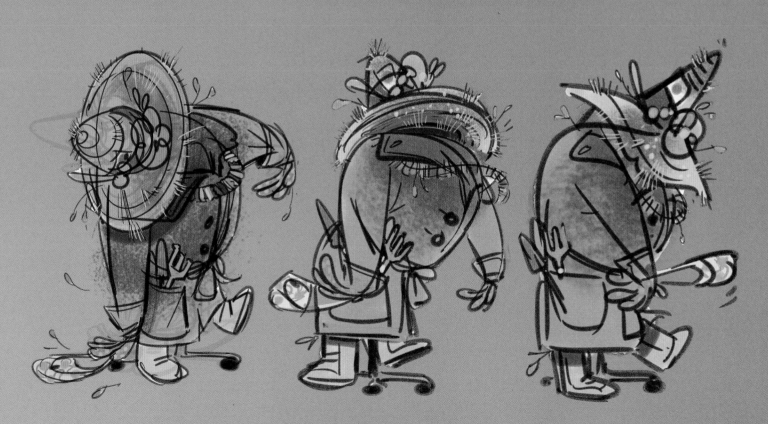

Deanna Marsigliese, DIGITAL

61

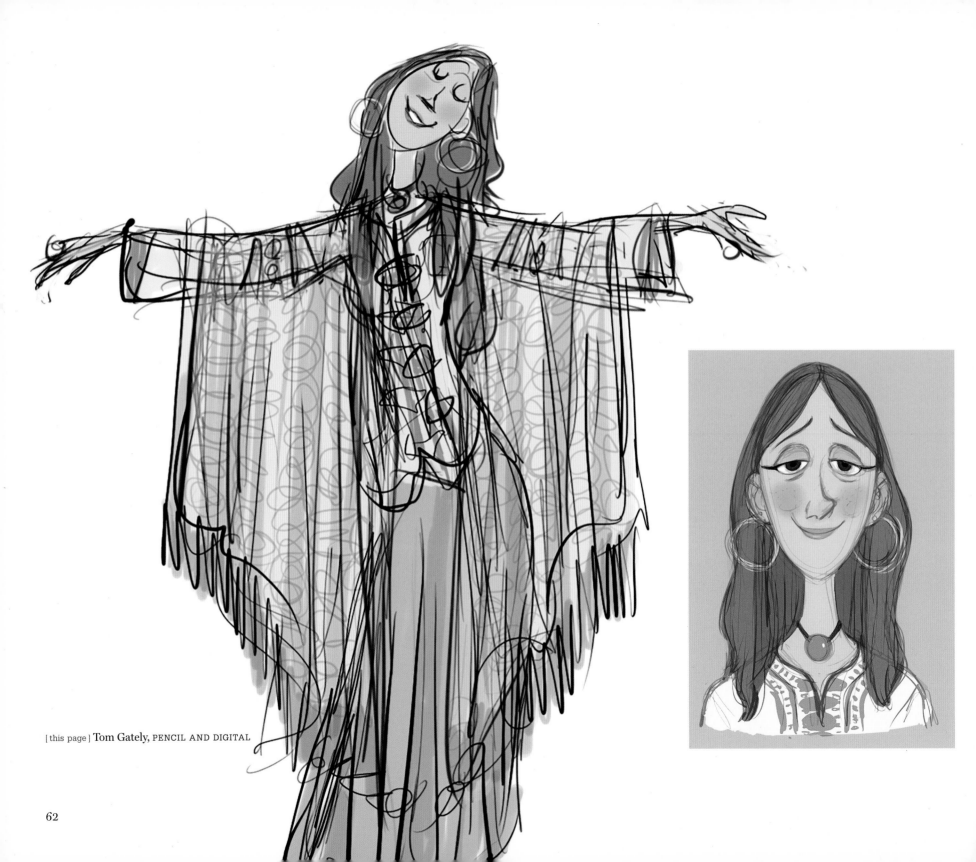

[this page] Tom Gately, PENCIL AND DIGITAL

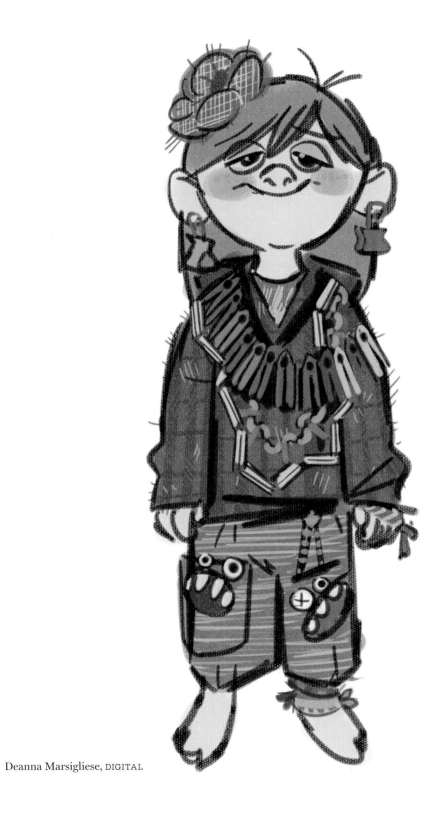

Deanna Marsigliese, DIGITAL

Tony Maki, DIGITAL STORYBOARD

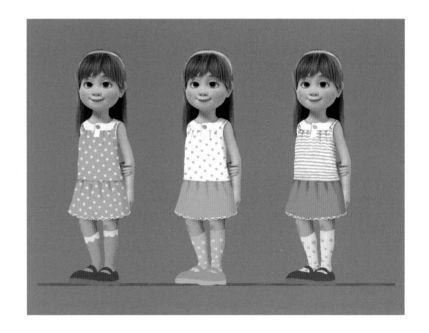

Jennifer Chang, DIGITAL PAINTING

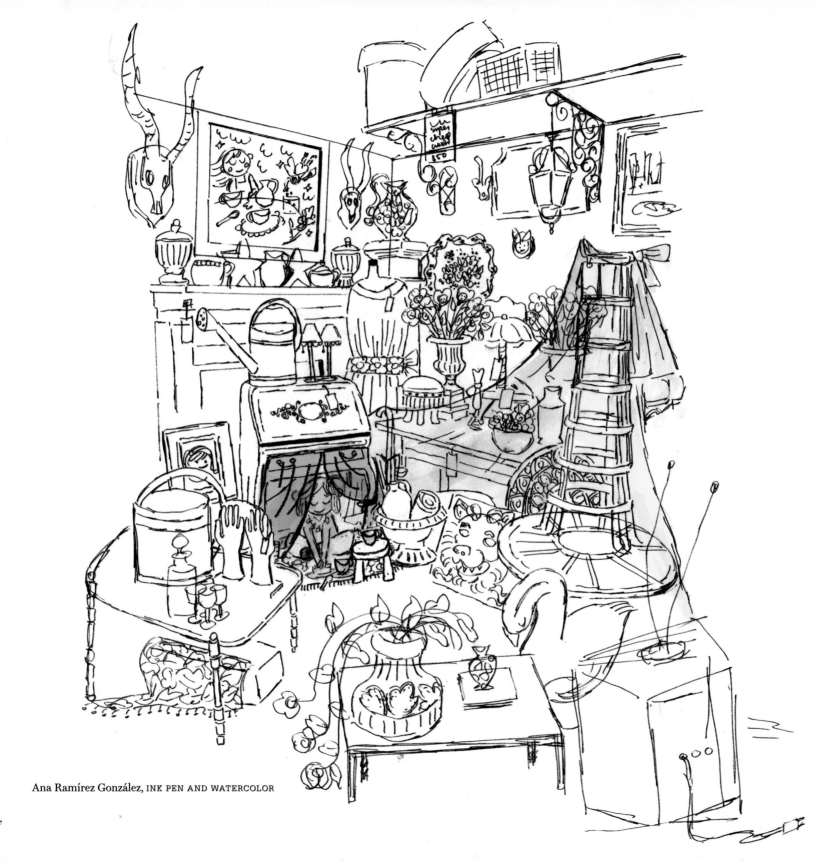

Ana Ramírez González, INK PEN AND WATERCOLOR

Ana Ramírez González, INK PEN AND WATERCOLOR

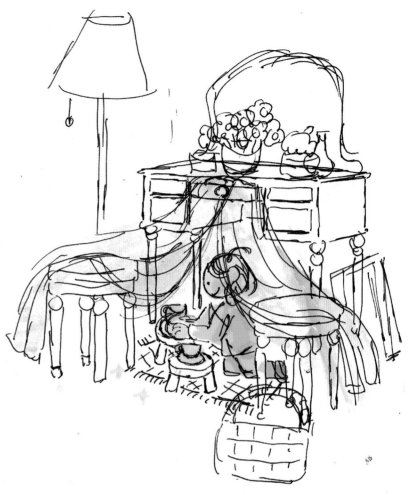

Ana Ramírez González,
INK PEN AND WATERCOLOR

Maria Lee, DIGITAL PAINTING

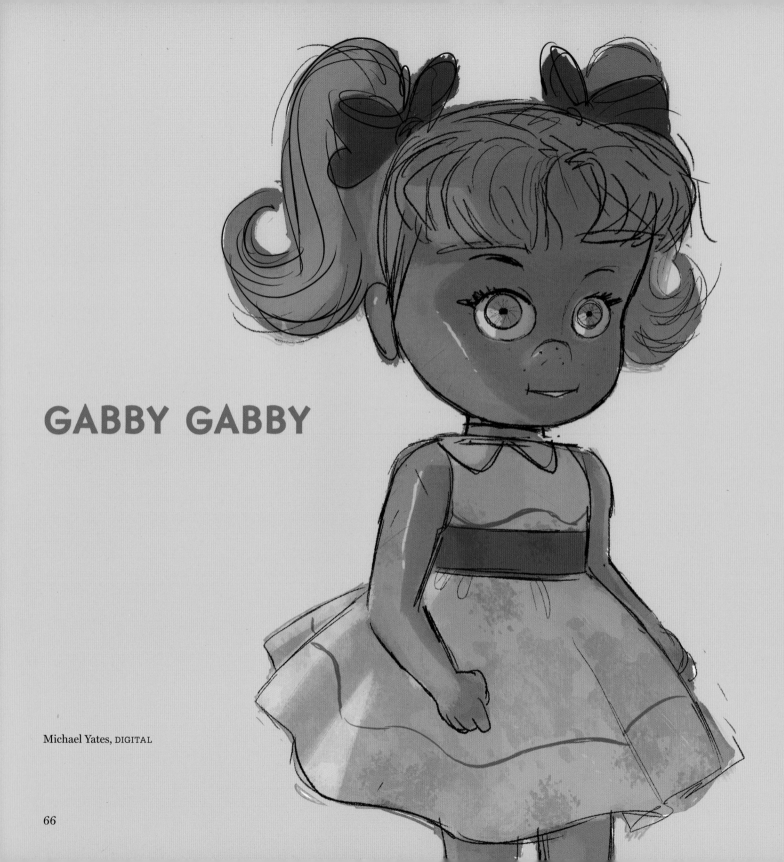

GABBY GABBY

Michael Yates, DIGITAL

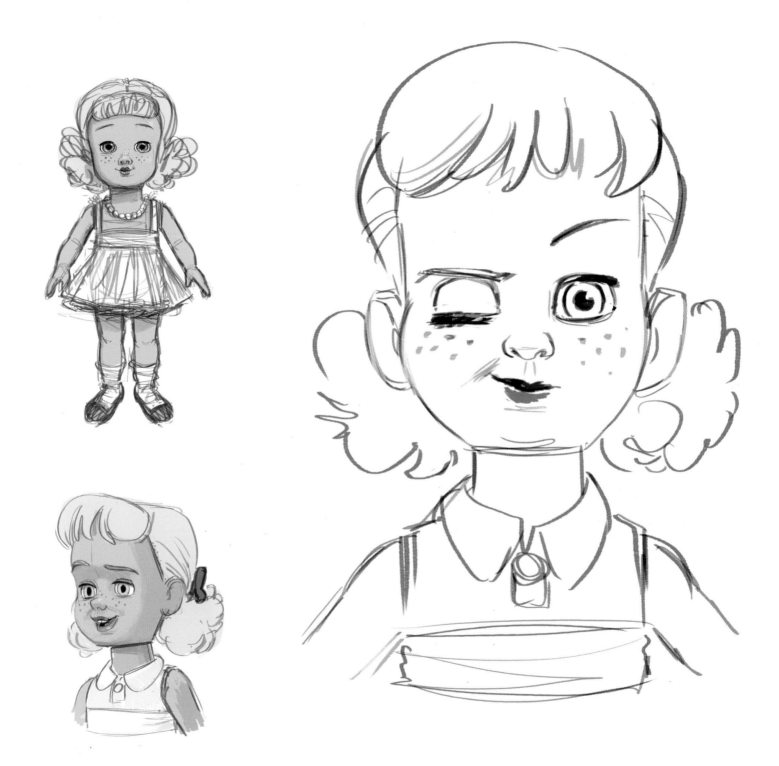

[this page]
Jason Deamer,
DIGITAL

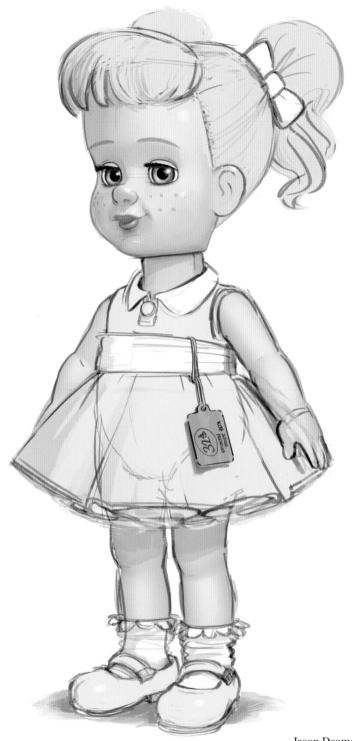

Jason Deamer, DIGITAL

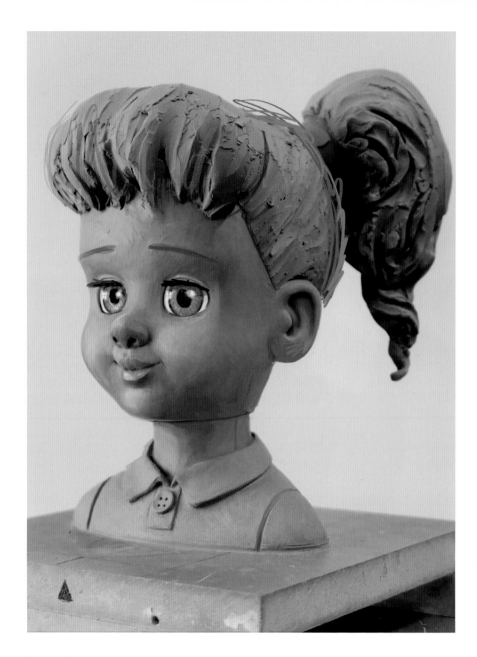

Jerome Ranft, CLAY

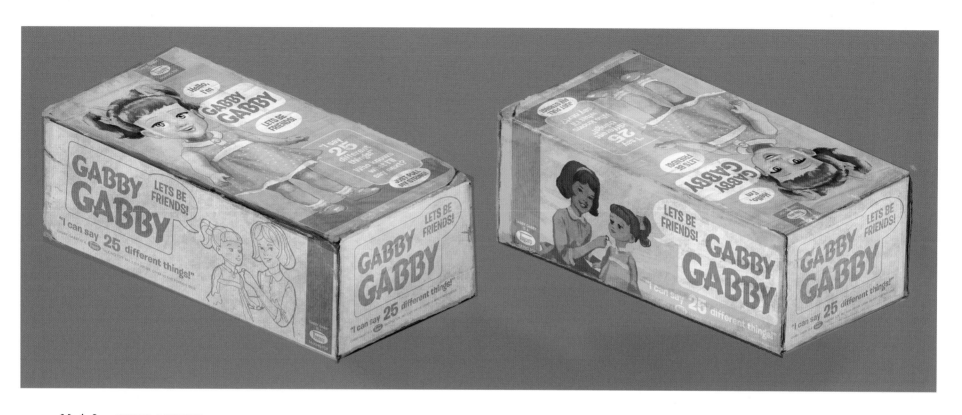

Maria Lee, DIGITAL PAINTING;
Graphics by Craig Foster, DIGITAL

Craig Foster, DIGITAL

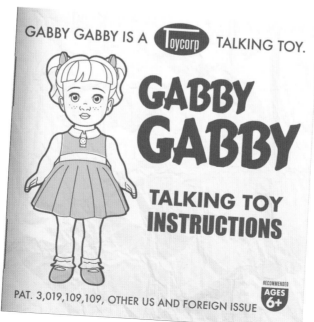

GABBY GABBY IS A **Toycorp** TALKING TOY.

GABBY GABBY

TALKING TOY INSTRUCTIONS

PAT. 3,019,109,109, OTHER US AND FOREIGN ISSUE

RECOMMENDED
AGES
6+

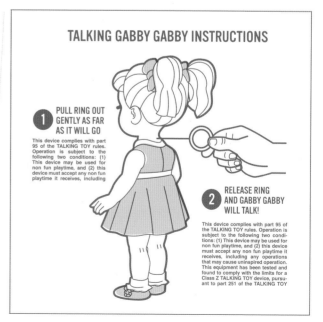

TALKING GABBY GABBY INSTRUCTIONS

1 PULL RING OUT GENTLY AS FAR AS IT WILL GO

This device complies with part 95 of the TALKING TOY rules. Operation is subject to the following two conditions: (1) This device may be used for non fun playtime, and (2) this device must accept any non fun playtime it receives, including

2 RELEASE RING AND GABBY GABBY WILL TALK!

This device complies with part 95 of the TALKING TOY rules. Operation is subject to the following two conditions: (1) This device may be used for non fun playtime, and (2) this device must accept any non fun playtime it receives, including any operations that may cause uninspired operation. This equipment has been tested and found to comply with the limits for a Class Z TALKING TOY device, pursuant to part 251 of the TALKING TOY

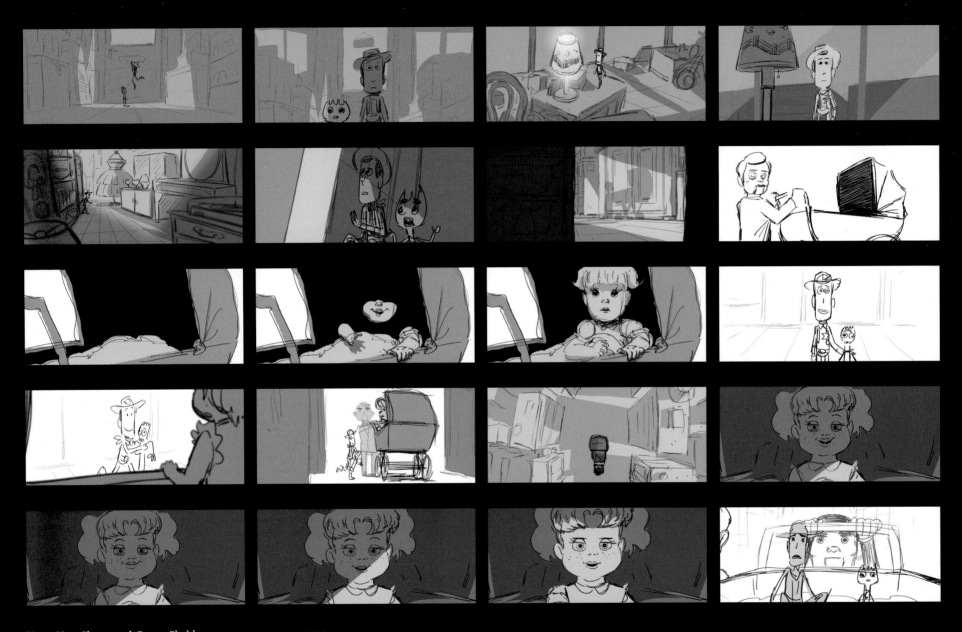

Yung-Han Chang and Garett Sheldrew, DIGITAL STORYBOARDS

Jason Deamer, DIGITAL

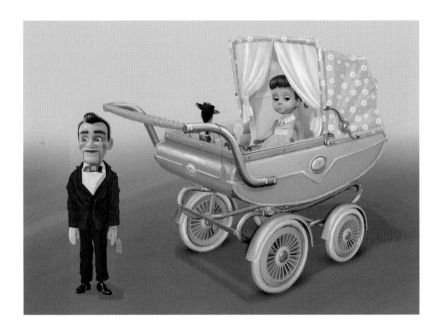

Maria Lee, DIGITAL PAINTING

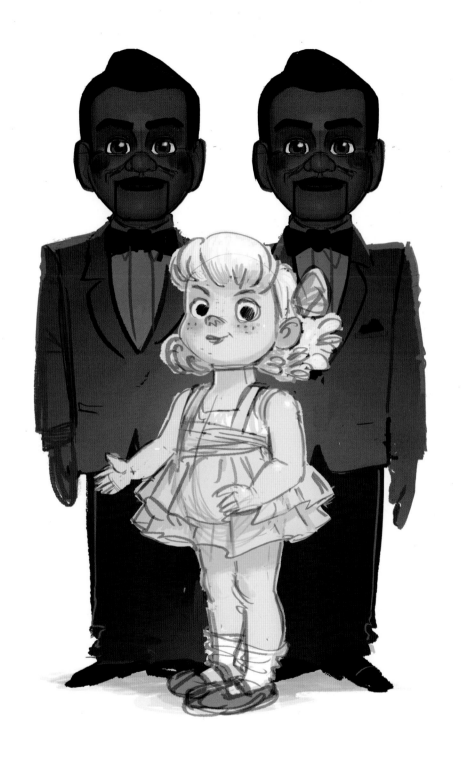

Jason Deamer, DIGITAL

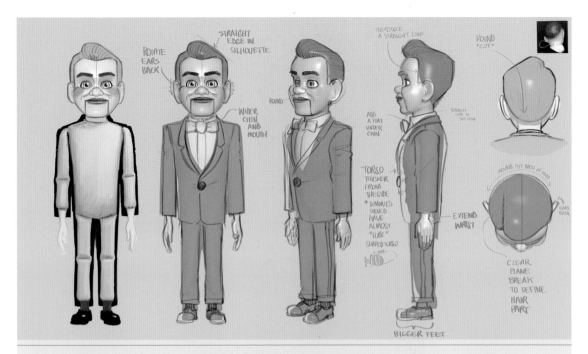

ROTATE EARS BACK

STRAIGHT EDGE IN SILHOUETTE

INTRODUCE A STRAIGHT LINE

ROUND "CUTE"

ROUND

WIDER CHIN AND MOUTH

AND A FLAT UNDER CHIN

TUCK LOW TO THE CHIN

TORSO THICKER FROM THE SIDE * DUMMIES SHOULD HAVE ALMOST "TUBE" SHAPED TORSO

EXTEND WRIST

ROUND OUT BACK UP HEAD

EARS BACK

CLEAR PLANE BREAK TO DEFINE HAIR PART

BIGGER FEET

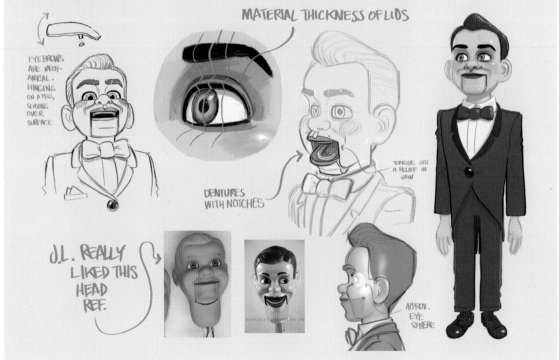

MATERIAL THICKNESS OF LIDS

EYEBROWS ARE MECHANICAL. HINGING ON A PEG, SLIDING OVER SURFACE

DENTURES WITH NOTCHES

TONGUE JUST A RELIEF IN JAW

J.L. REALLY LIKED THIS HEAD REF.

WWW.CLOWNANTIQUES.COM

APPROX. EYE SPHERE

Jason Deamer, DIGITAL

Bob Pauley, DIGITAL

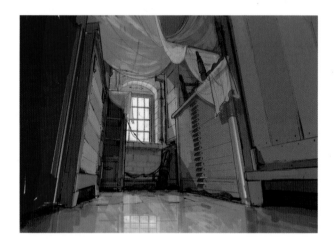

Kristian Norelius, DIGITAL OVER PENCIL

John Lee, DIGITAL PAINTING

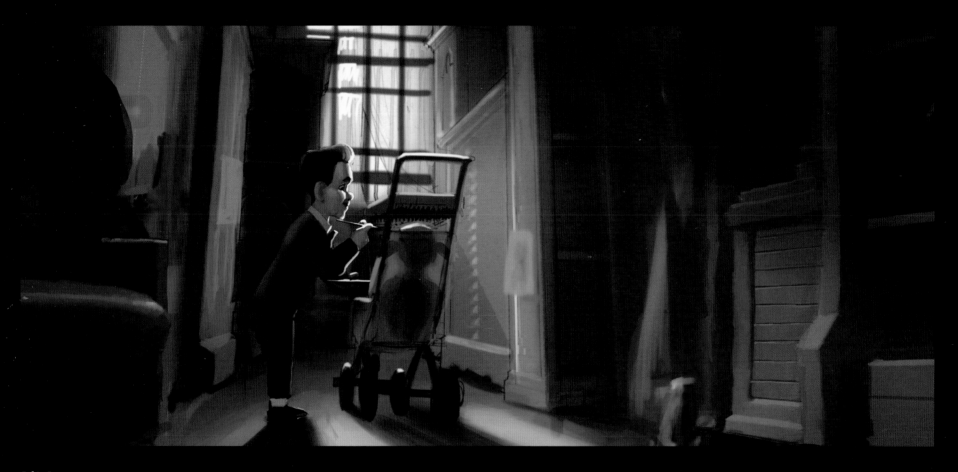

John Lee, DIGITAL PAINTING

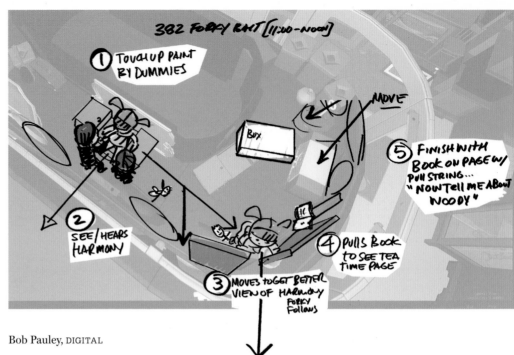

Bob Pauley, DIGITAL

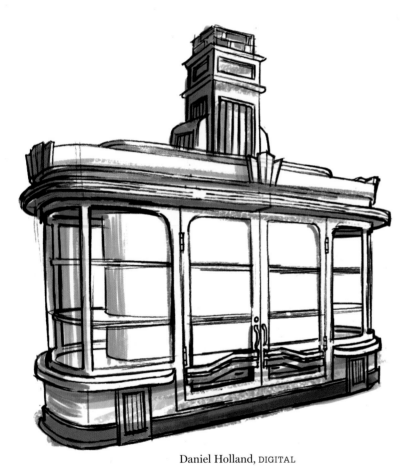

Daniel Holland, DIGITAL

Bob Pauley, DIGITAL

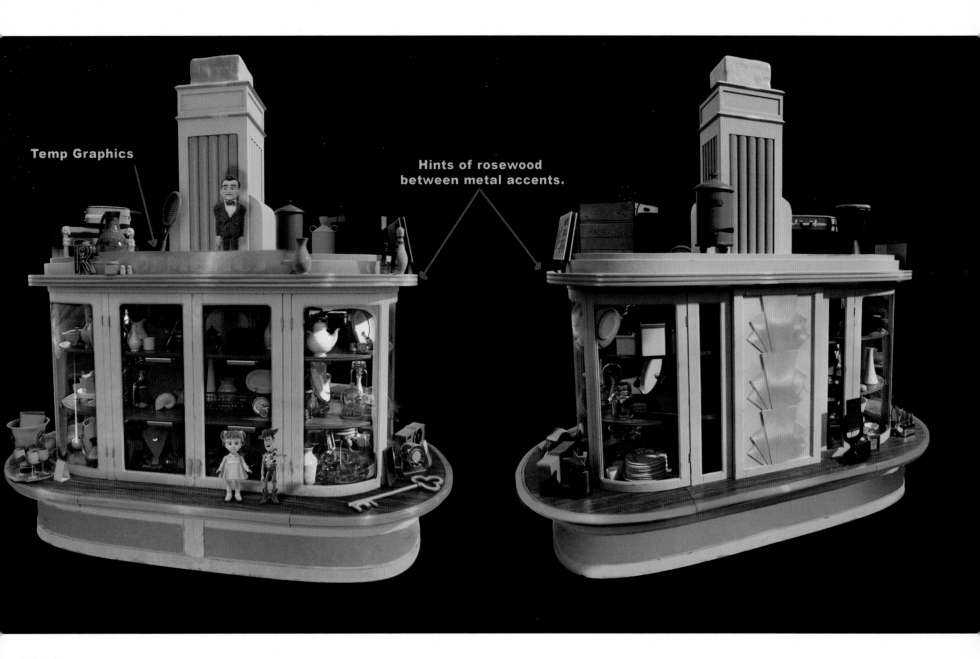

Temp Graphics

Hints of rosewood between metal accents.

Bill Zahn, DIGITAL PAINTING

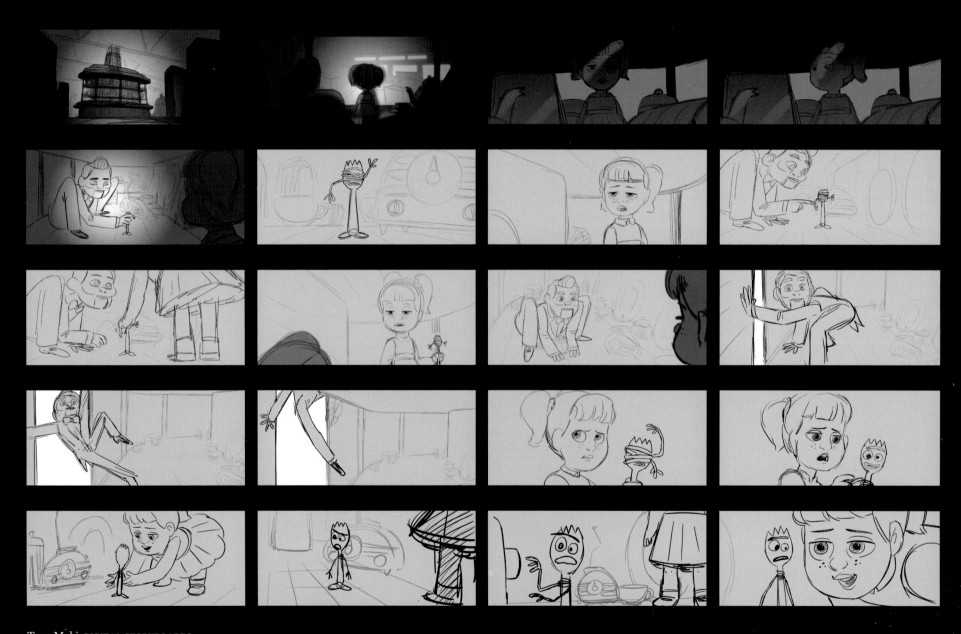

Tony Maki, DIGITAL STORYBOARDS

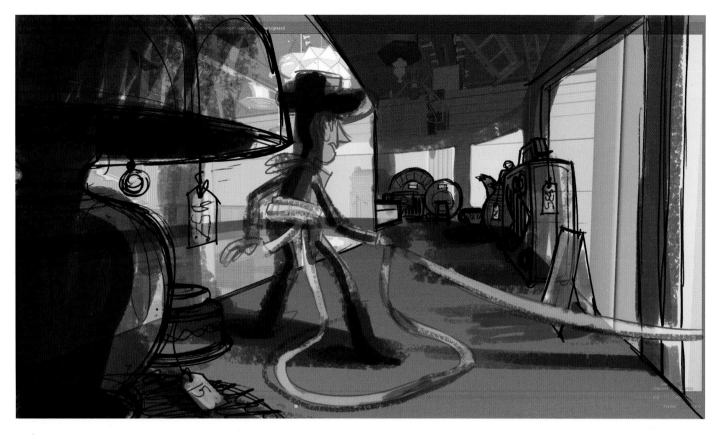

Daniel Holland, DIGITAL

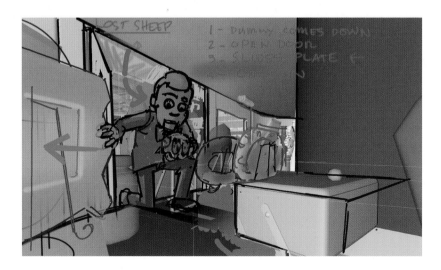

Nelson Bohol, DIGITAL

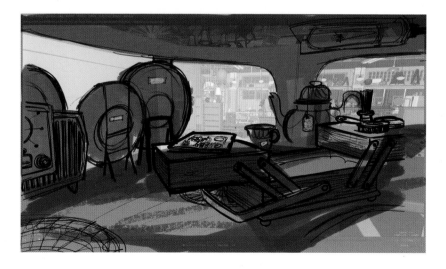

Daniel Holland, DIGITAL

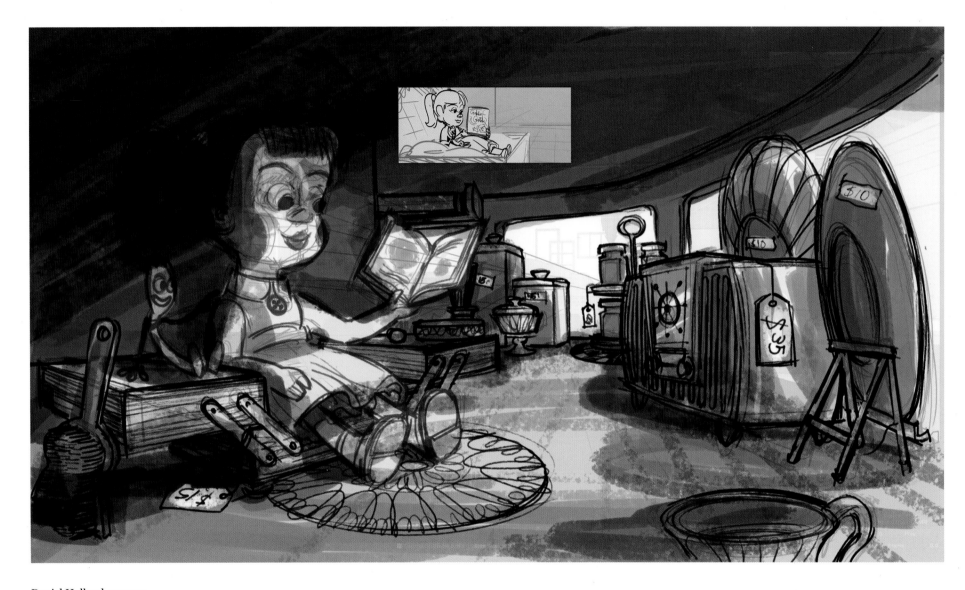

Daniel Holland, DIGITAL

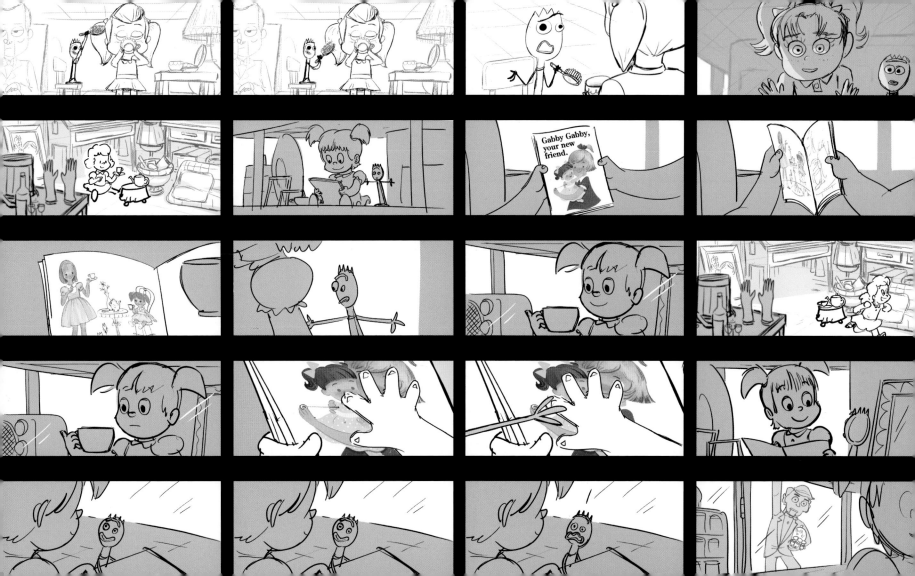

She plays with her;
Reads book to her;
Talks to her,
They are best friends…

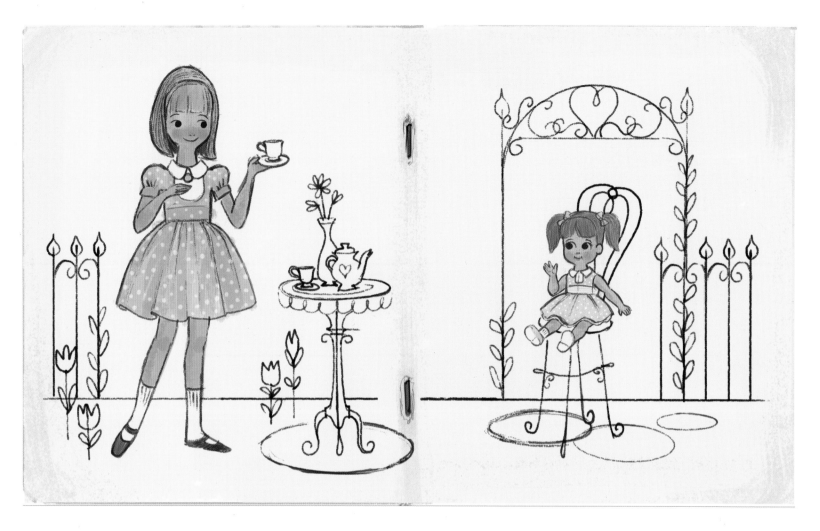

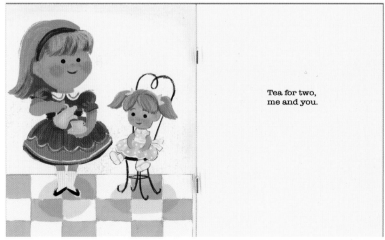

Tea for two,
me and you.

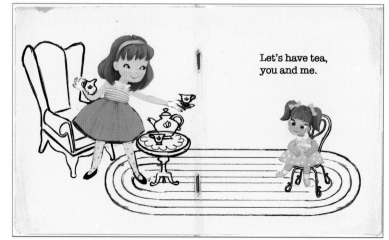

Let's have tea,
you and me.

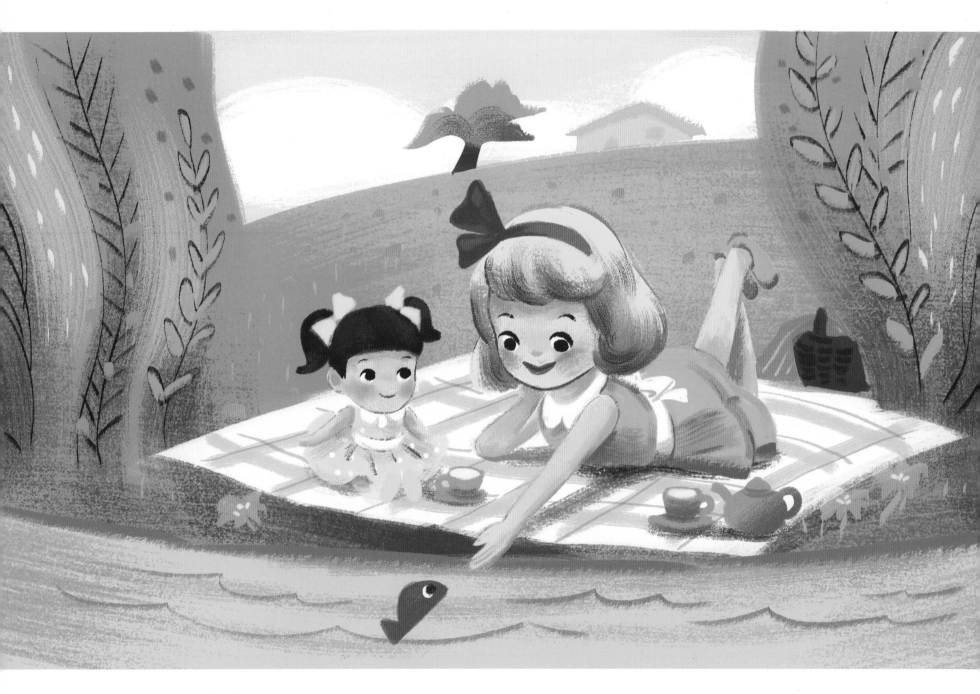

Celine You, DIGITAL

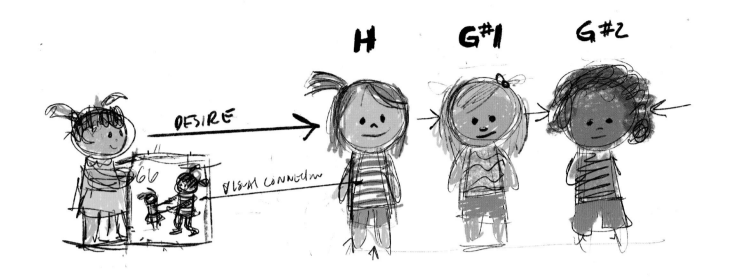

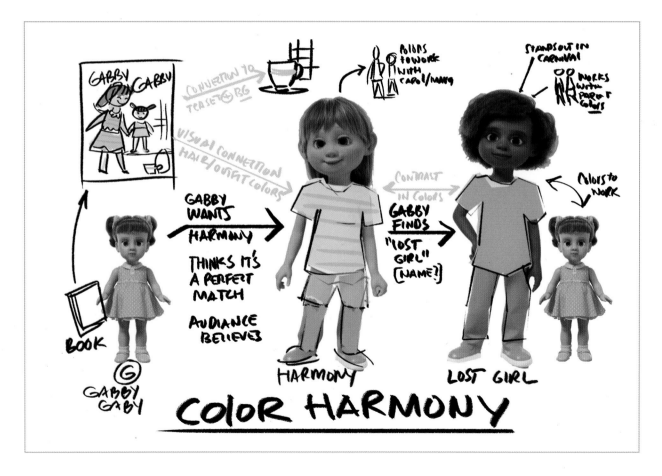

[this page] Bob Pauley, DIGITAL

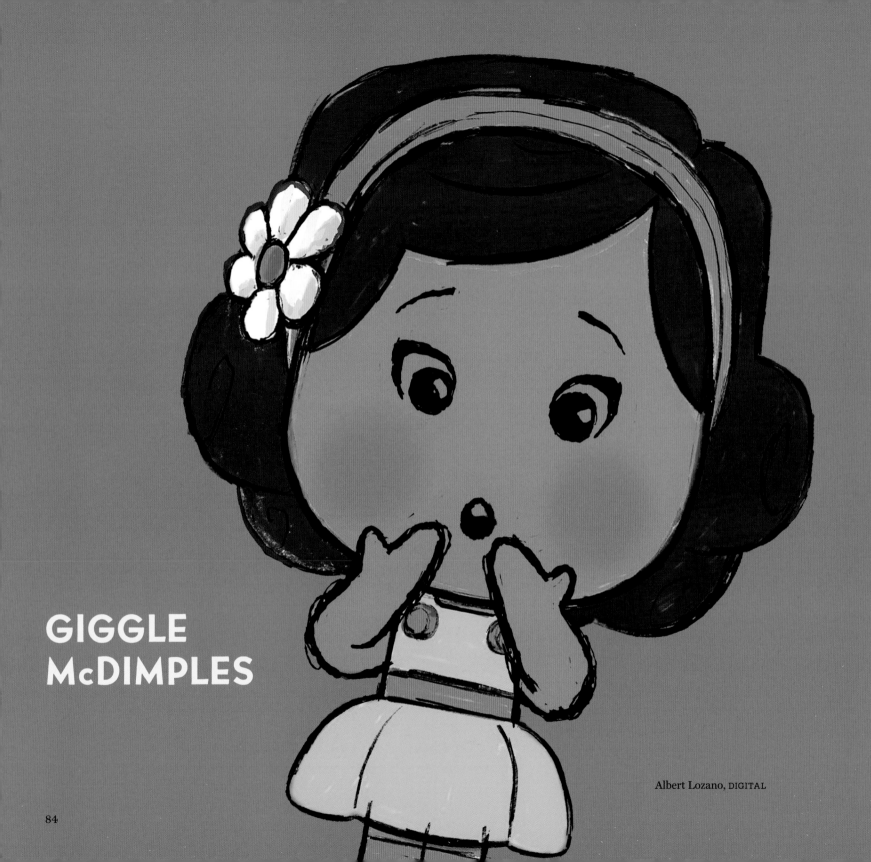

GIGGLE
McDIMPLES

Albert Lozano, DIGITAL

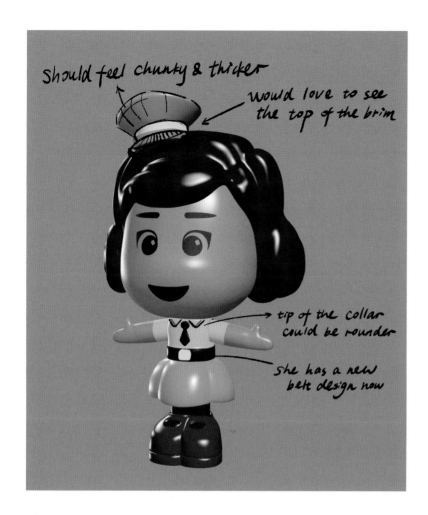

Albert Lozano and Celine You, DIGITAL

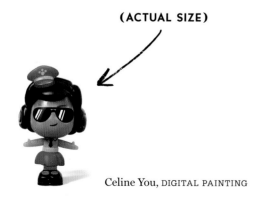

(ACTUAL SIZE)

Celine You, DIGITAL PAINTING

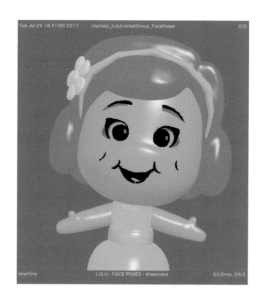

Albert Lozano and Celine You, DIGITAL

Celine You, DIGITAL PAINTING

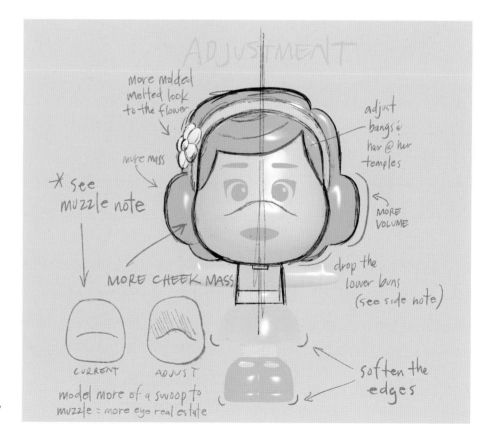

Albert Lozano
and Celine You,
DIGITAL

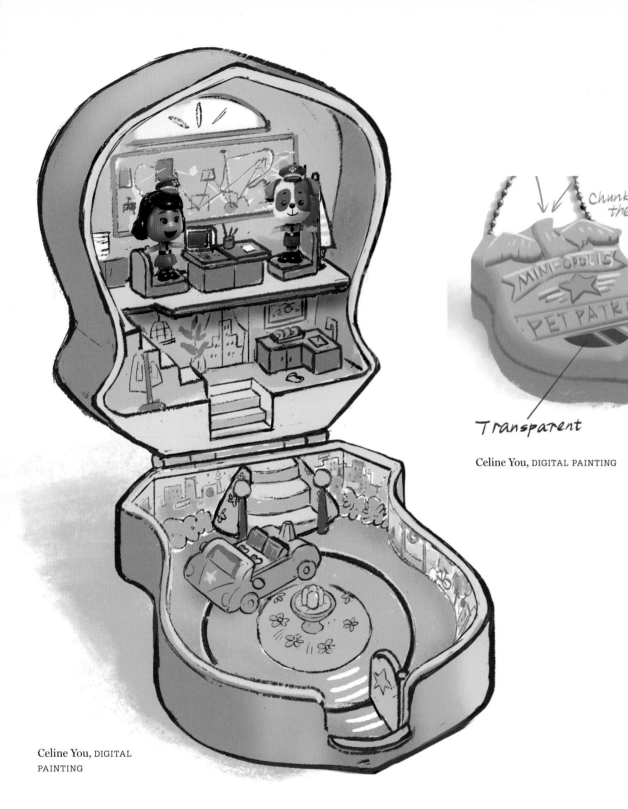

Celine You, DIGITAL
PAINTING

Catherine Kelly, DIGITAL

Celine You, DIGITAL PAINTING

Celine You, DIGITAL PAINTING

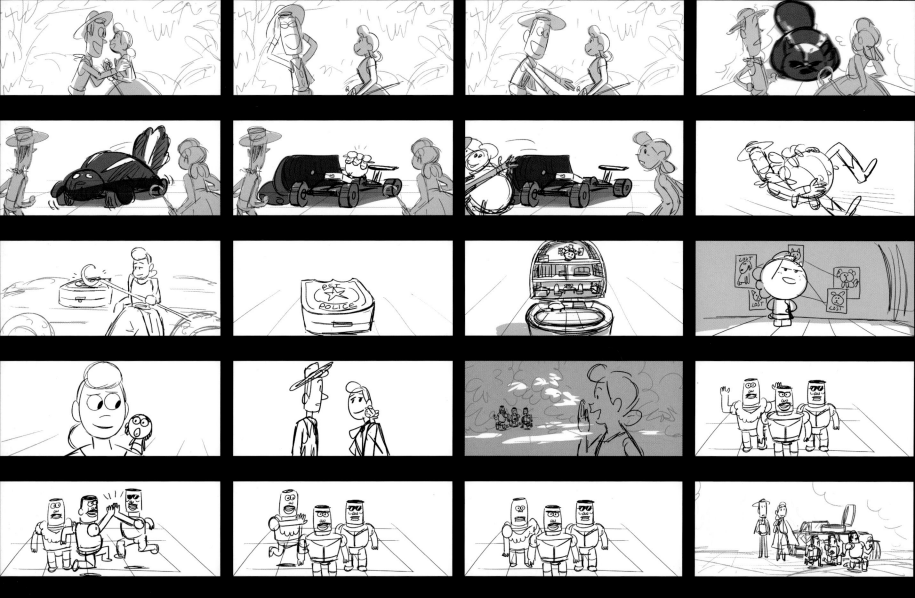

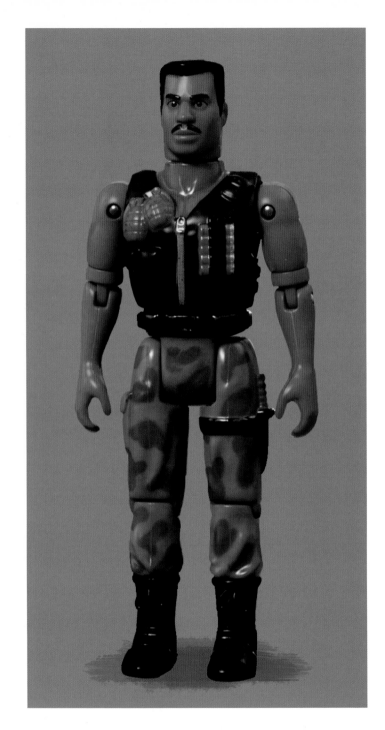

[this page] Albert Lozano, DIGITAL

88

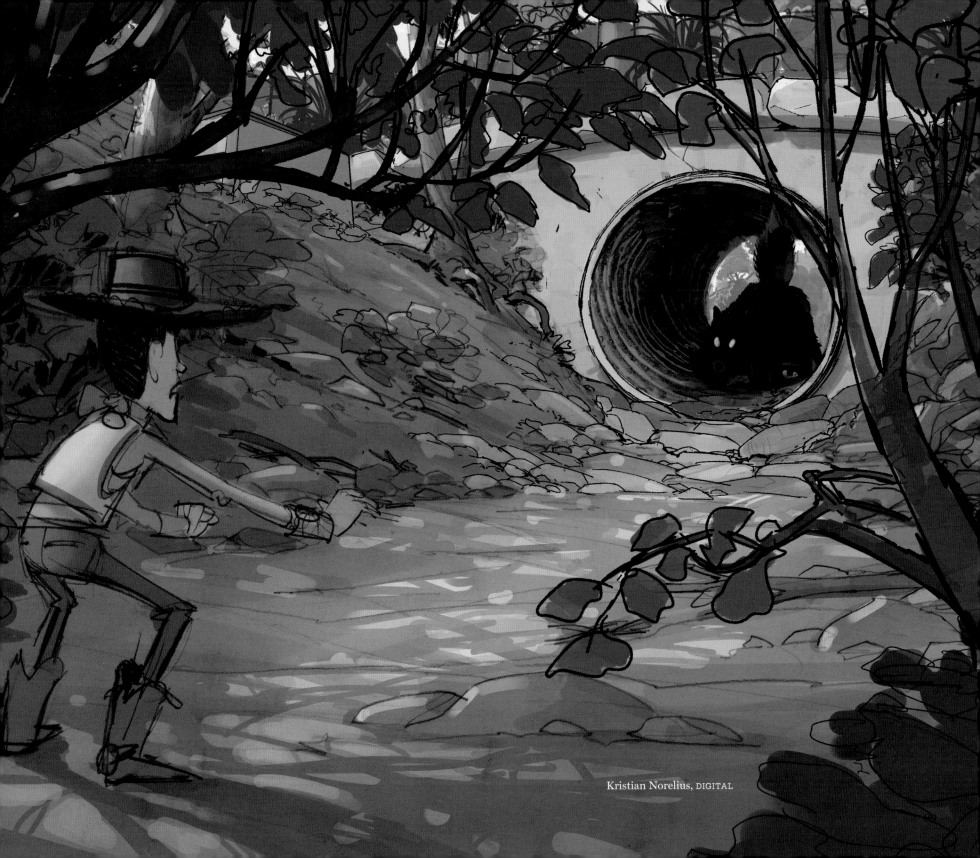

Kristian Norelius, DIGITAL

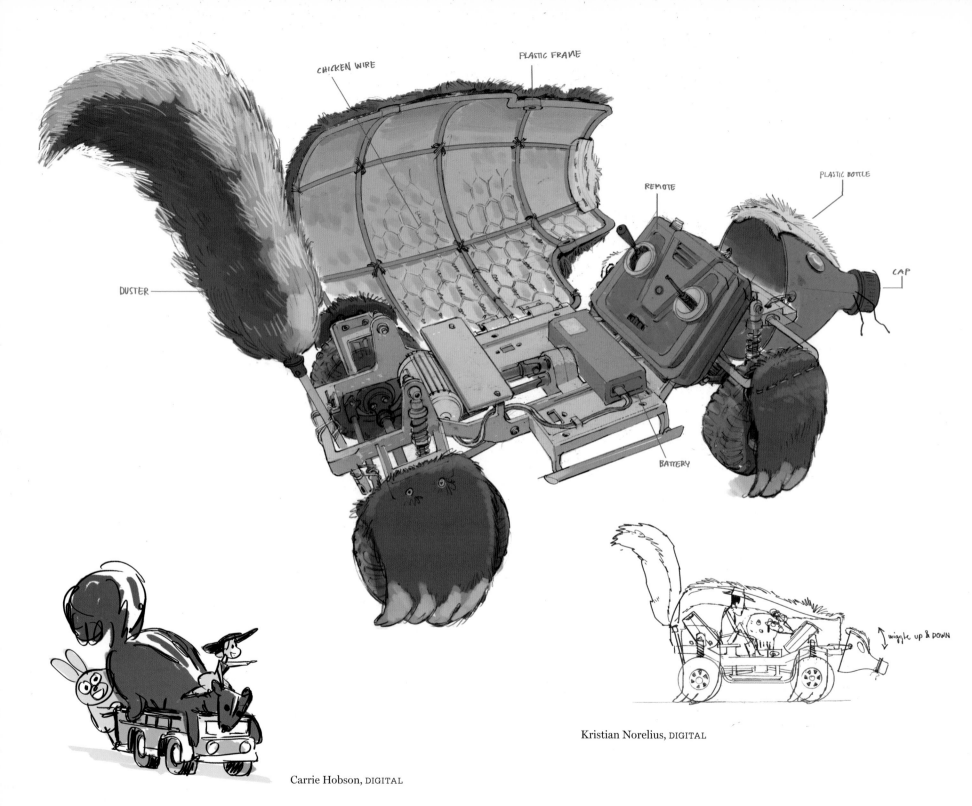

DUSTER

CHICKEN WIRE

PLASTIC FRAME

REMOTE

PLASTIC BOTTLE

CAP

BATTERY

wiggle up & DOWN

Carrie Hobson, DIGITAL

Kristian Norelius, DIGITAL

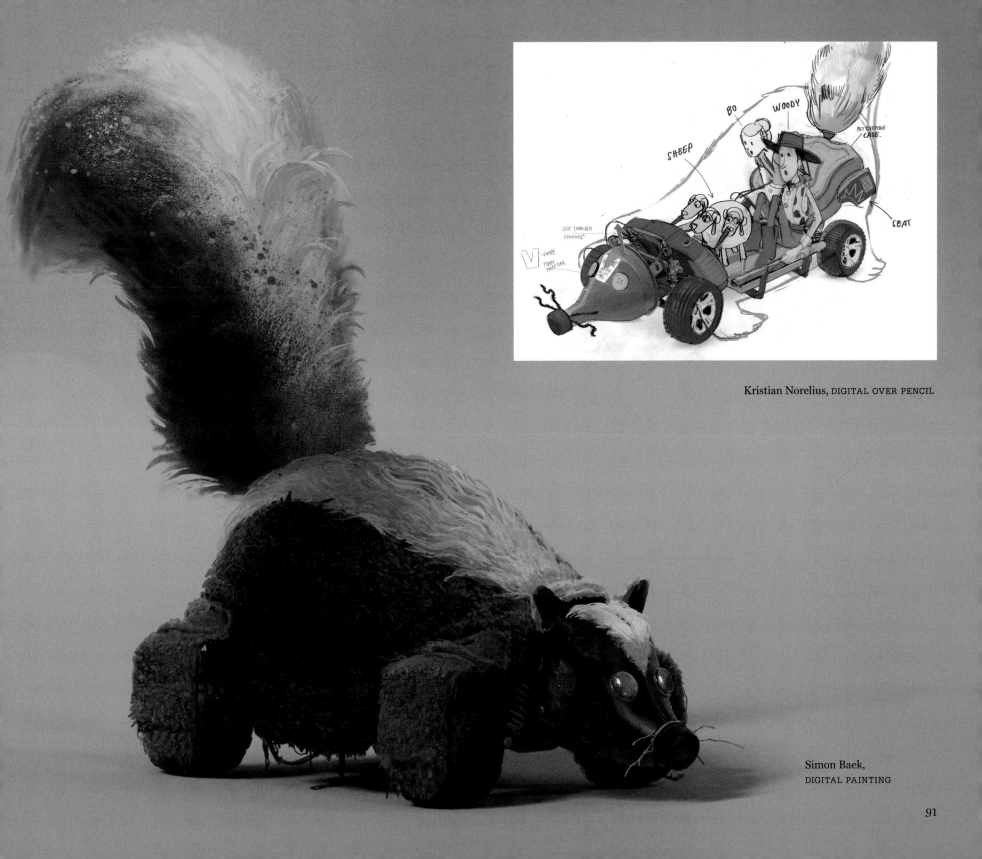

Kristian Norelius, DIGITAL OVER PENCIL

Simon Baek,
DIGITAL PAINTING

91

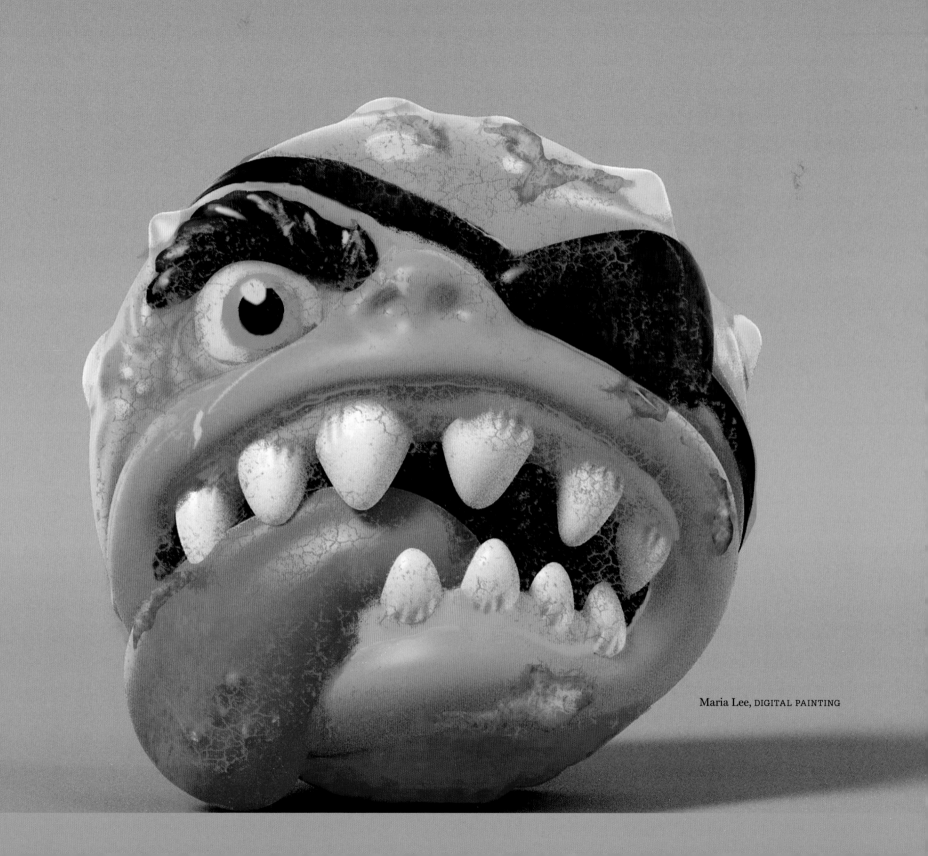

Maria Lee, DIGITAL PAINTING

Mesh

A.

B.

[this page] Celine You, DIGITAL

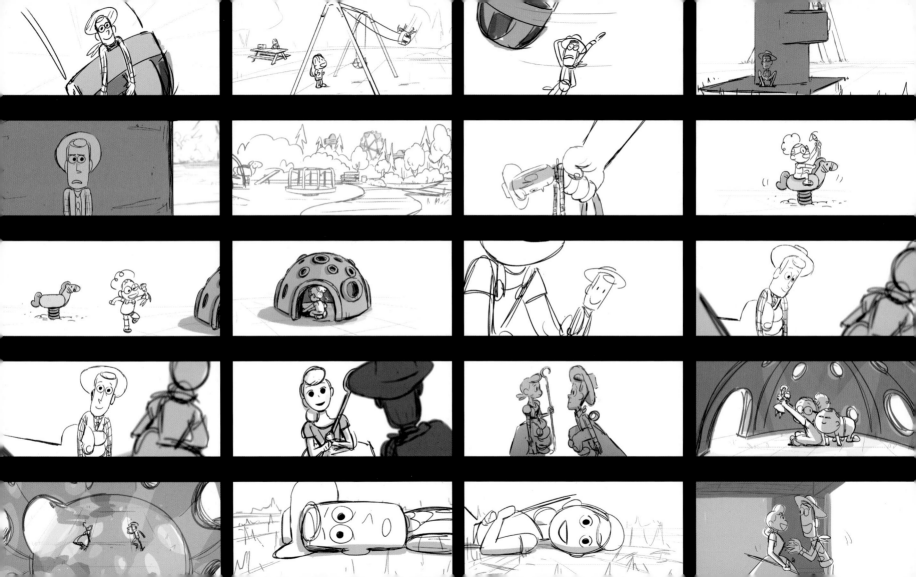

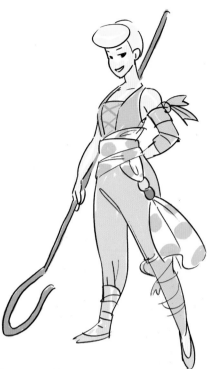

Mara MacMahon, DIGITAL

Bo Peep was a secondary character in the previous *Toy Story* films. We refined her design with greater detail in her face and body for her expanded role, using current tech to fulfill the original goal, some twenty-plus years ago, of a beautiful porcelain doll. Re-envisioning Bo's outfit to support her character was a challenge and a journey, made possible by "Team Bo." "Team Bo," which spanned several years of effort, was a collaborative group of artists from art, story, character, and animation departments, including Daniela Strijleva, Tanja Krampfert, Mara MacMahon, Carrie Hobson, Radford Hurn, Laura Phillips, Albert Lozano, Mariana Galindo, Celine You, Ana Ramírez González, Becki Tower, Patty Kihm, George Nguyen, and me.

In *Toy Story 4*, Bo is empowered and independent, she has moved beyond her traditional hoop skirt and has left her lamp behind. Her clothing reflects her evolution, part remnants from her original costume plus some found elements and tape repairs reflecting her breaks along the way. Her dress can double as a cloak to give her maximum freedom of movement. No lost toy, Bo is in charge of her future. She has grown to adapt to her changing situation, taking care of herself all along while looking out for her sheep. —BOB PAULEY, PRODUCTION DESIGNER

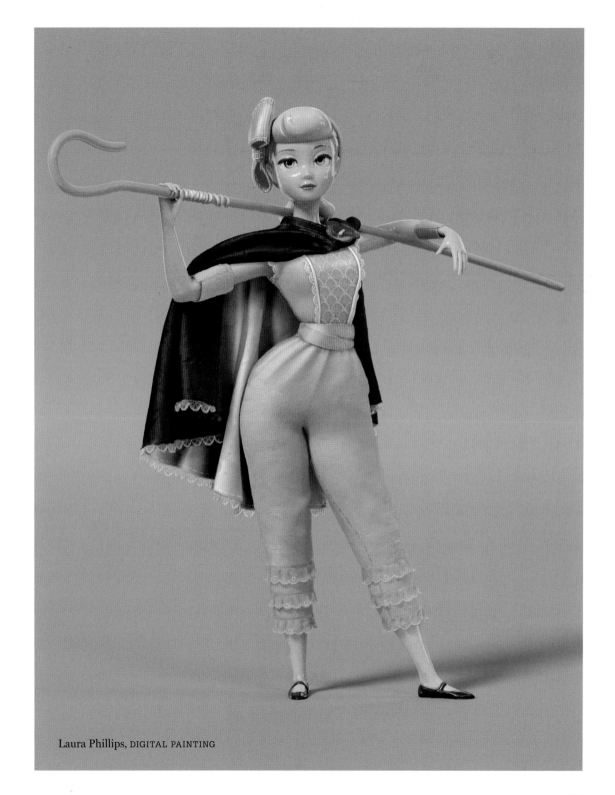

Laura Phillips, DIGITAL PAINTING

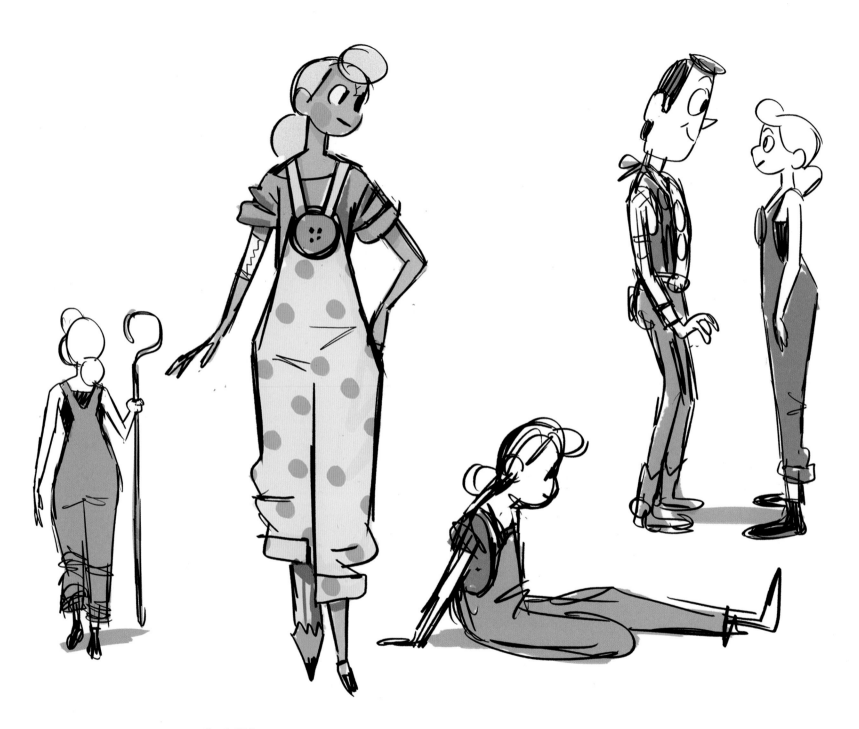

[this page] Carrie Hobson, DIGITAL

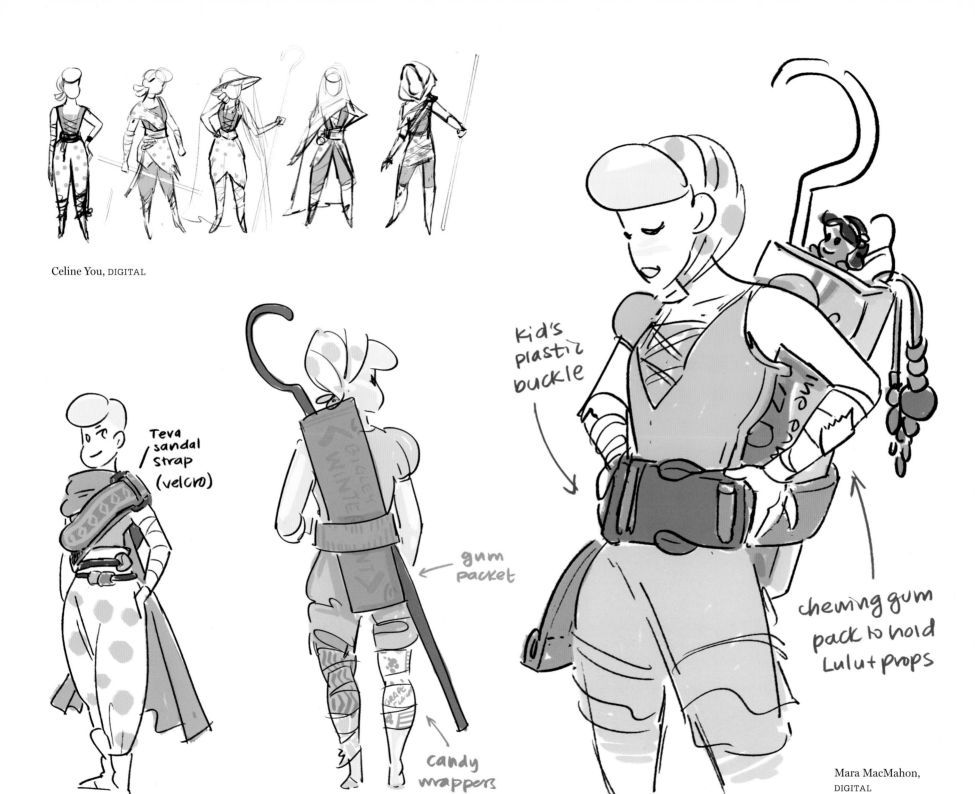

Celine You, DIGITAL

Teva
sandal
strap
(velcro)

gum
packet

candy
wrappers

kid's
plastic
buckle

chewing gum
pack to hold
Lulu+props

Mara MacMahon,
DIGITAL

97

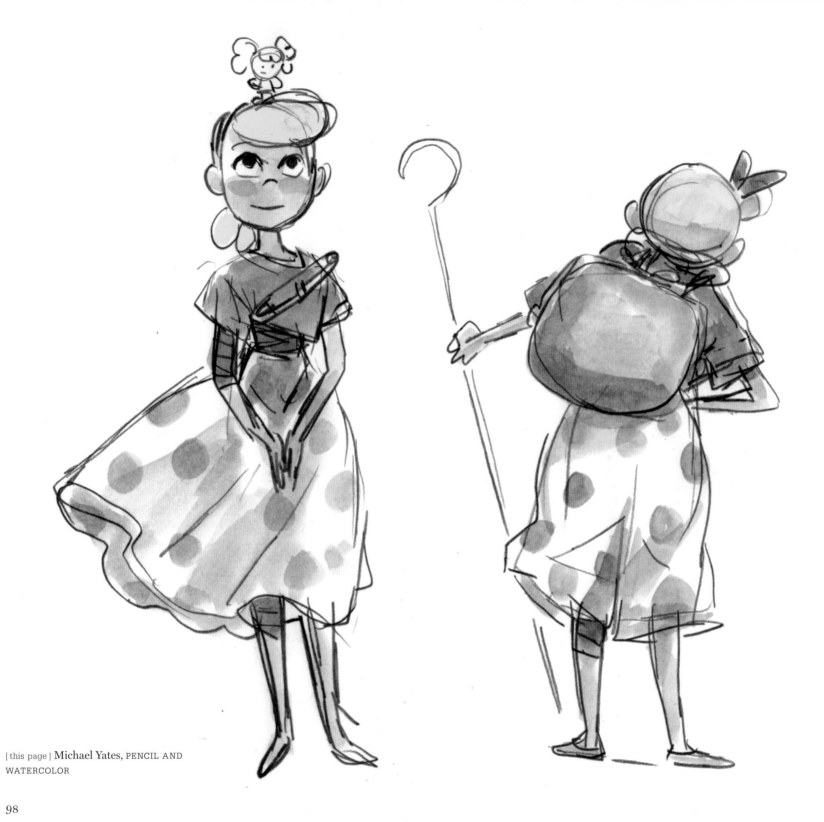

[this page] Michael Yates, PENCIL AND
WATERCOLOR

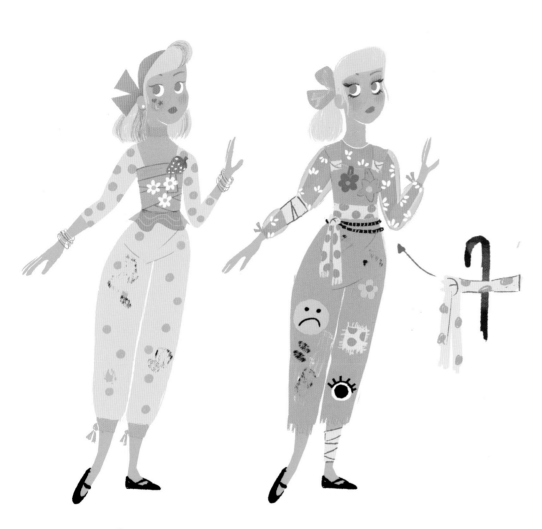

Ana Ramírez González, DIGITAL

Mara MacMahon, DIGITAL

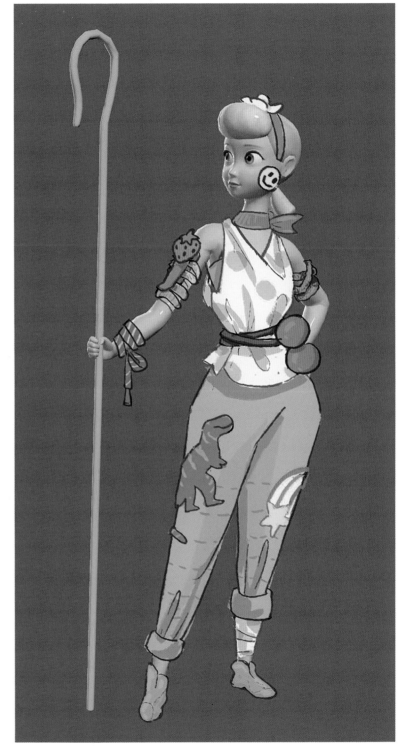

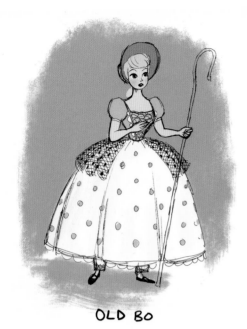

OLD BO

[above] Daniel Strijleva, INK PEN AND DIGITAL COLOR

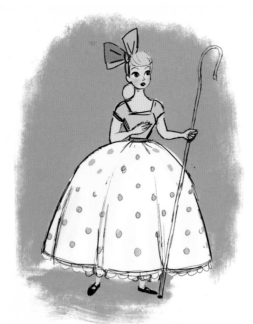

FIRST MEET
(SCAMMING PLAYTIME)

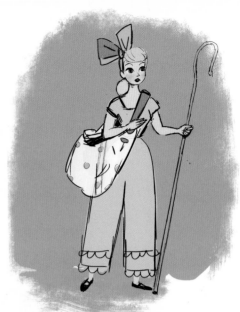

TRAVEL
BO

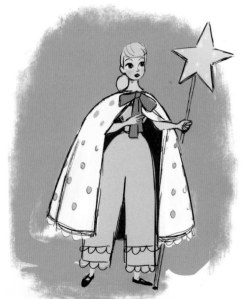

PLAY MODE
SUPERHERO/WIZARD/ROYAL

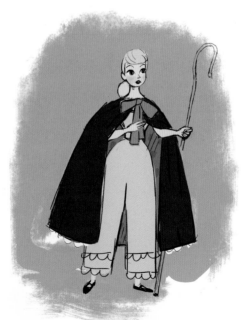

STEALTH

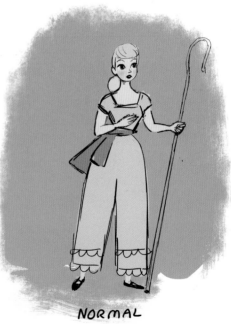

NORMAL
BO

[this page] Carrie Hobson, DIGITAL DRAWOVER

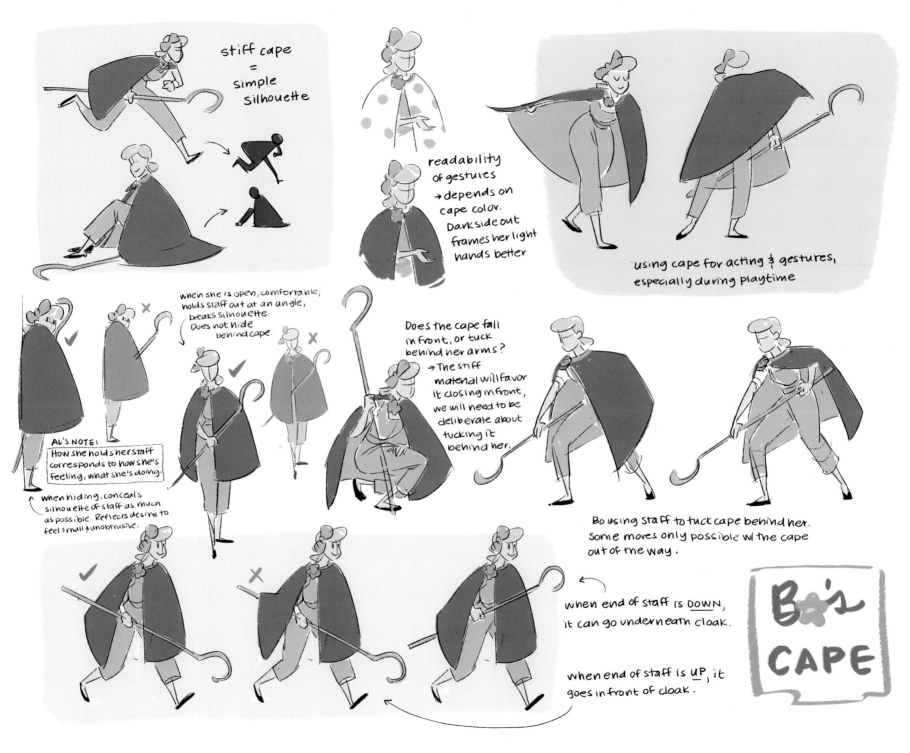

stiff cape = simple silhouette

readability of gestures → depends on cape color. Dark side out frames her light hands better

using cape for acting & gestures, especially during playtime

When she is open, comfortable, holds staff out at an angle, breaks silhouette. Does not hide behind cape.

AL'S NOTE: How she holds her staff corresponds to how she's feeling, what she's doing.

When hiding, conceals silhouette of staff as much as possible. Reflects desire to feel small & unobtrusive.

Does the cape fall in front, or tuck behind her arms? → The stiff material will favor it closing in front, we will need to be deliberate about tucking it behind her.

Bo using staff to tuck cape behind her. Some moves only possible w/ the cape out of the way.

when end of staff is DOWN, it can go underneath cloak.

when end of staff is UP, it goes in front of cloak.

Bo's CAPE

[this page] Mara MacMahon, DIGITAL

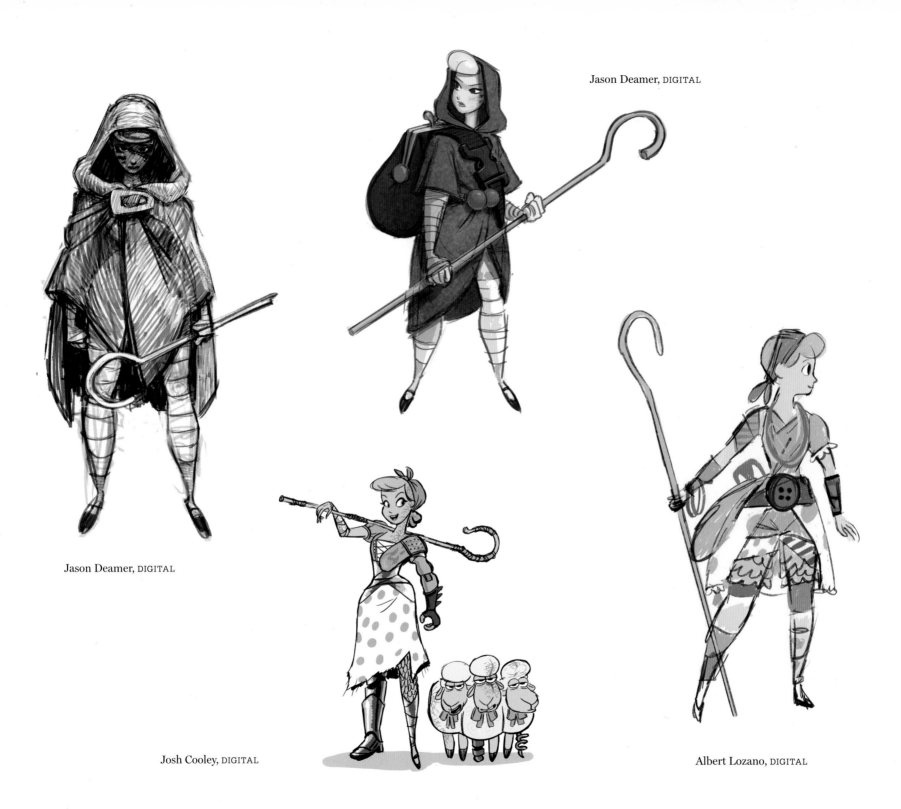

Jason Deamer, DIGITAL

Jason Deamer, DIGITAL

Josh Cooley, DIGITAL

Albert Lozano, DIGITAL

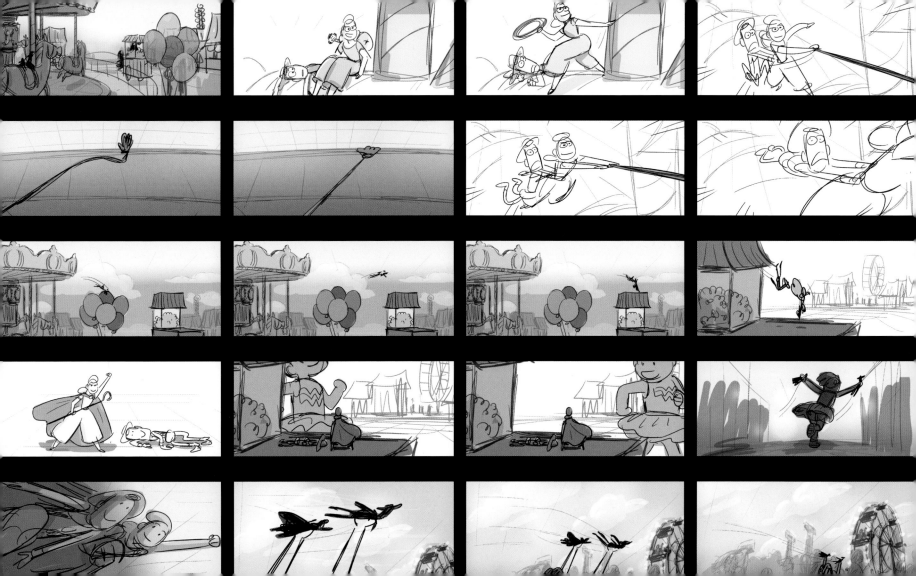

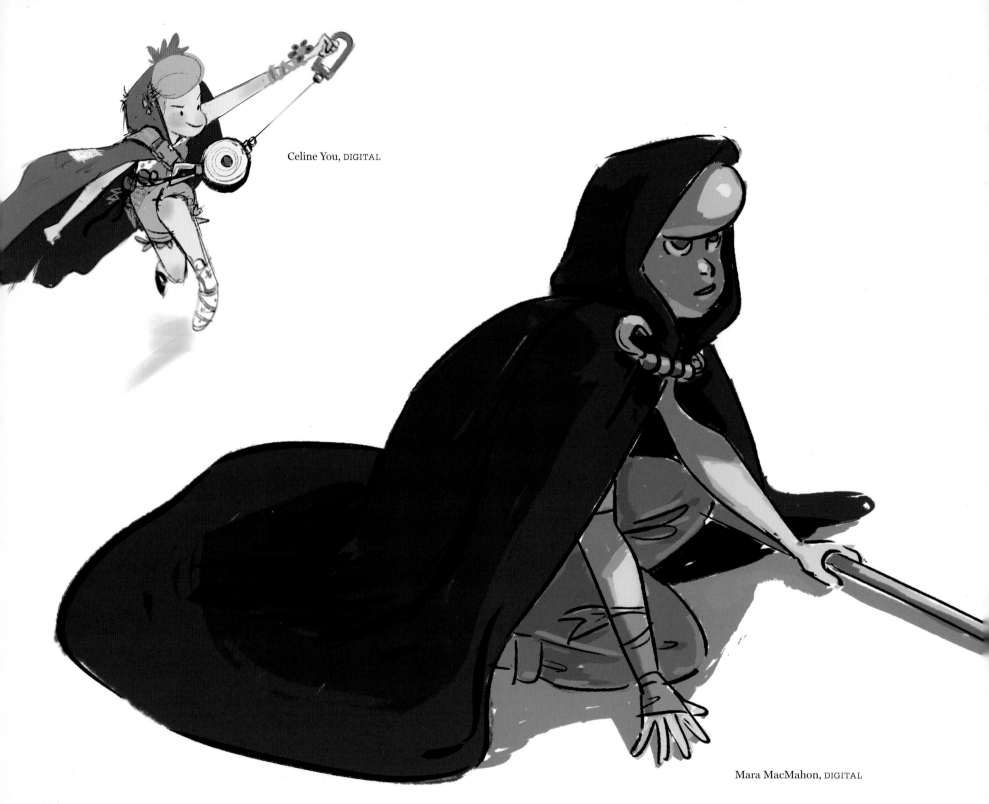

Celine You, DIGITAL

Mara MacMahon, DIGITAL

104

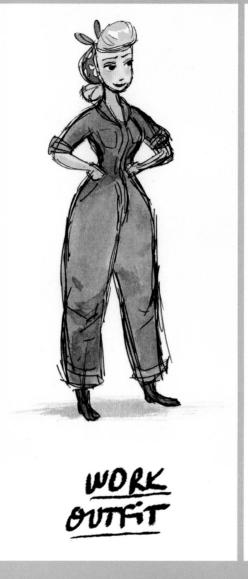

WORK
OUTFIT

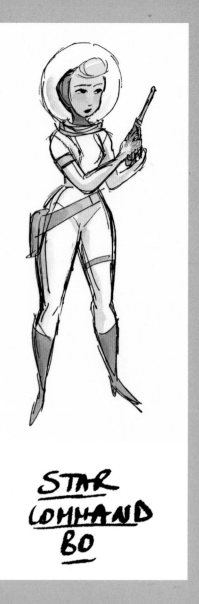

STAR
COMMAND
BO

Daniela Strijleva, INK PEN AND GOUACHE

Daniela Strijleva, INK PEN, DIGITAL COLOR, AND GOUACHE

In an early version of the film, the antique store was a huge city full of old toys that were all trying to fix themselves so they could be sold. Woody found Bo in the store dressed in a work outfit like Rosie the Riveter. Bo was trading batteries and toy parts for fabric to make a new dress so she could be sold as a porcelain figurine.

The Star Command Bo design was from a wild idea where Woody's head and Buzz's heads were removed and put onto each other's bodies. No, seriously. Buzz's head on Woody's body and Woody's head on Buzz's body. When Buzz's body was switched to demo mode, Woody was able to see what Buzz saw when he thought he was a real space ranger. Everything became super-space-realistic in his eyes . . . including Bo Peep. —JOSH COOLEY, DIRECTOR

 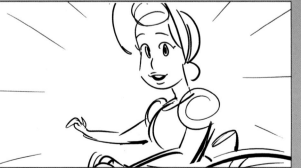

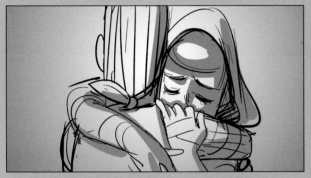

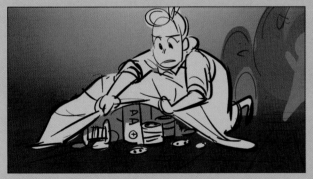

[this spread] **Domee Shi**, DIGITAL STORYBOARDS

One version of the film had Woody re-meeting Bo Peep inside the antique store, in the toy version of a black market/gambling den. This was a place, hidden between shelves, where toys bartered and made bets to get things they needed to repair themselves. Bo's character was a Robin Hood-like personality that would cheat the already-corrupt system to get the things she needed for her pack of toy friends. We also explored the idea of Woody having immediate flashback memories when he sees her again. —VALERIE LAPOINTE, STORY SUPERVISOR

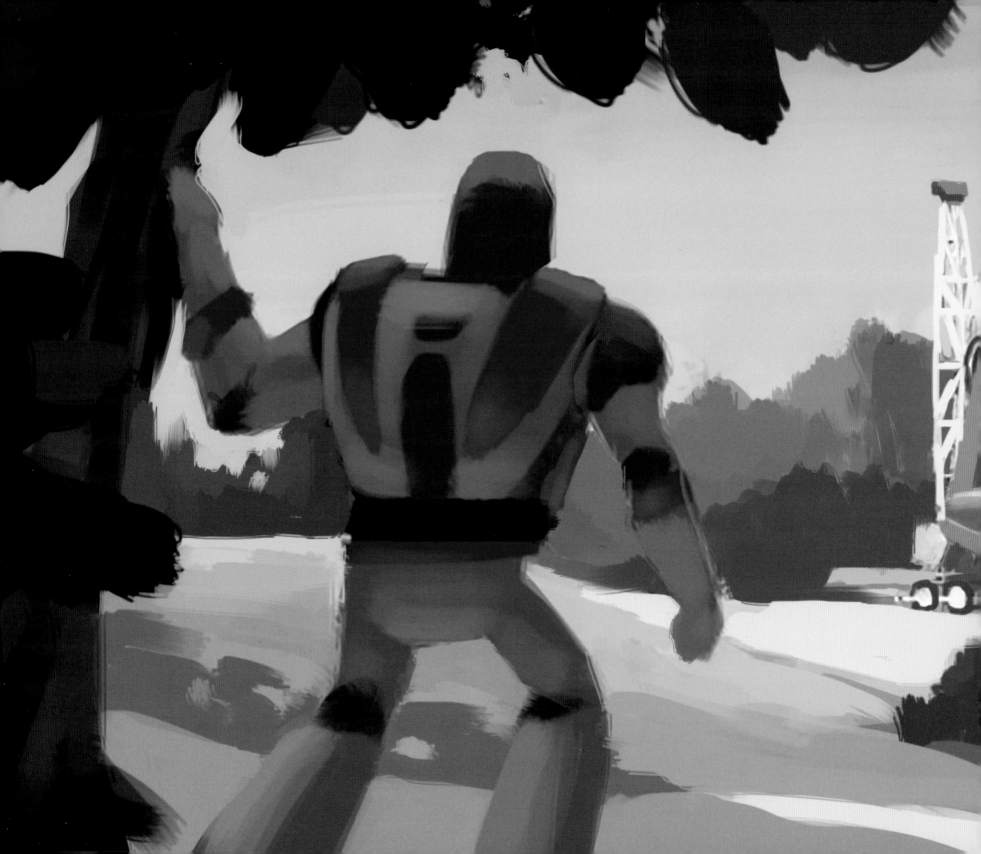

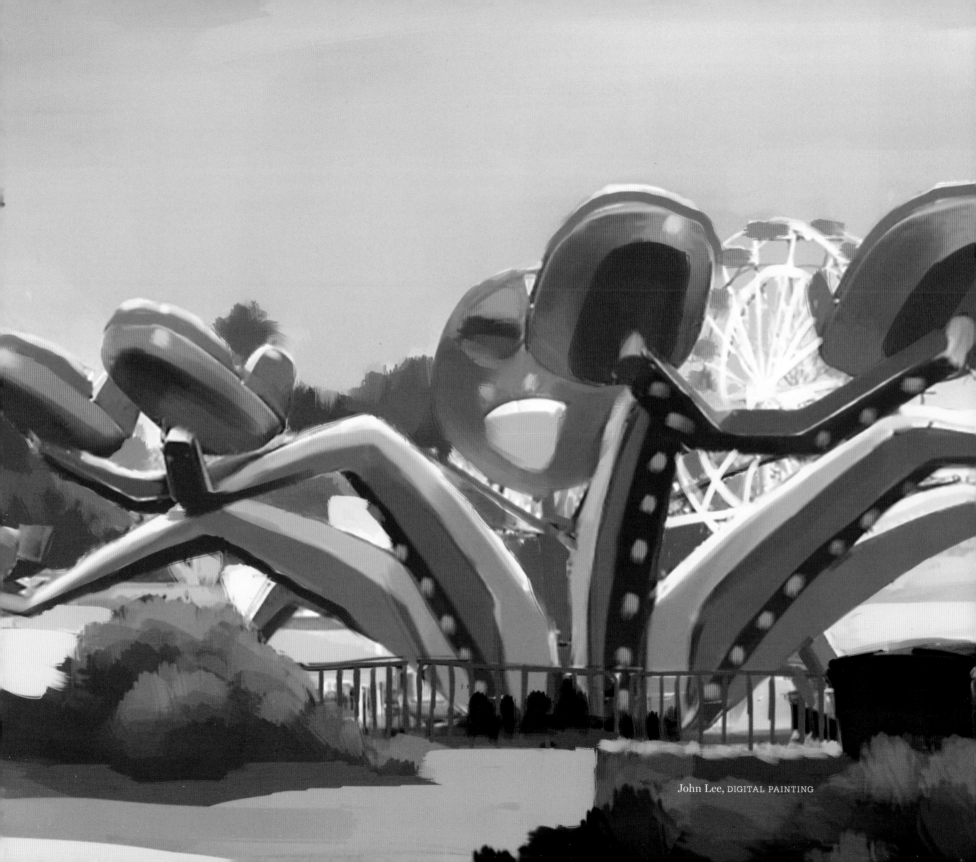

John Lee, DIGITAL PAINTING

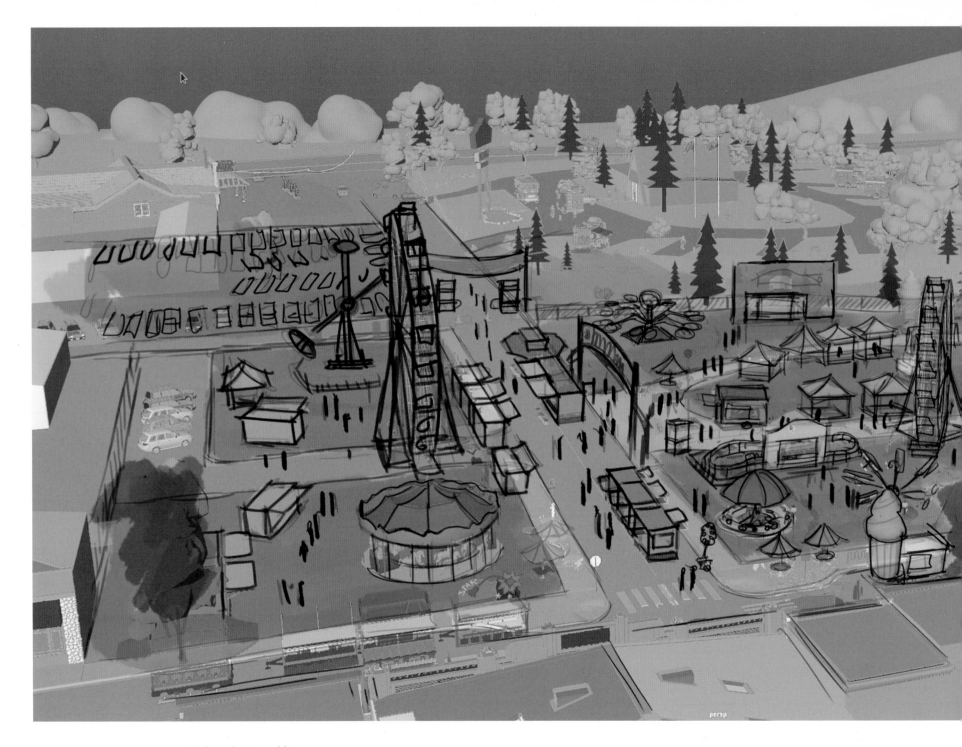

Nathaniel McLaughlin, DIGITAL

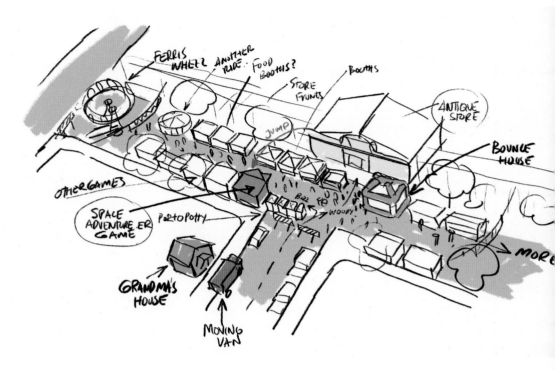

Bob Pauley, DIGITAL

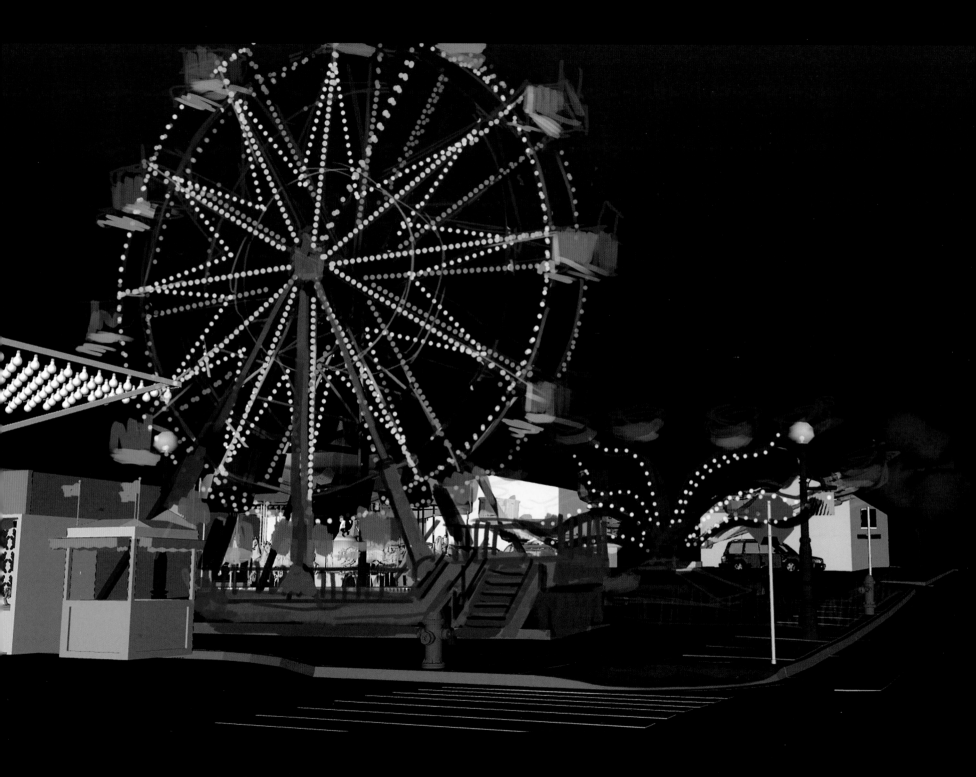

Nathaniel McLaughlin, DIGITAL

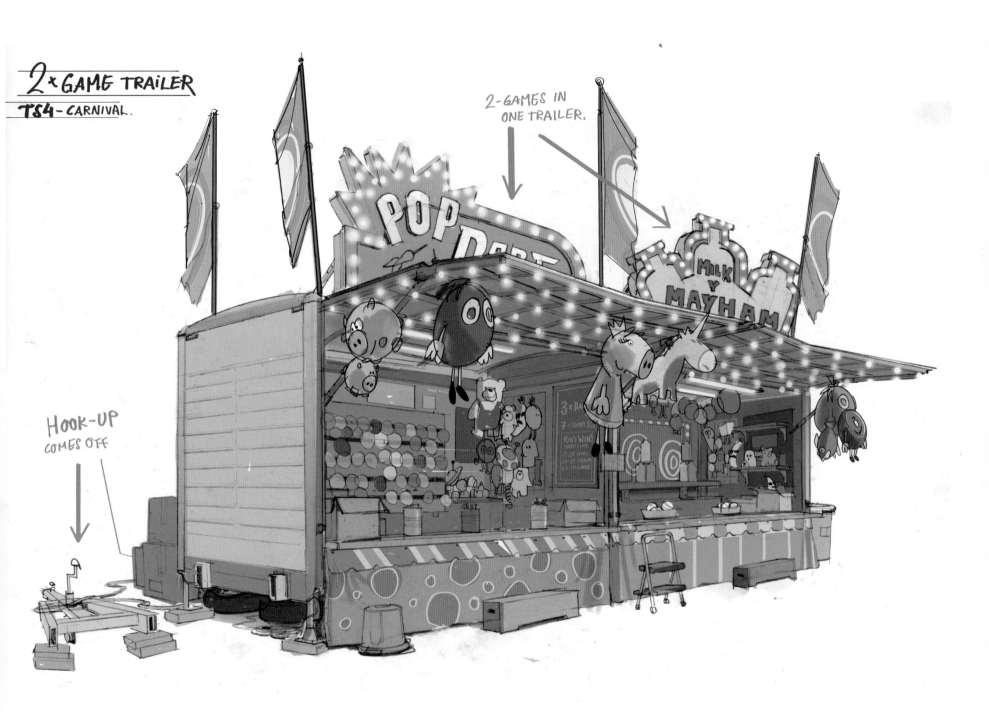

2 x GAME TRAILER
TS4 - CARNIVAL.

2-GAMES IN
ONE TRAILER.

HOOK-UP
COMES OFF

Kristian Norelius, DIGITAL

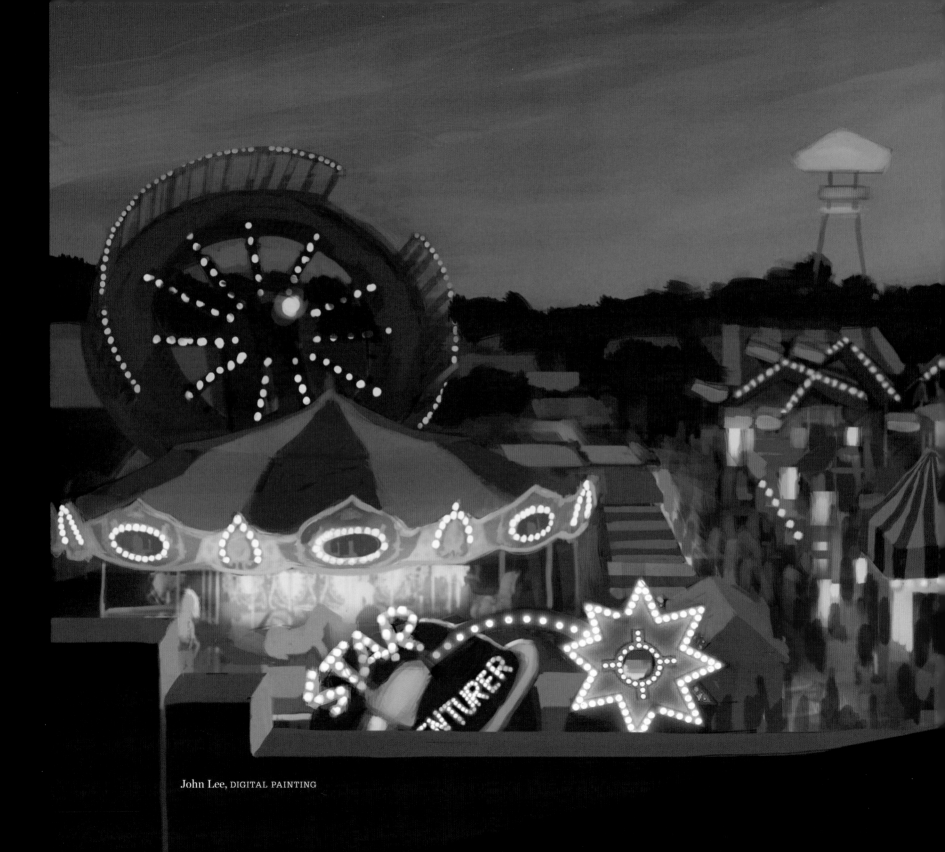

John Lee, DIGITAL PAINTING

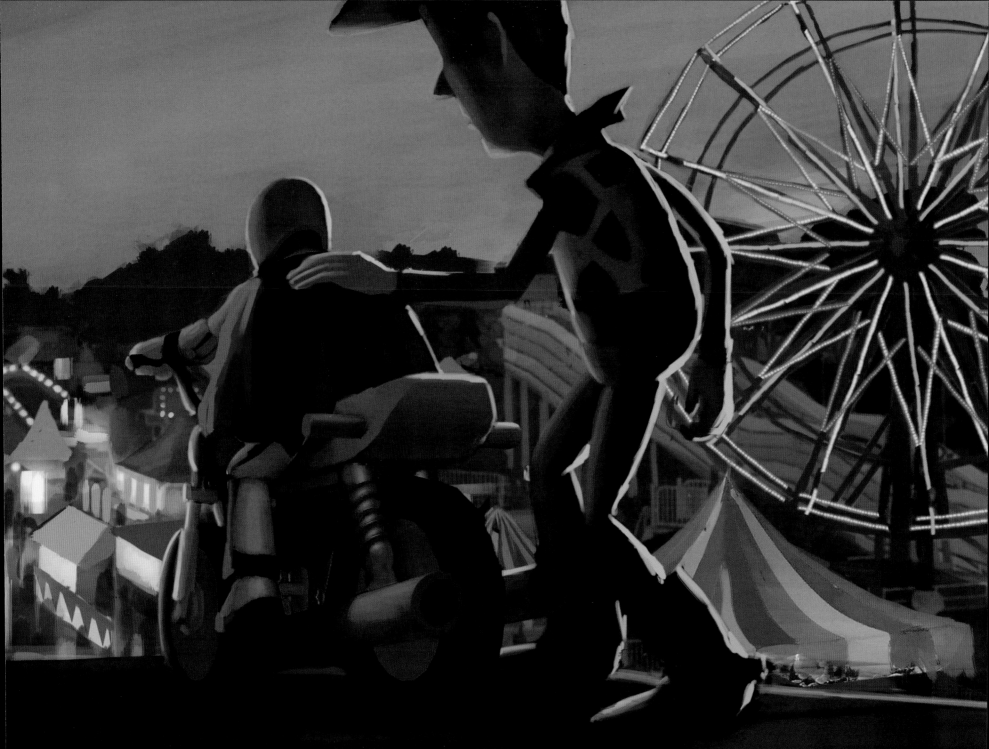

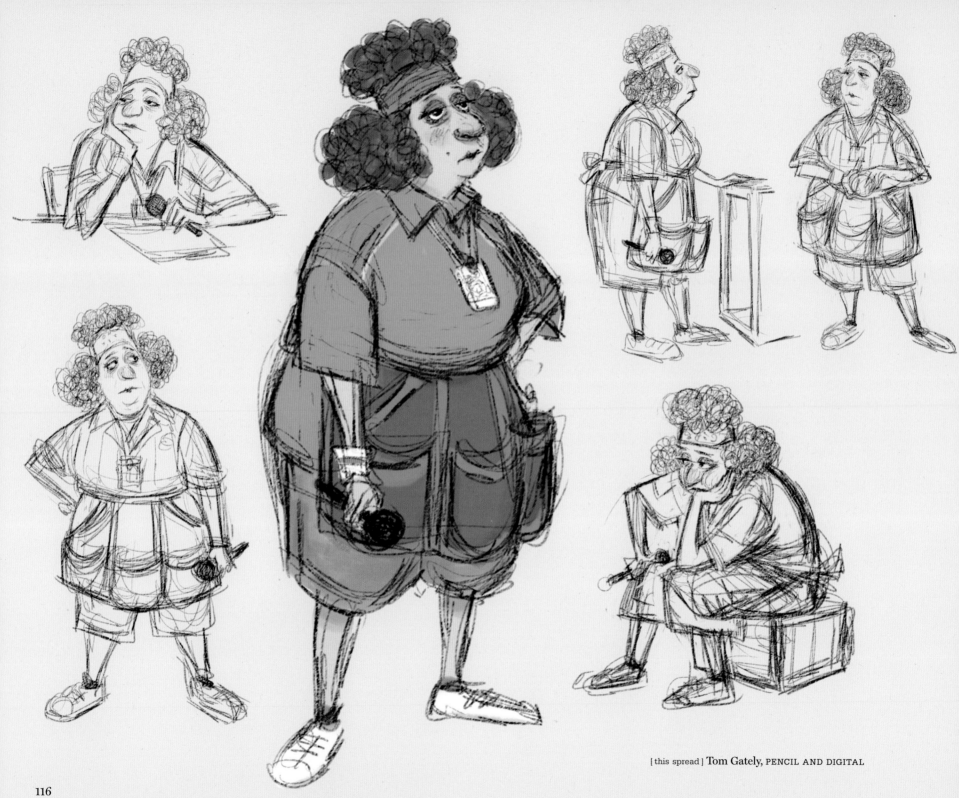

[this spread] Tom Gately, PENCIL AND DIGITAL

[above] Craig Foster, DIGITAL

spinning Head is mounted
slightly off-axis

Piston attach to arms

scale cars Down to .85 of current size (2 riders each)

TERRANTULUS

sheet metal covered Base

Arms attach to hub

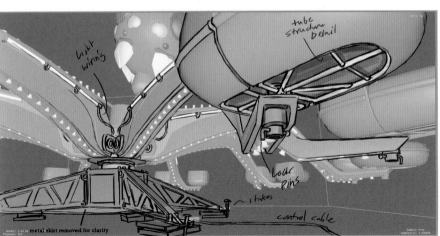

tube structure detail

light wires

lock pins

stakes

control cable

metal skirt removed for clarity

[this page] Nathaniel McLaughlin, DIGITAL

118

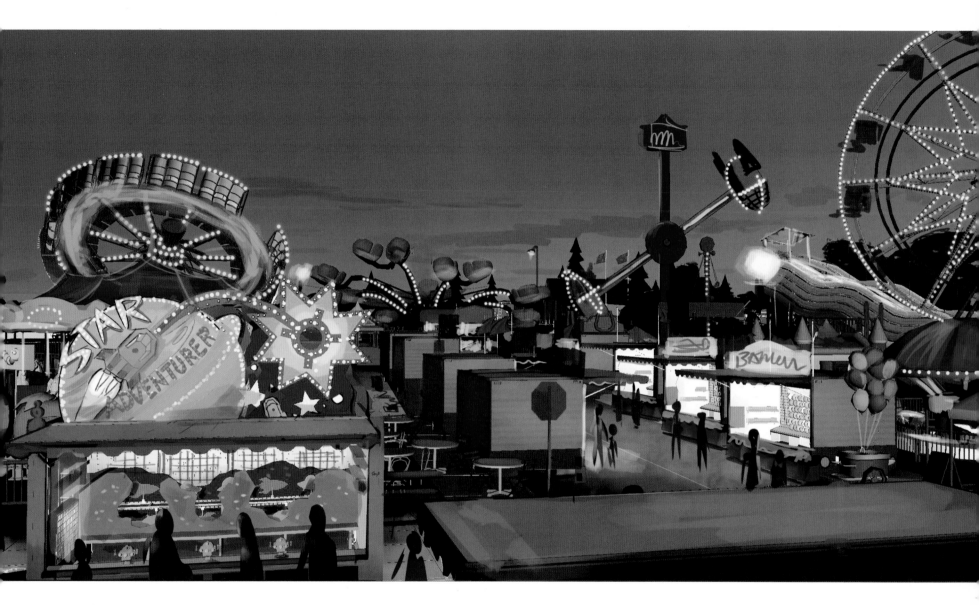

Nathaniel McLaughlin, DIGITAL

[this page] Nathaniel McLaughlin, DIGITAL

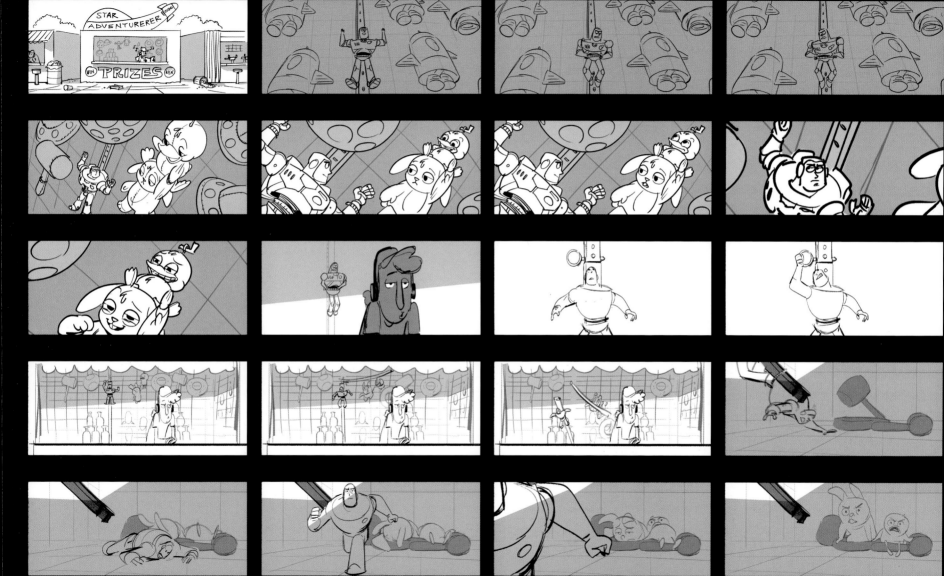

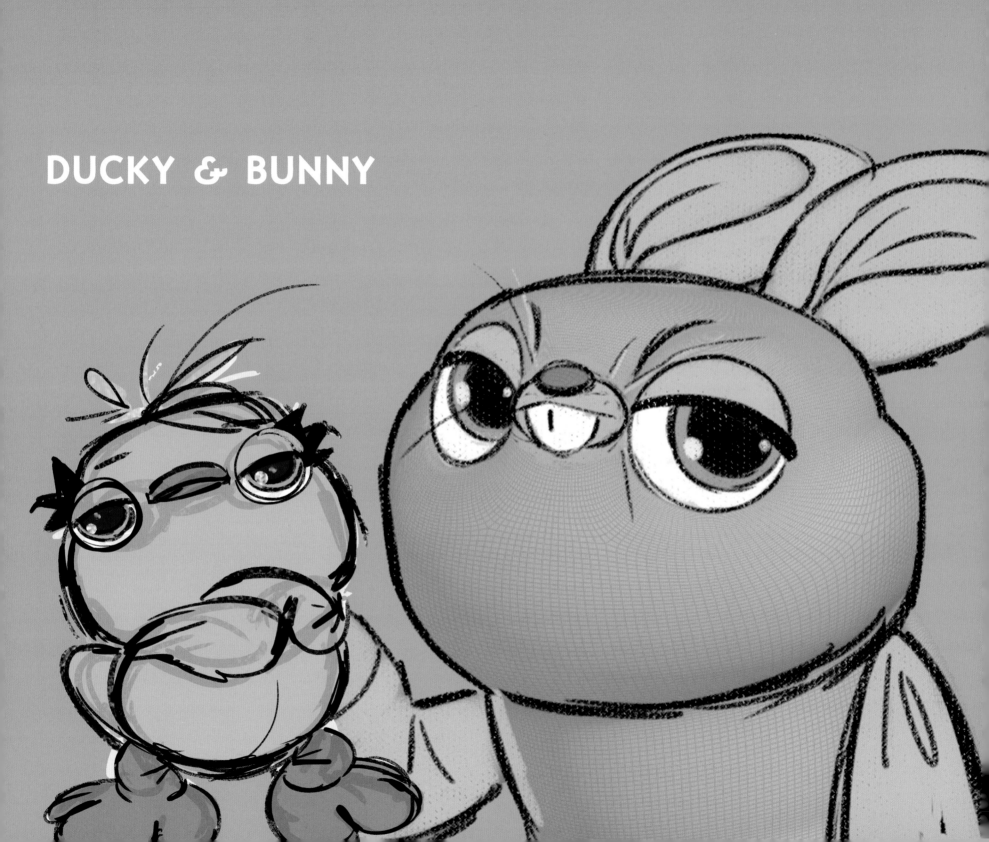

DUCKY & BUNNY

[opposite and above] **Deanna Marsigliese**, DIGITAL

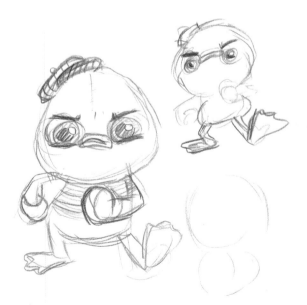

John Lasseter, PENCIL

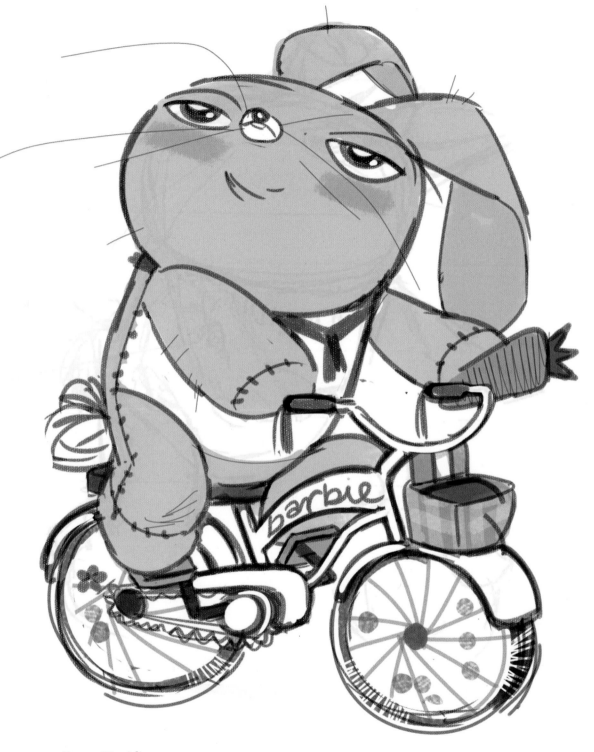

Deanna Marsigliese, DIGITAL

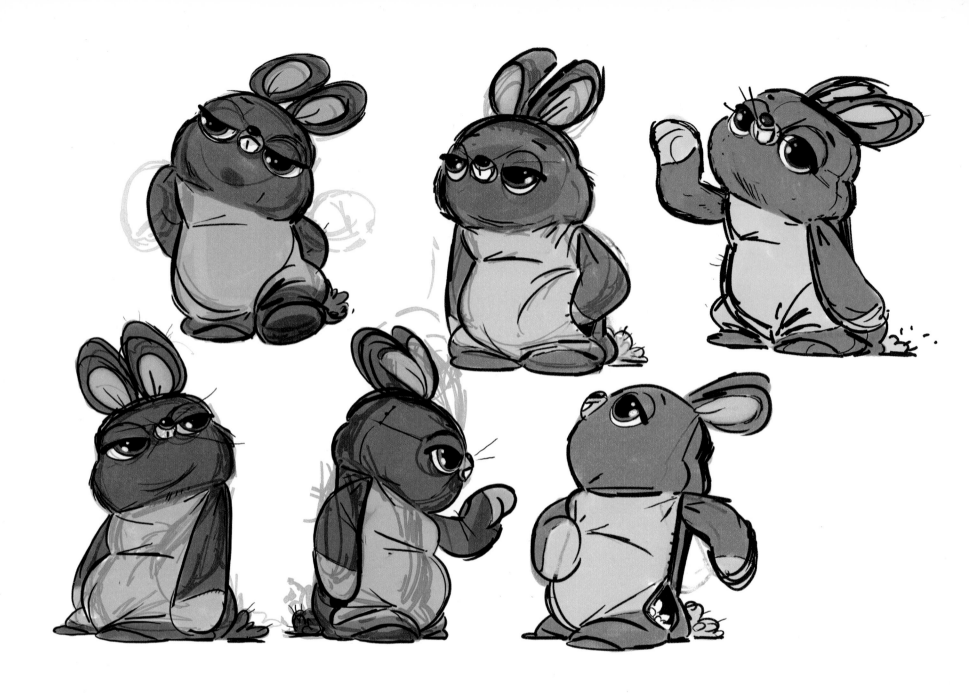

[this spread] Deanna Marsigliese, DIGITAL

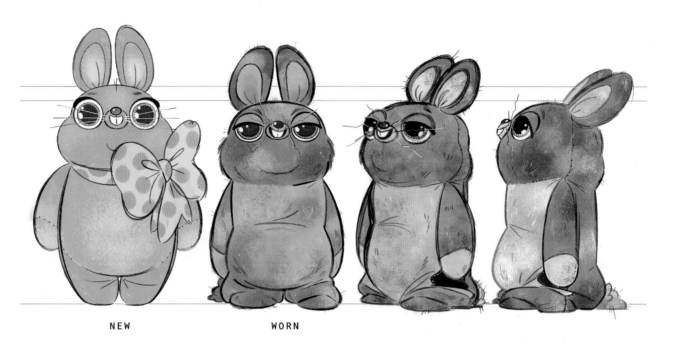

NEW WORN

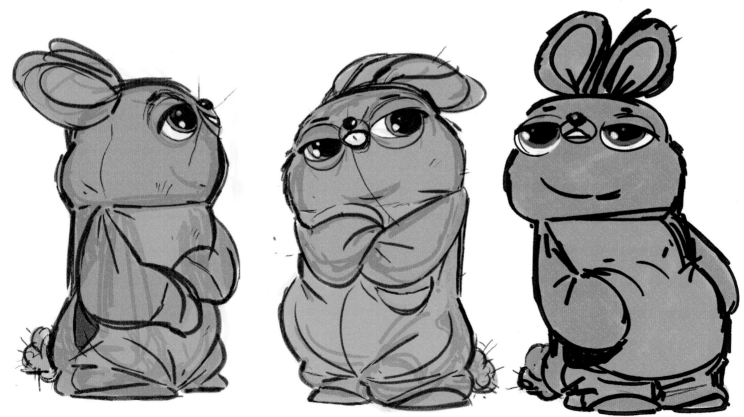

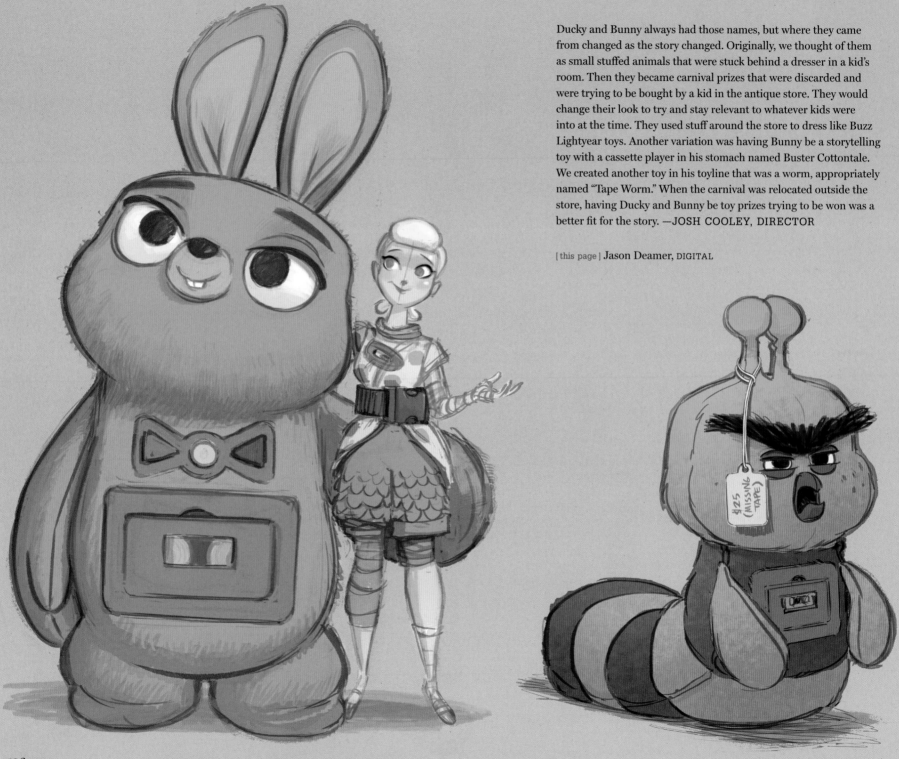

Ducky and Bunny always had those names, but where they came from changed as the story changed. Originally, we thought of them as small stuffed animals that were stuck behind a dresser in a kid's room. Then they became carnival prizes that were discarded and were trying to be bought by a kid in the antique store. They would change their look to try and stay relevant to whatever kids were into at the time. They used stuff around the store to dress like Buzz Lightyear toys. Another variation was having Bunny be a storytelling toy with a cassette player in his stomach named Buster Cottontale. We created another toy in his toyline that was a worm, appropriately named "Tape Worm." When the carnival was relocated outside the store, having Ducky and Bunny be toy prizes trying to be won was a better fit for the story. —JOSH COOLEY, DIRECTOR

[this page] Jason Deamer, DIGITAL

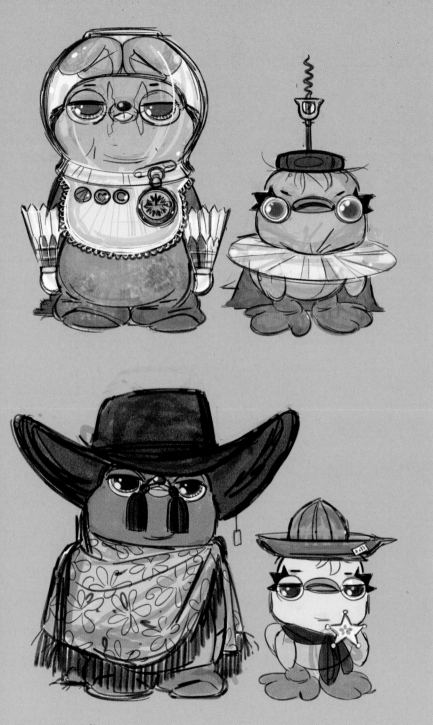

Deanna Marsigliese, DIGITAL

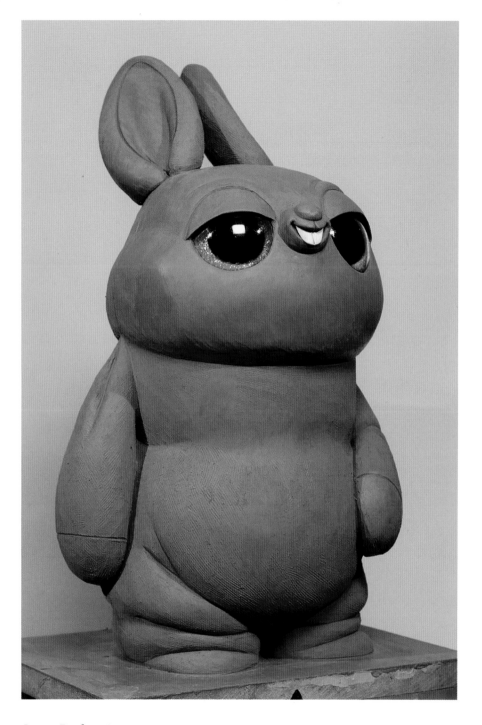

Jerome Ranft, CLAY

127

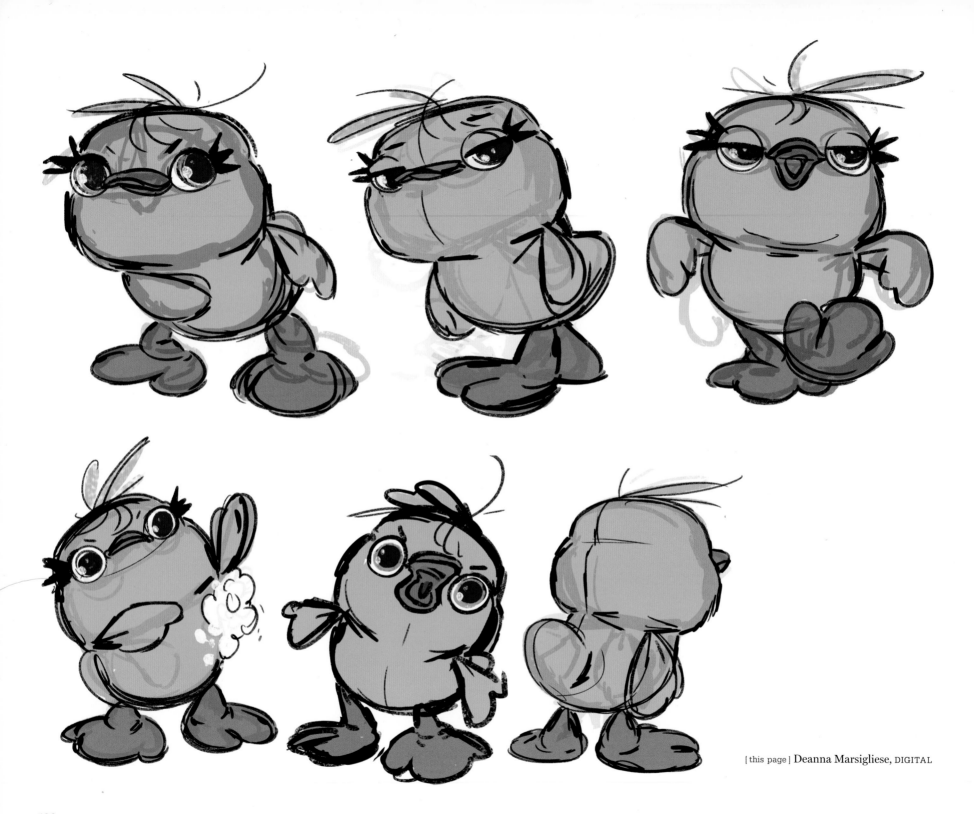

[this page] Deanna Marsigliese, DIGITAL

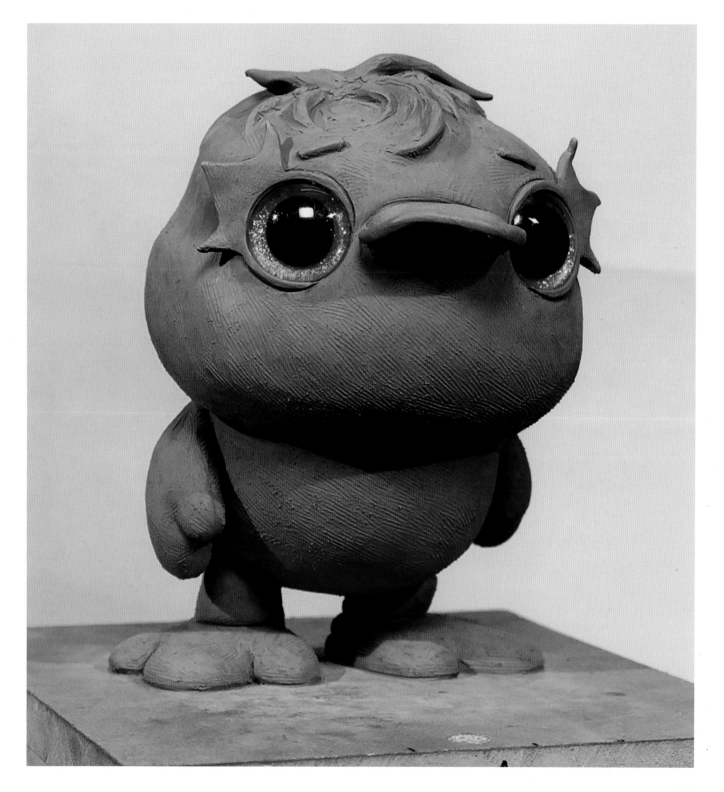

Jerome Ranft, CLAY

John Lee, DIGITAL PAINTING

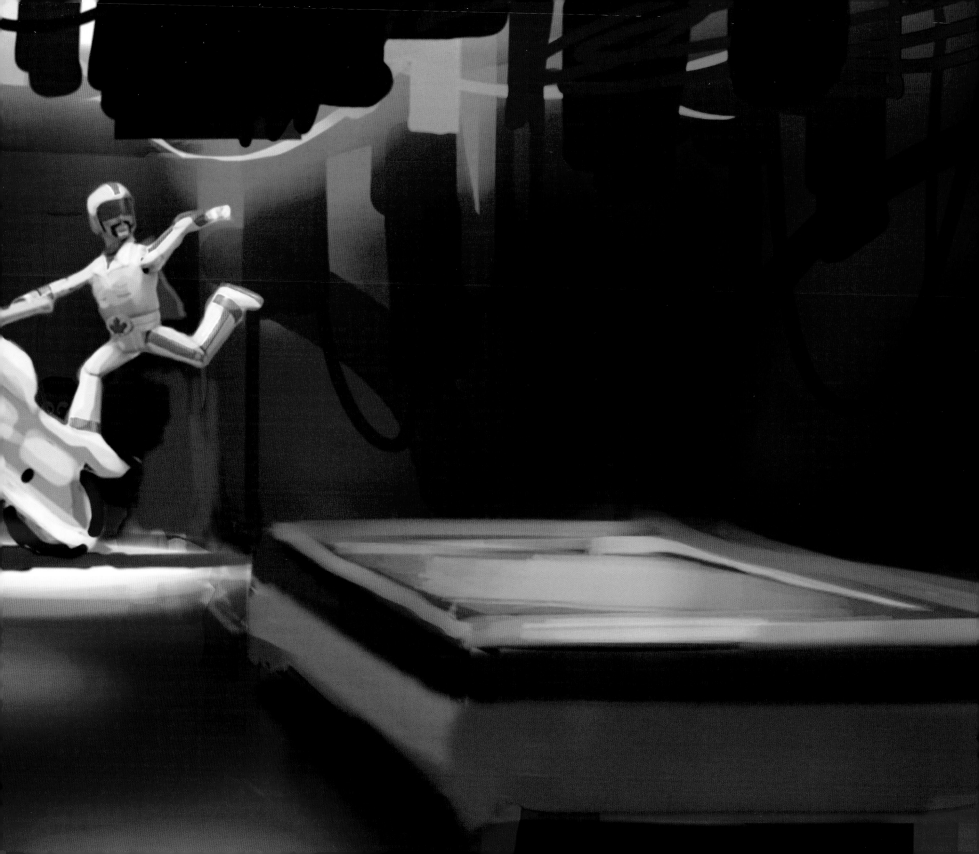

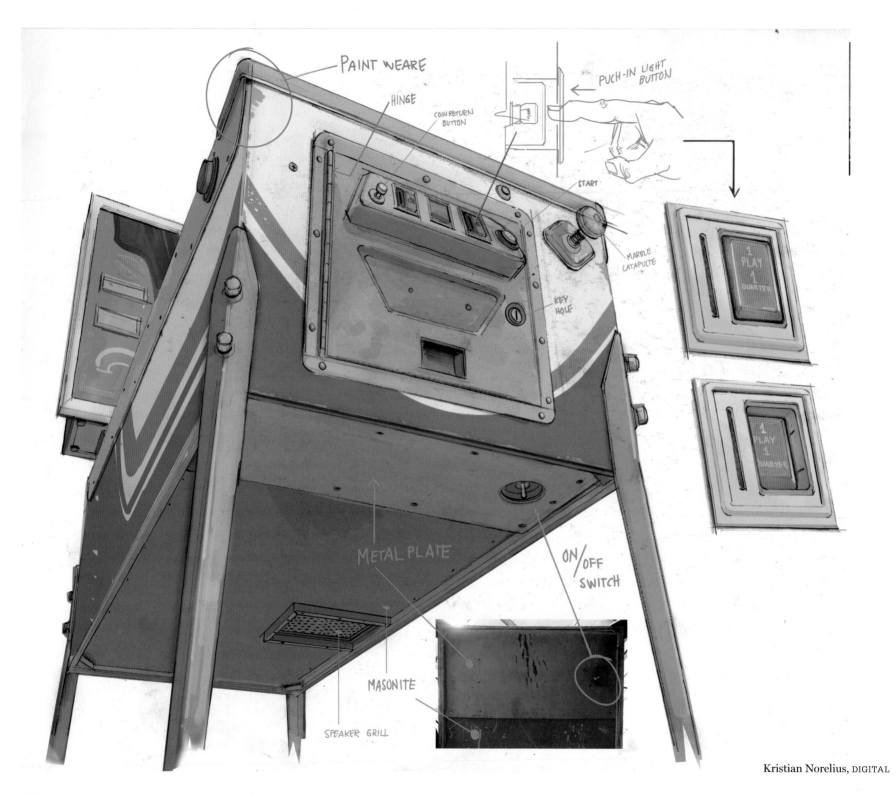

PAINT WEARE

HINGE

COIN RETURN BUTTON

PUCH-IN LIGHT BUTTON

START

MARBLE CATAPULTE

KEY HOLE

1 PLAY 1 QUARTER

1 PLAY 1 QUARTER

METAL PLATE

ON/OFF SWITCH

MASONITE

SPEAKER GRILL

Kristian Norelius, DIGITAL

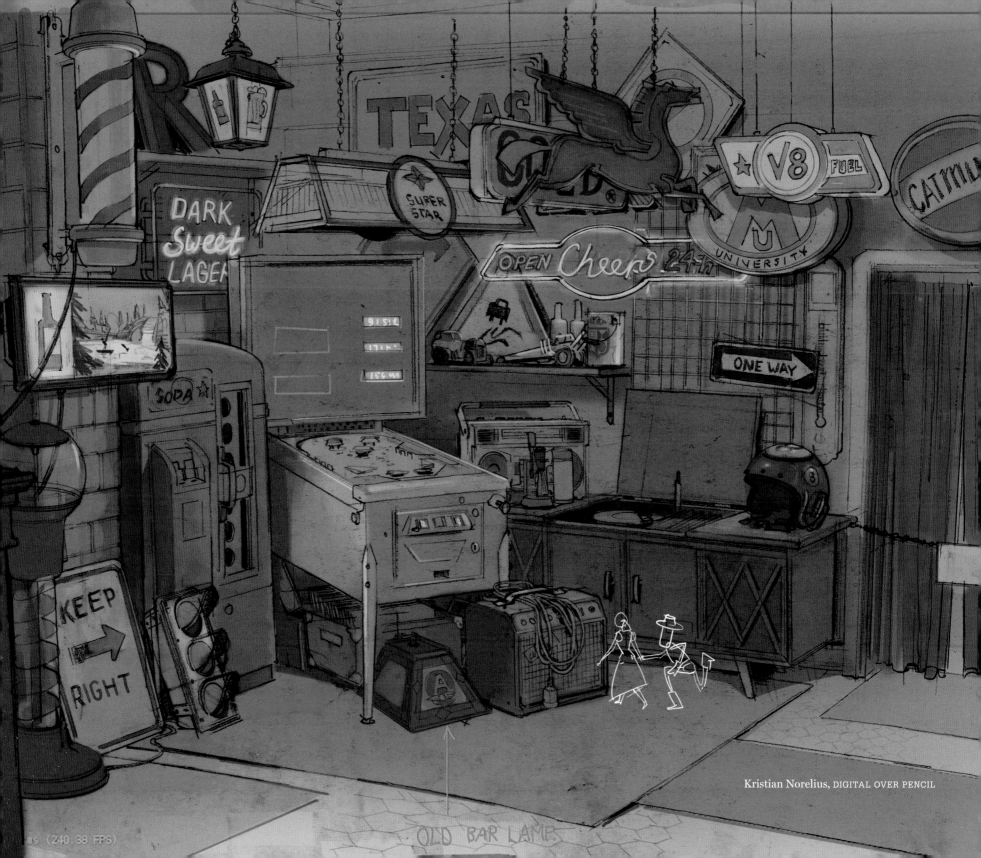

Kristian Norelius, DIGITAL OVER PENCIL

Having access to a pinball machine from Duke's era was crucial in helping us to keep things authentic, so I brought mine in. We had to know what was real so that we could break the rules when we needed to. —DANIEL HOLLAND, ART DIRECTOR, SETS

[right] Deborah Coleman, PHOTOGRAPHS

[below] Camilo Castro, DIGITAL PAINTING

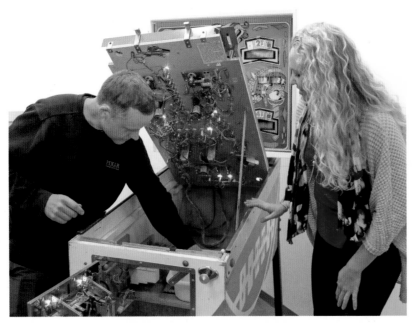

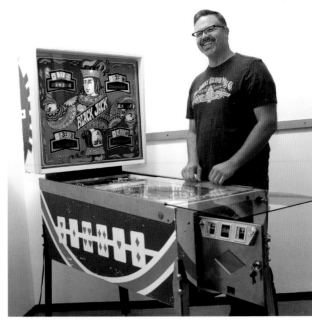

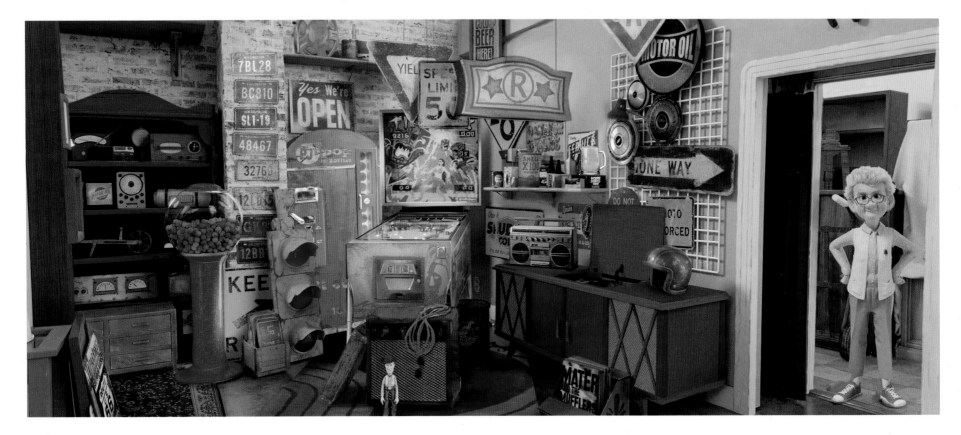

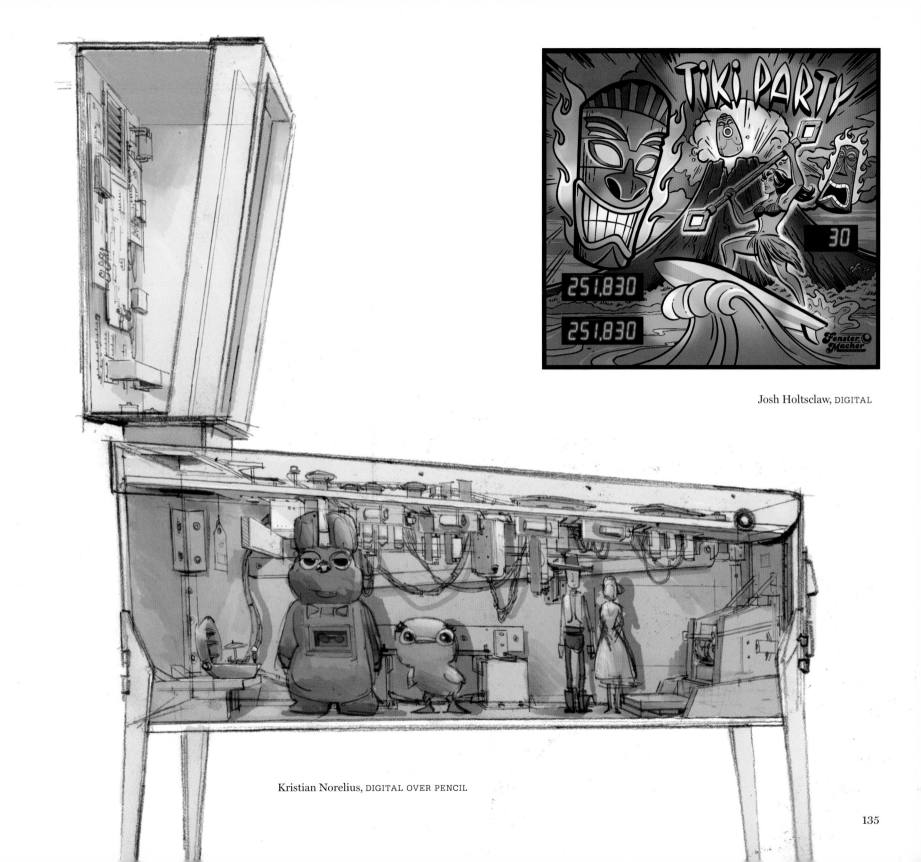

TIKI PARTY

251,830

251,830

30

Fenster Macher

Josh Holtsclaw, DIGITAL

Kristian Norelius, DIGITAL OVER PENCIL

DUKE CABOOM

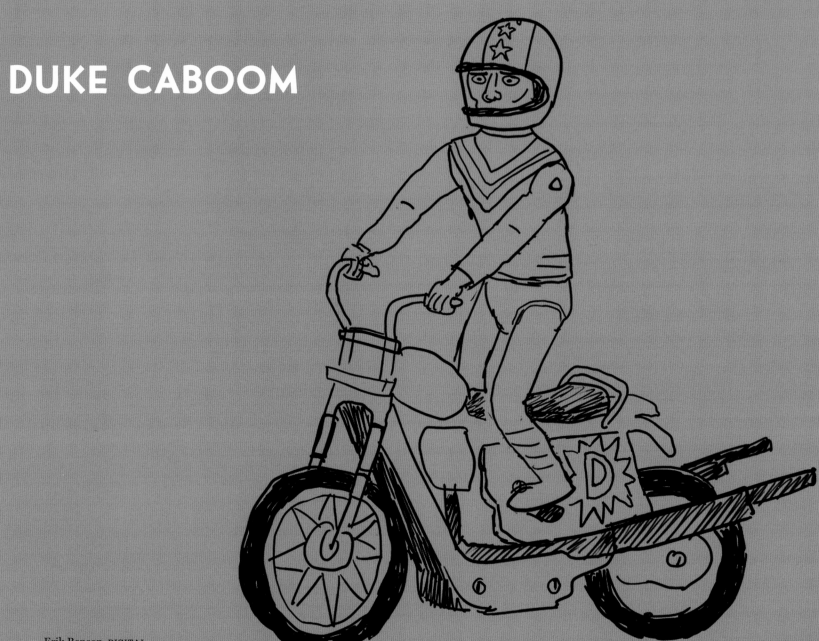

Erik Benson, DIGITAL

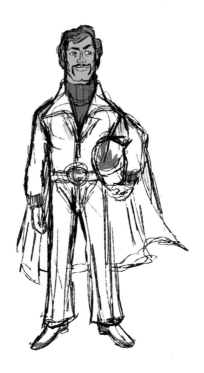

Daniel Holland, DIGITAL

[above and below] **Albert Lozano,**
DIGITAL

137

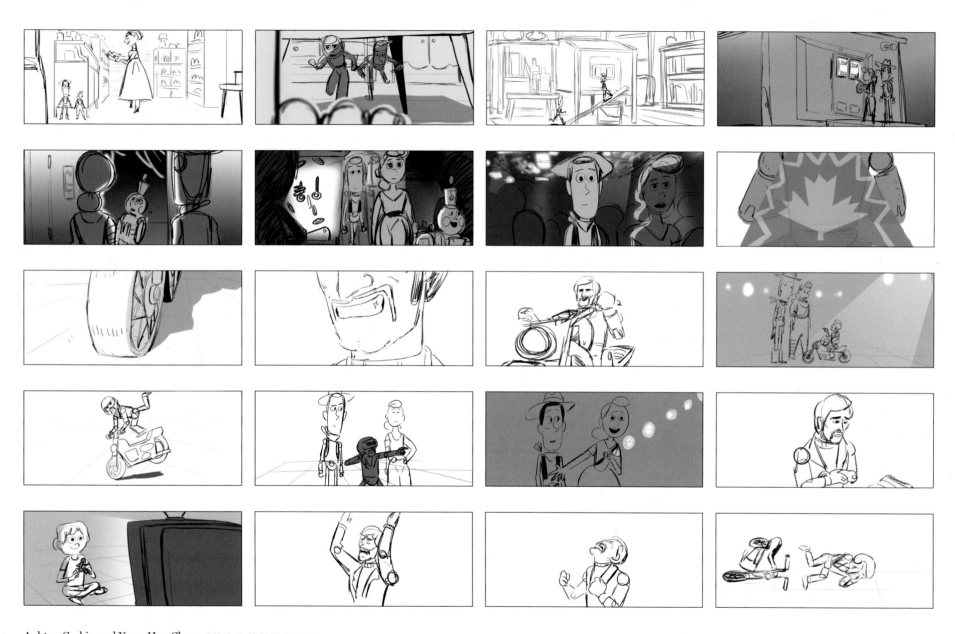

Aphton Corbin and Yung-Han Chang, DIGITAL STORYBOARDS

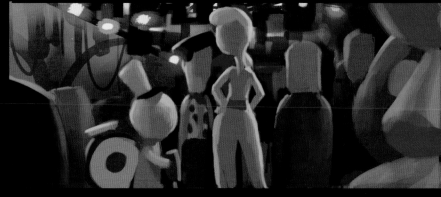
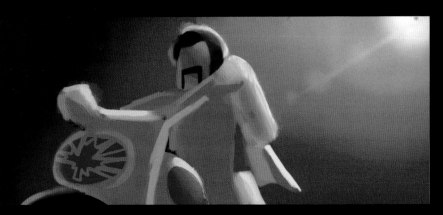

[this page] John Lee, DIGITAL PAINTING

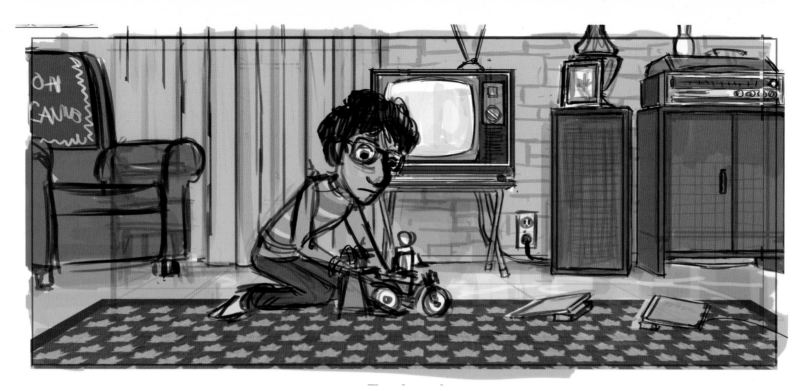

Nathaniel McLaughlin, DIGITAL

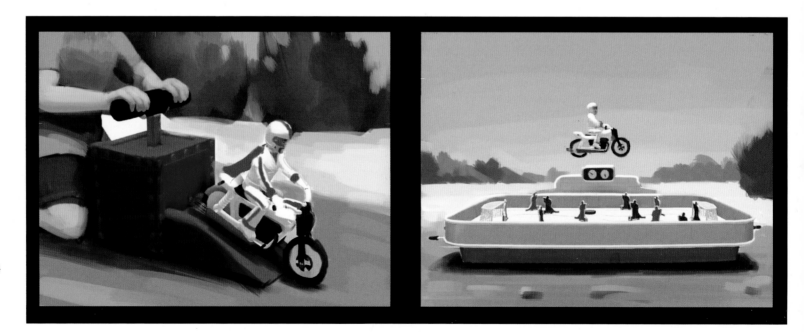

John Lee, DIGITAL PAINTING

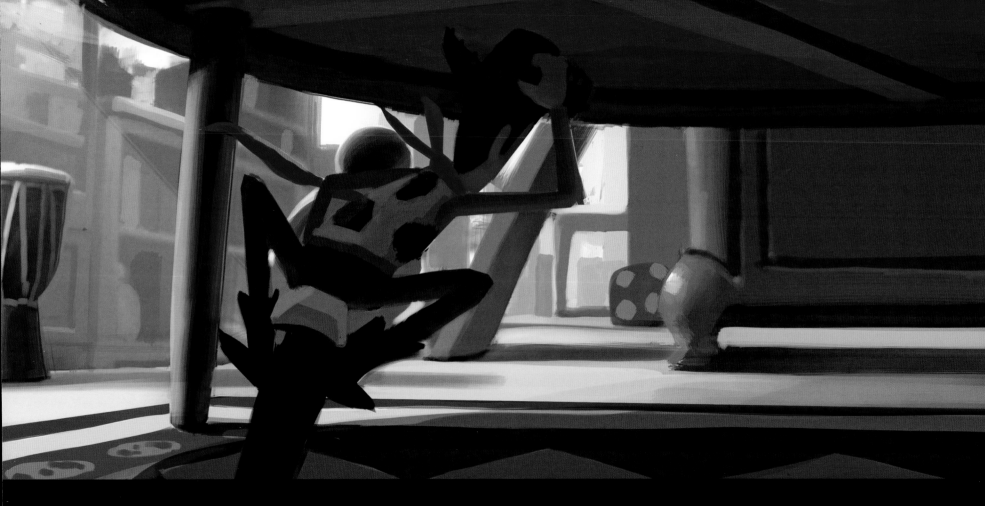

John Lee, DIGITAL PAINTING

Jason Deamer, DIGITAL

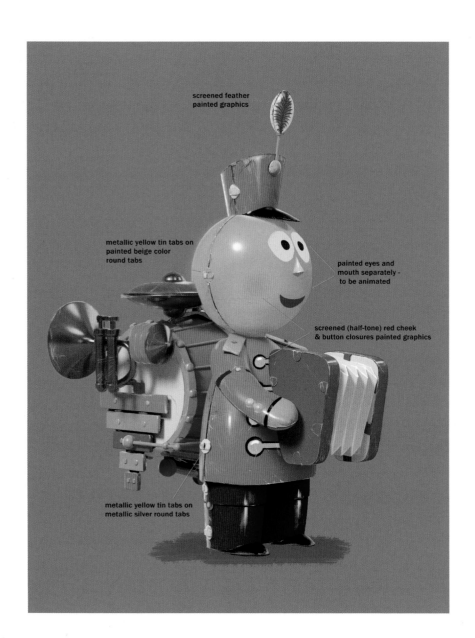

screened feather painted graphics

metallic yellow tin tabs on painted beige color round tabs

painted eyes and mouth separately - to be animated

screened (half-tone) red cheek & button closures painted graphics

metallic yellow tin tabs on metallic silver round tabs

Maria Lee, DIGITAL PAINTING

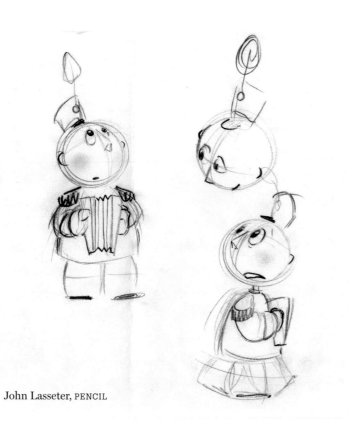

John Lasseter, PENCIL

Tinny is a character throwback to Pixar's short film *Tin Toy*. This "digital recycling" from the groundbreaking short film is a way *Toy Story 4* is connecting with our Pixar heritage. This is a timeless design that holds up well and gets a modern upgrade. We are happy to have Tinny in the film. —BOB PAULEY, PRODUCTION DESIGNER

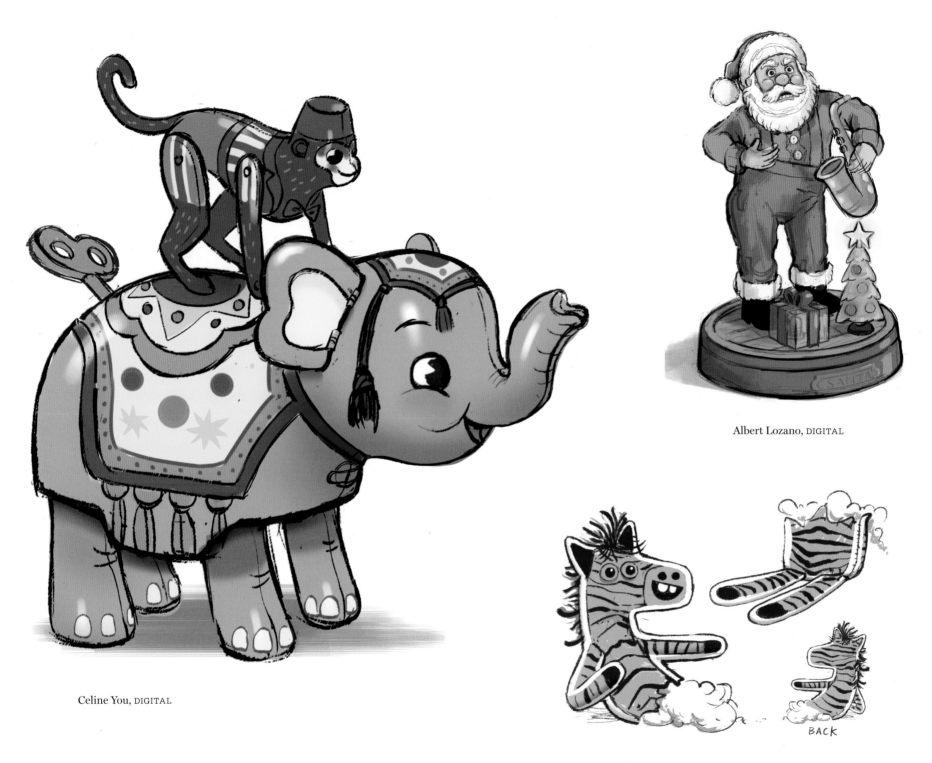

Celine You, DIGITAL

Albert Lozano, DIGITAL

BACK

Celine You, DIGITAL

143

Deanna Marsigliese, DIGITAL

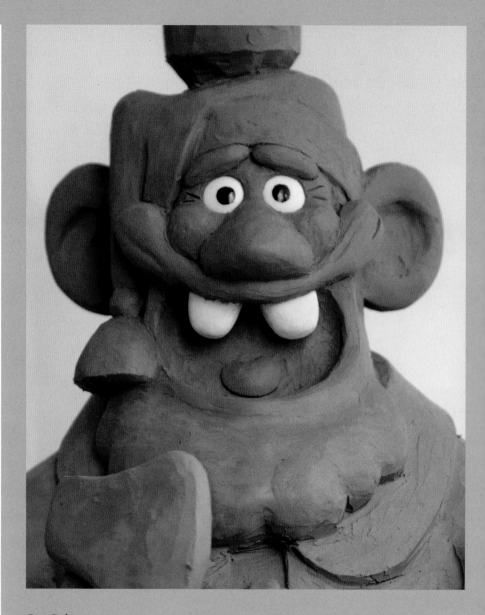

Greg Dykstra, CLAY

At one point in development, when Woody was looking for Bo Peep in the antique mall, he was directed instead to Beaux the Lamp. From afar the silhouette is similar to Bo Peep's, and when they get up close he comes out of the shadows and you meet the most charming French-Canadian fur trapper lamp. Deanna [Marsigliese], who designed the character, did her research to ensure his costume and design were authentic to this part of Canada, which happens to be where she is from. —BOB PAULEY, PRODUCTION DESIGNER

Your Smile light up my world

[this page] Celine You, DIGITAL

145

Celine You, DIGITAL

BANJO BEAR

* MADE FROM AN ASSORTMENT
 OF MATERIALS.
- SELDOM SEEN IN MODERN TOYS

THE BEAR WILL NOT HAVE
PAINTED, OR HEAVILY SCULPTED
BROWS. THEY WILL BE SUBTLY
SCULPTED TO INDICATE
EXPRESSION CHANGES.

THE BEAR'S
FACE IS A
MOLDED
PLASTIC

THE BEAR'S
PANTS ARE
MADE OF A
THICK FABRIC
LIKE CANVAS

* SHOES ARE
MADE OF TIN.

THE BEAR IS MADE
OF MULTIPLE MATERIALS
- TIN
- PLASTIC
- FABRIC
- PLUSH

Albert Lozano, DIGITAL

Back:
Claxton

① Jimmy Claxton

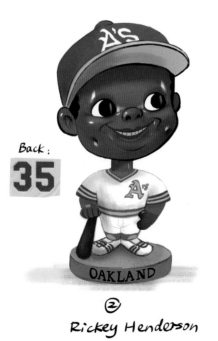

Back:
35

② Rickey Henderson

③

Celine You, DIGITAL

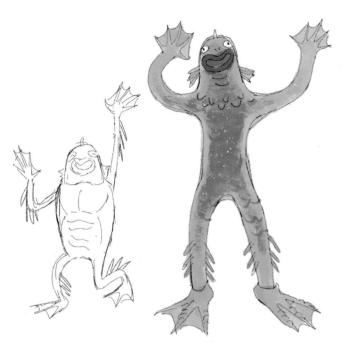

Nancy Tsang, DIGITAL

Celine You, DIGITAL

Albert Lozano,
DIGITAL

Celine You, DIGITAL

Jason Deamer, DIGITAL

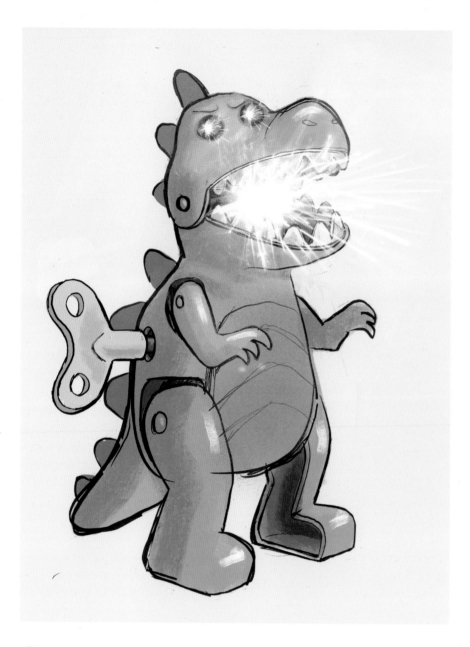

Albert Lozano, DIGITAL

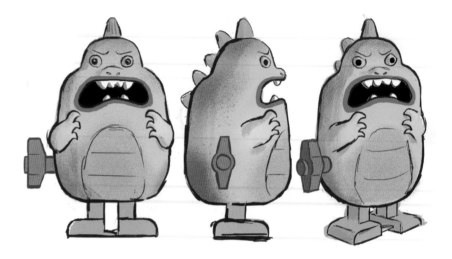

Albert Lozano, DIGITAL

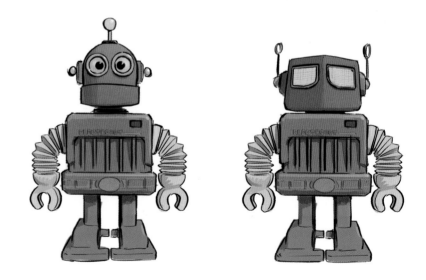

Jason Deamer, DIGITAL

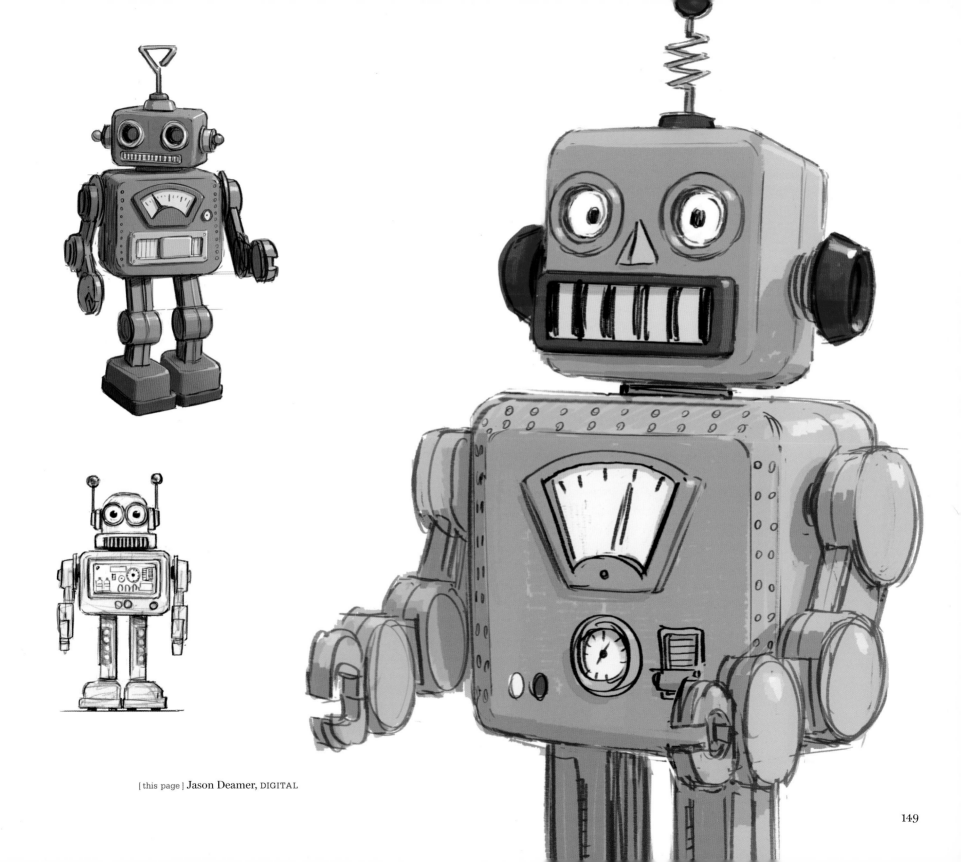

[this page] Jason Deamer, DIGITAL

149

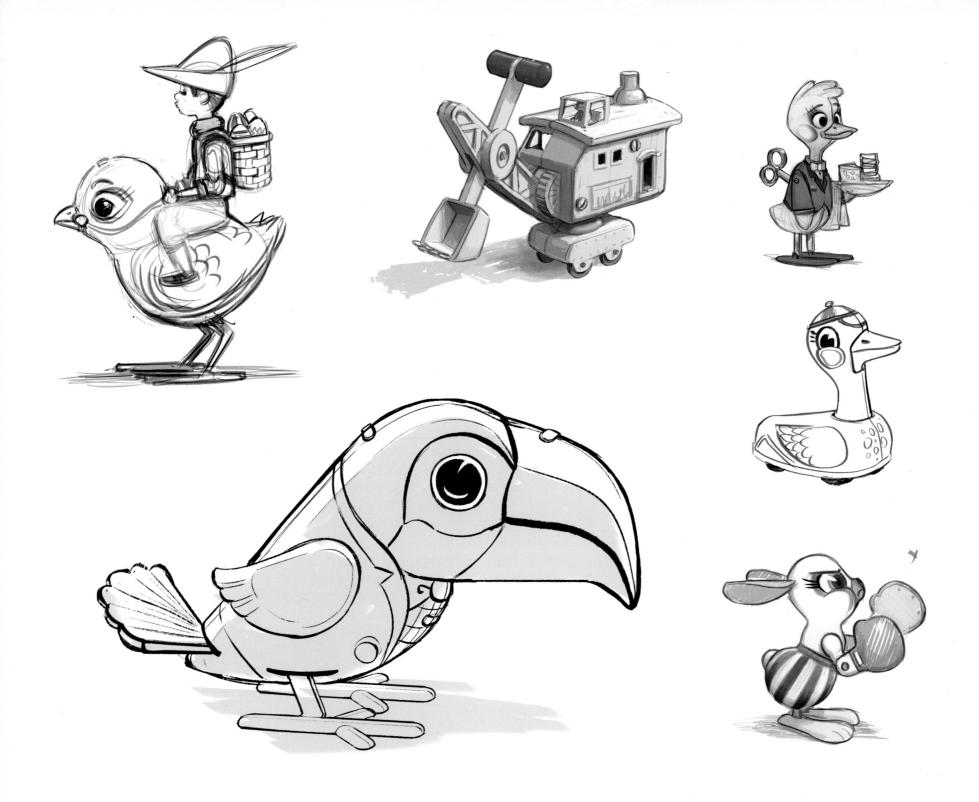

REVOLUTIONARY RABBIT: SOAP FOR LA RÉSISTANCE

REVOLUTIONARY WAR GEN.

NAPOLEON GOAT?

[this spread] Jason Deamer, DIGITAL

BO LIGHT PLAN — CONNECTION TO WOODY

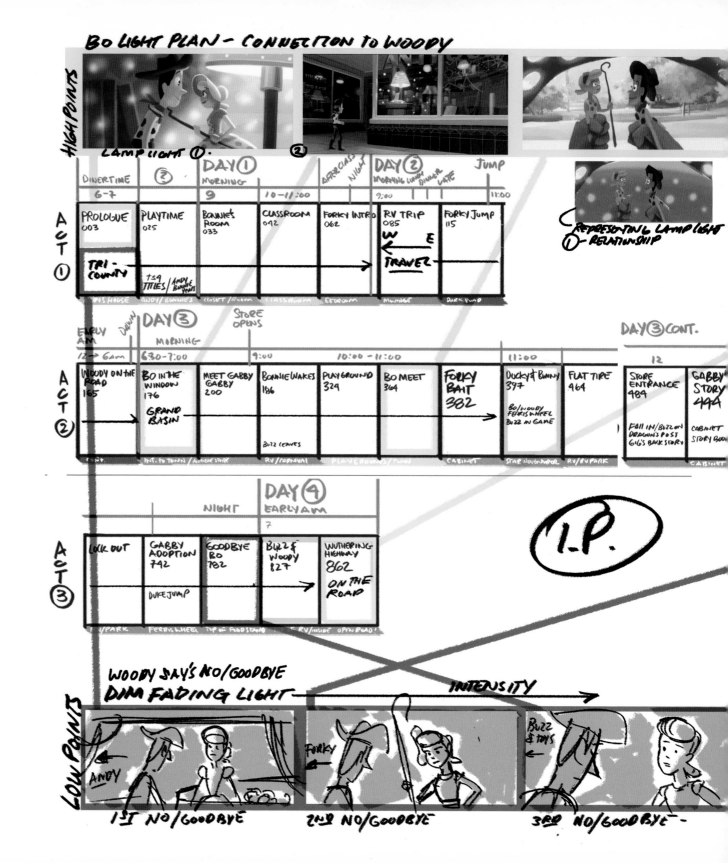

HIGH POINTS

LAMP LIGHT ① ②

③ REPRESENTING LAMP LIGHT ① — RELATIONSHIP

	DINER TIME ③		DAY ① MORNING		AFTER CLASS NIGHT	DAY ② MORNING LUNCH DINNER LATE	JUMP
	6-7		9	10-11:00		9:00	11:00
ACT ①	PROLOGUE 003	PLAYTIME 025	BONNIE'S ROOM 033	CLASSROOM 092	FORKY INTRO 062	RV TRIP 085 W ⟶ E	FORKY JUMP 115
	TRI-COUNTY	↑s9 TITLES / ANDY BONNIE YARD				TRAVEL	
	ANS HOUSE	ANDY/BONNIE'S	CLOSET/ROOM	CLASSROOM	BEDROOM	MONTAGE	DARK ROAD

	EARLY AM	DAWN	DAY ③ MORNING	STORE OPENS	10:00 - 11:00		11:00		DAY ③ CONT. 12		
	12 → 6am		6:30-7:00	9:00							
ACT ②	WOODY ON THE ROAD 165	BO IN THE WINDOW 176 GRAND BASIN	MEET GABBY GABBY 200	BONNIE WAKES 186 BUZZ LEAVES	PLAYGROUND 329	BO MEET 364	FORKY BAIT 382	DUCKY & BUNNY 397 BO/WOODY FERRIS WHEEL BUZZ IN GAME	FLAT TIRE 464	STORE ENTRANCE 484 FALL IN/BUZZ ON DRAGON'S POST 616'S BACK STORY	GABBY STORY 494 CABINET STORY BOOK
	CONT.	INT. TO TOWN / ANTIQUE STORE	RV/CARNIVAL		PLAYGROUND/TURNS		CABINET	STAR ADVENTURER	RV/RV PARK	CABINET	

I.P.

		NIGHT	DAY ④ EARLY AM		
			7		
ACT ③	LOCK OUT	GABBY ADOPTION 742 DUKE JUMP	GOODBYE BO 782	BUZZ & WOODY 827	WUTHERING HIGHWAY 862 ON THE ROAD
	RV/PARK	FERRIS WHEEL	TOP OF FOOD STAND	RV/INSIDE	OPEN ROAD

WOODY SAY'S NO/GOODBYE
DIM FADING LIGHT ⟶ INTENSITY ⟶

LOW POINTS

ANDY · FORKY · BUZZ & TOYS

1ST NO/GOODBYE 2ND NO/GOODBYE 3RD NO/GOODBYE —

② ③ LAMP LIGHT / CARNIVAL LIGHTS?

SUNSET | CLOSE ODENS CASE | THEY LEAVE

	FRENEMIES 522	RECRUIT DUKE 544	GABBY'S READY 558	COMING TOGETHER 572	BREAK IN 586	BO LEAVES 629	GABBY STANDOFF 664	REJECTION 686
3:00?	4:00	5:00	7:00		8:00?			
			HAIR/COMB TEA	SCOUT CABINET		RIB INTRO ALLEY TIME CAT/SAY GOODBYE	HARMONY/MARG IN OFFICE	HARMONY SAYS NO TO GABBY WOODY TRAPS FORKY
	CARNIVAL	PINBALL	CABINET	LIGHTING STALL	CABINET	ALLEY IN BACK	LAMP AREA	

FINAL SHOTS

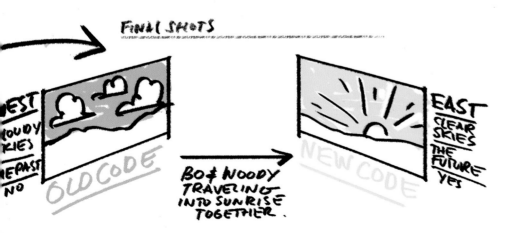

OLD CODE

WEST CLOUDY SKIES THE PAST NO

BO & WOODY TRAVELING INTO SUNRISE TOGETHER.

NEW CODE

EAST CLEAR SKIES THE FUTURE YES

[chart] Bob Pauley, DIGITAL

[paintings] John Lee, DIGITAL PAINTING

153

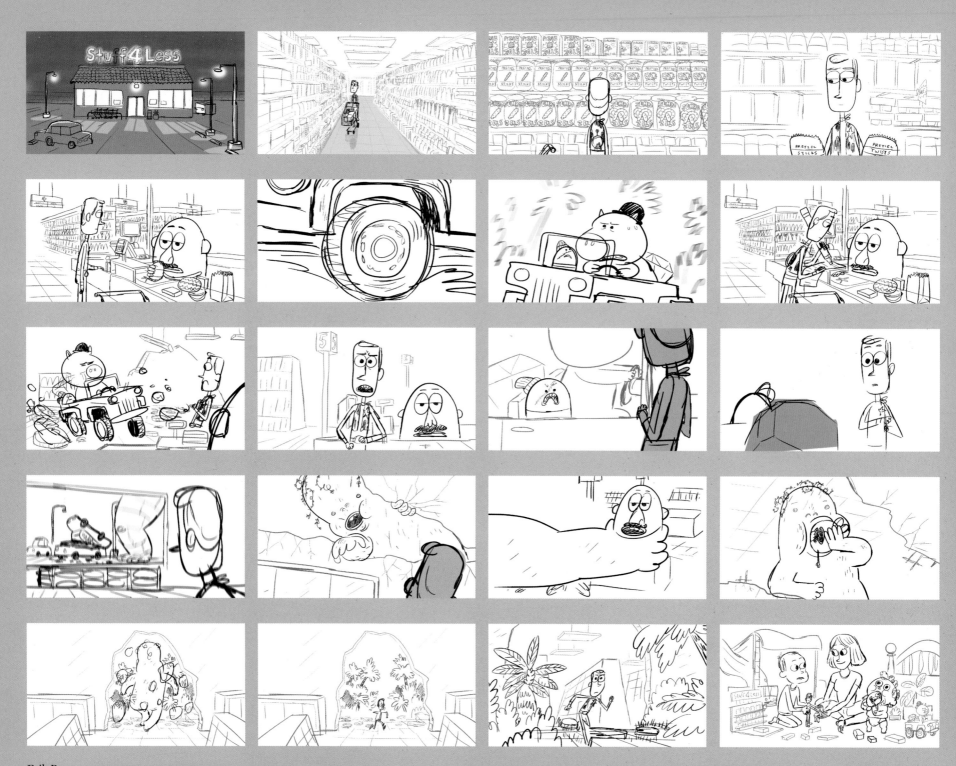

Erik Benson, DIGITAL STORYBOARDS

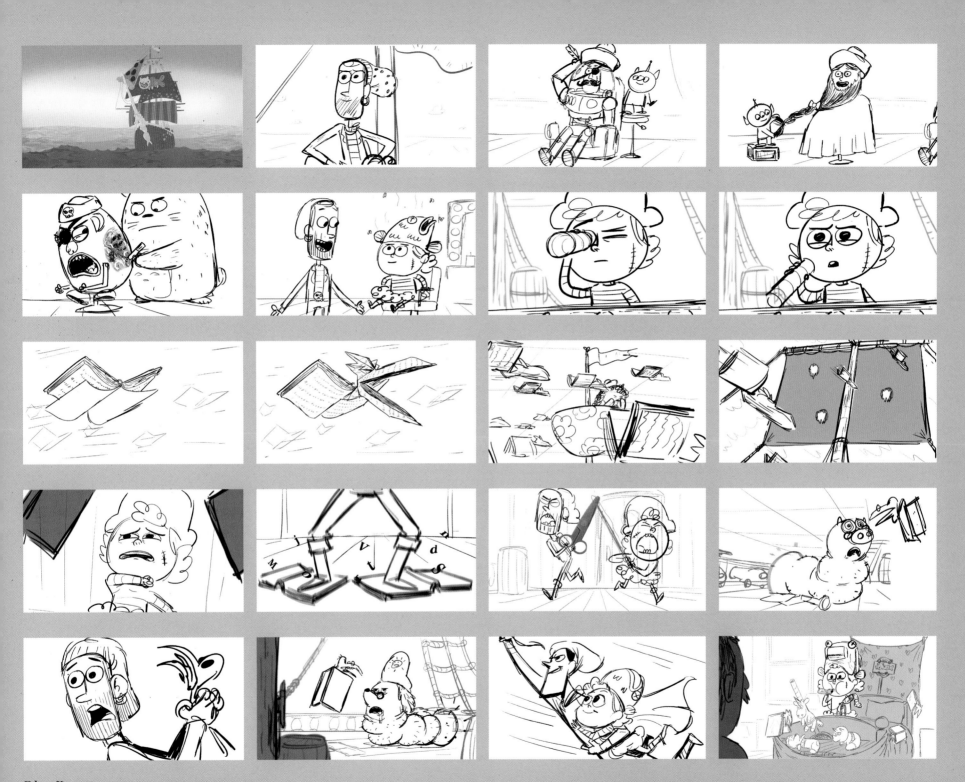

Edgar Karapetyan, DIGITAL STORYBOARDS

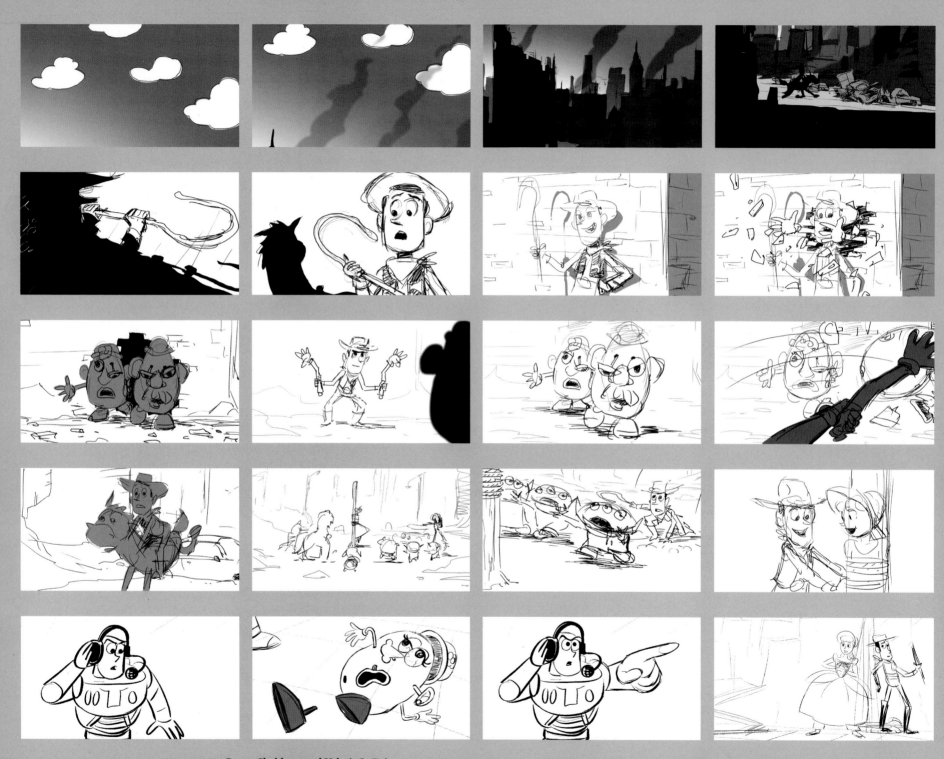

[this spread] Garett Sheldrew and Valerie LaPointe, DIGITAL STORYBOARDS

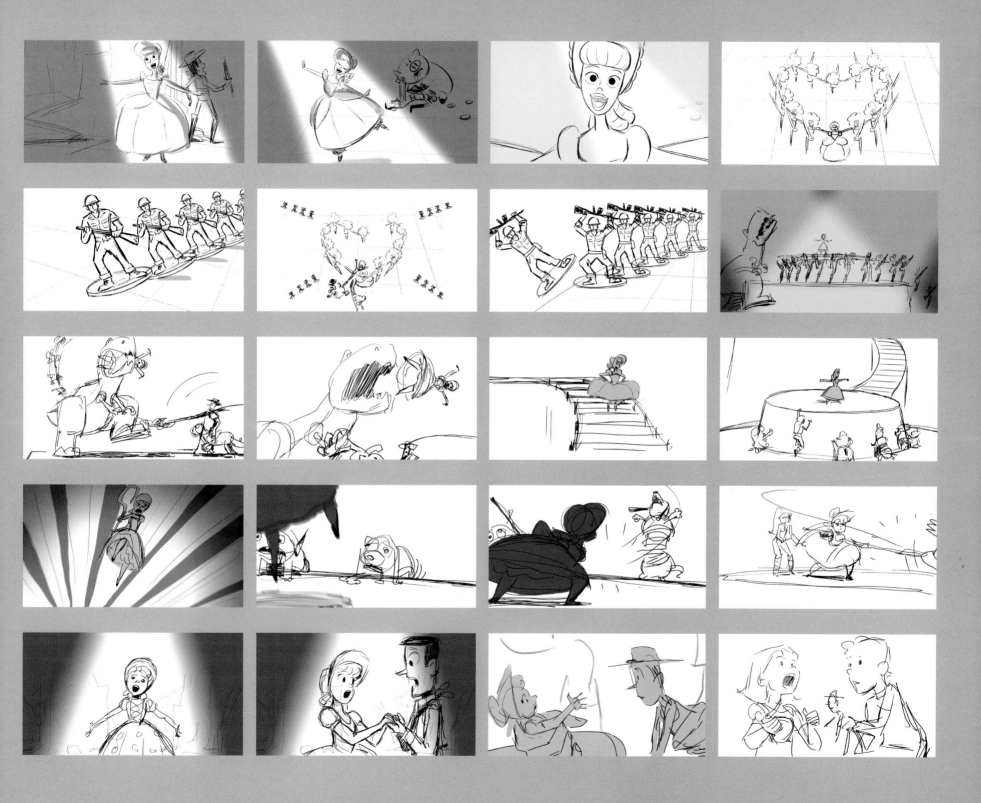

ACKNOWLEDGMENTS

We feel so lucky that we have this book as our reminder of how much talent and love went into *Toy Story 4*. Along with the other wonderful "Art of" books in the Pixar library, this is a look behind the process of making an animated movie. It's an attempt to capture the sketching, drawing, painting, and more than anything, the thinking that goes into making the film. The artwork that fills these pages is created by some of the most talented artists in the movie industry. It's a very important book for us. It's sort of the unofficial yearbook for the *Toy Story 4* crew, and we are so proud of it.

A tremendous heartfelt thanks to the *Toy Story 4* Art Department led by Bob Pauley and Margo Zimmerman, and Story Department led by Valerie LaPointe and Samantha Wilson. Working alongside the amazing artists on this film is the equally talented creative production staff that kept it all moving forward: Maura Turner, Austin Goddard, Jess Walley, Nick Berry, Erik Langley, Hope Bogle, Elise FitzGerald, and Emily Oyster.

Pixar's own publishing team poured their heart and soul into this book. You would not be reading this without the talents of Molly Jones, Jenny Spring, Deborah Cichocki, and Shiho Tilley. They partnered with our dear friends at Chronicle Books: Lia Brown, Neil Egan, Frank Parisi, and Beth Steiner, who together help run the greatest publishing company on the planet! Thank you all!

There would be no book, no film, and no fun without the *Toy Story 4* Production Team. Bob Moyer, Kim Collins, Elissa Knight, Marguerite Enright, Erinn Burke, Kimmy Birdsell, Vincent Salvano, and Maxwell Ernst. A special thanks to our fearless Feature Relations champion Melissa Bernabei. Thank you for being part of this crew. #Squad Goals Forever!

And to the Pixar leadership team that supported us along the way: Pete Docter, Andrew Stanton, Lee Unkrich, John Lasseter, Dan Scanlon, Peter Sohn, Rosanna Sullivan, Jim Morris, Ed Catmull, Katherine Sarafian, Marc Greenberg, Tom Porter, Jonathan Garson, Jim Kennedy (it was a fumble), Lindsey Collins, Steve May, and Britta Wilson. This group always had our backs, and we love you for it. A very special thanks to Galyn Susman, who set this production up and helped to shape one of the greatest production teams ever assembled.

Finally, we draw inspiration from many people and places, and we'd be remiss if we didn't call them out here. So a very special thank you to: Lake Chalet, Chateau Marmont, Disneyland, House of Prime Rib, all our friends at the Oakland A's (including Bob Melvin, Vince Cotroneo, and Ken Korach), Howard Green, Tony Baxter, El Compadre, The Walt Disney Family Museum, Hyacinth Sensationnelle D'Eden, Lucky Clover, The Oaks Card Club, Tacos Chavez, and those beautiful Golden Bears of California.

And of course, thank you to our parents, who filled our lives with love and toys, and inspired us to make movies about how fun it was to grow up.

Last but not least, many thanks to everyone at Pixar. It continues to be an honor beyond words to work among such a talented and inspired group of people.

Jonas Rivera and Mark Nielsen
Producers, *Toy Story 4*

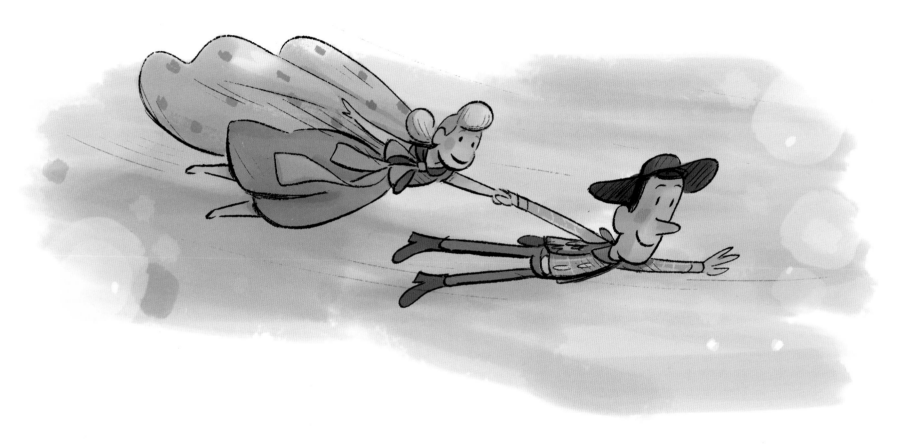

Carrie Hobson, DIGITAL

[opposite] Deborah Coleman, PHOTOGRAPH

Vincent Salvano and Kimmy Birdsell stand
in front of the *Toy Story 4* quota board,
which tracks the production of the film.

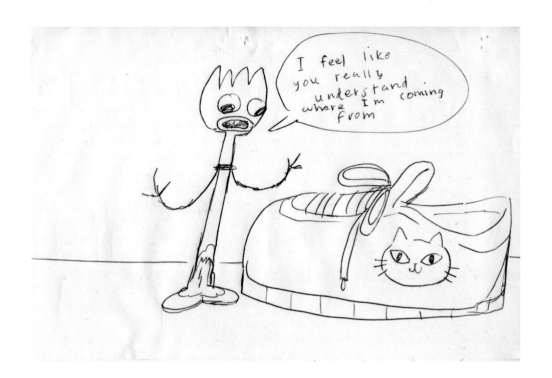

Erik Benson, PENCIL ON PAPER

Yung-Han Chang, PEN ON PAPER

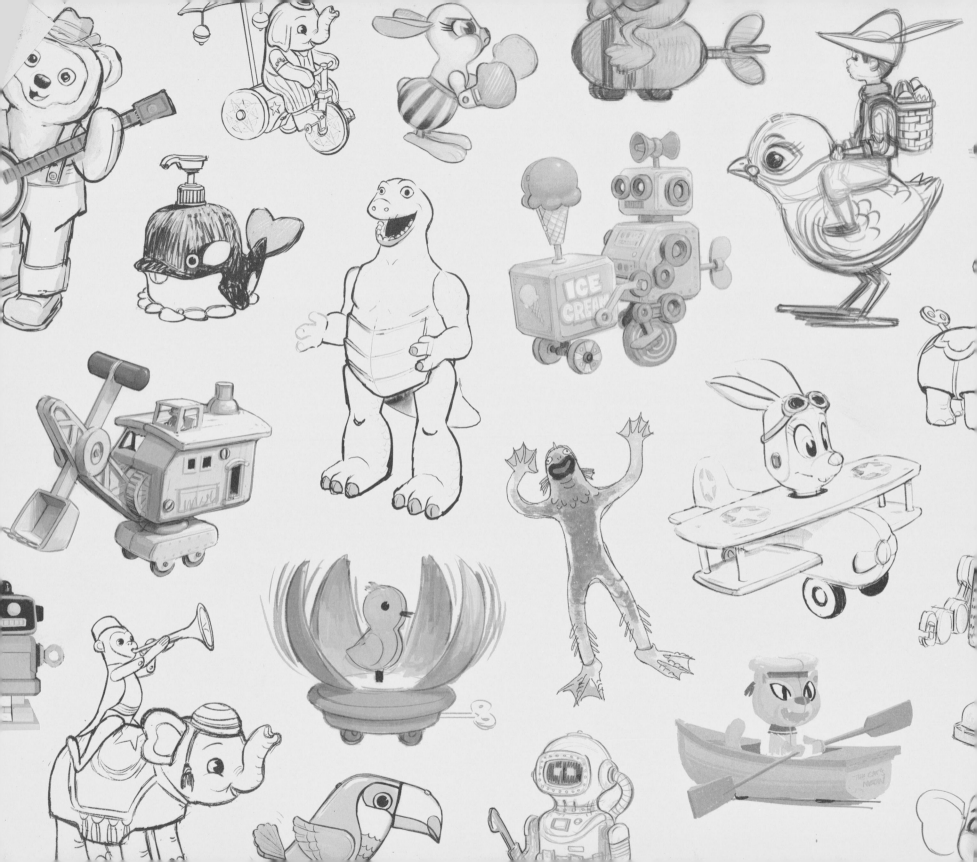